WEBCOMICS

STEVEN WITHROW & JOHN BARBER

ILEX

WEBCOMICS
Copyright © 2005 The Ilex Press Limited

First published in the United Kingdom
in 2005 by
I L E X
3 St Andrews Place
Lewes
East Sussex
BN7 1UP

I L E X is an imprint of
The Ilex Press Ltd
Visit us on the Web at:
www.ilex-press.com

This book was conceived by:
I L E X, Cambridge, England
Publisher: Alastair Campbell
Executive Publisher: Sophie Collins
Creative Director: Peter Bridgewater
Managing Editor: Tom Mugridge
Project Editor: Ben Renow-Clarke
Art Director: Tony Seddon
Designer: Jonathan Raimes
Junior Designer: Jane Waterhouse

British Library Cataloguing-in-
Publication Data.
A catalogue record for this book is
available from the British Library.

ISBN 1-904705-50-2

Printed and bound in China

For more information on this title
please visit:
www.web-linked.com/webcuk

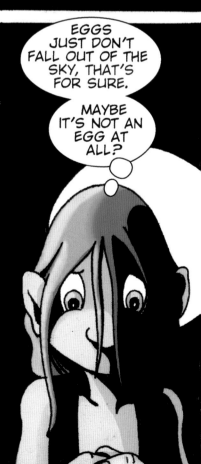

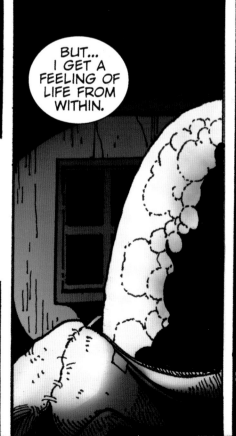

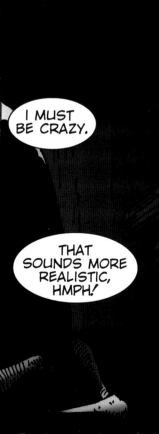

CONTENTS

FOREWORD

In the mid-1990s, cartoonists began to envision a culture on the Web: new work constantly in rotation, an audience once hampered by bad distribution now finding their favourite comics and searching them out as part of their daily routines, an uninitiated audience finding pleasure in a new art form spreading before their eyes. And then: paperless paper rolls, cartoon strips on our mobile phones and PDAs, state-of-the-art screen resolutions, and aggregate sites and filters to sort the whole thing out. A new audience with no nostalgic affinity for the smell of paper, the turn of the page, the ritual of the cramped and difficult distribution/retail network. And finally: geniuses for whom paper is no object, who craft as easily in electrons and pixels as our earliest practitioners did in ink and line.

A friend once said to me that the World Wide Web was a cobbled-together contraption: nothing but wires and springs and jury-rigged code. We would be lucky if anything came to fruition as quickly as we were all hoping it would.

The more I think about this, the more I see that it applies to just about everything in life. Things progress and evolve much more slowly than we imagine they will. Our small projects, our community's dreams, our global visions are all snail-like in development.

Now, it shouldn't be that way with pixels, light, and electrons, but alas, because people are behind it, the Web's development, like my friend suggests, isn't much faster.

But this isn't such a bad state of affairs. Today, audiences for a scant few strips are enormous, and most strips and stories still only capture a tiny niche audience. Thousands of new readers are not necessarily being won by the sudden universal nature of our favourite art form on the Web. Cartoon stories on our mobile phones are rare, and strips for our personal devices are tough to read and difficult to find.

But look around. Many of the artistic/creative ends of these dreams have actually come true, or are working themselves out at a comfortable pace. We have thousands of cartoonists out there, working in pixels and light more easily than with pen and paper. We have brilliant individuals who are creating unique, screen-based (will the screen, too, become antiquated?) experiences. To thousands of hopeful creators, the Internet has given them the chance to create, learn, explore, experiment, grow, share, and shine, while readers numbering in the tens of thousands – and growing every day – feed their healthy addictions to cartoon art – fixes that aren't being satisfied in daily newspapers, in magazines, in local stores, or anywhere within the reach of our slow and stubborn molecules.

This book is a celebration and investigation of the techniques and processes of the creators who have adopted, embraced, and built this new medium. Here is that opportunity to look around: a survey of the state of affairs in a very interesting medium at a very exciting time.

Tom Hart
New York City, 2004

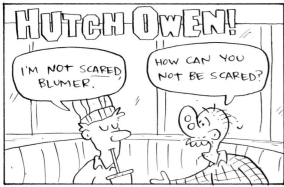
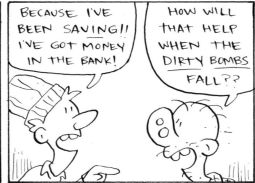
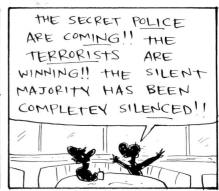
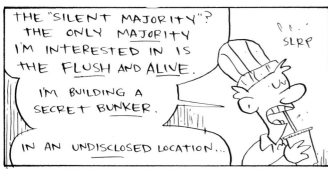
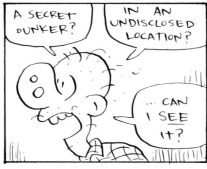
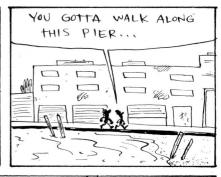
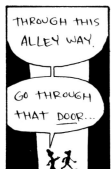
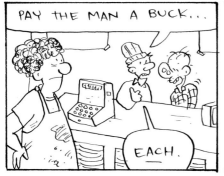

#ONE

A NEW DAY FOR COMICS

'I link, therefore I am!'

This twist on Descartes' famous quote not only introduces Charley Parker's pioneering webcomic, *Argon Zark!*, but also encapsulates the electric, here-there-and-everywhere spirit of online cartooning. This book aims to show how, each hour around the world, webcartoonists are busy working and reworking our basic definition into a thriving art form with qualities unlike any other.

The Web offers unprecedented opportunities for author– audience interactivity, creator collaboration, and perhaps even the creation of a thriving industry. Webcartoonists have adapted to the online environment in delightfully unexpected ways – proving to be some of the world's most innovative digital artists. A look at the emerging history, as well as the now-global breadth of webcartooning, reveals three fundamental threads that are likely to guide the future of the medium:

1. Technological adaptation
2. Formal experimentation
3. Cultural expansion

INTRODUCTION

The mere concept of online or digital comics, by virtue of being relatively new and largely untested, defies simple classification.

While we the authors acknowledge that all theories are both descriptive and prescriptive, we have sought as inclusive a definition of webcomics as is useful for our purposes in the context of this book.

Our theory of webcomics is that there exists a continuum of artistic, communicative, and/or narrative works that are bonded (though by no means *bounded*) by the following two properties:

1. Delivery and presentation through a digital medium or a network of digital electronic media

2. Incorporation of the graphic design principles of spatial and/or sequential juxtaposition, word–picture interdependence, and/or closure

Given this definition, one might group webcomics with related works in print, on film, in broadcast media, or elsewhere online. However, we stress that webcomics have developed, in their little more than a decade of existence, a discrete identity, malleable though it may be, that allows for coherent discussion.

Later in the book, we will present some of the formal 'grey areas' that webcartoonists are now exploring – for example, the narrowing gap between webcomics and digital animation or between webcomics and online games. But here at the start, it suffices to say that webcomics in their most common format are comics that you read on the World Wide Web.

In other words, webcomics exist as binary code and can be stored as digital files and also transferred from person to person through a network of digital devices such as online computers, PDAs, and mobile phones.

See the books of Will Eisner, Scott McCloud, and R.C. Harvey, as well as Dylan Horrocks's 'Inventing Comics' essay as cited in the bibliography, for further discussion of these principles.

Images on this spread were created by Swiss webcartoonist demian.5 (www.demian5.com).

a new day for comics

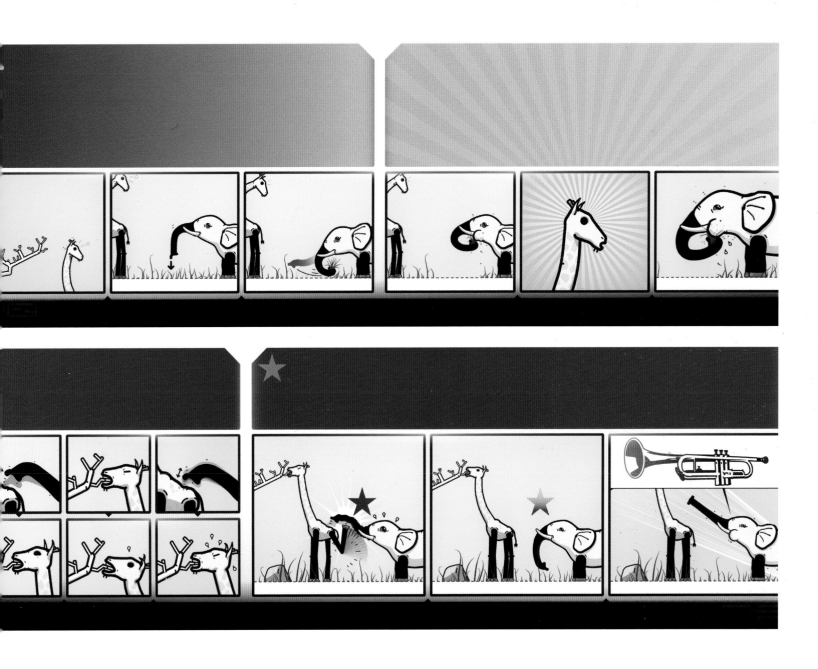

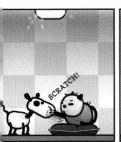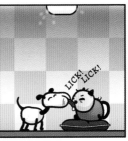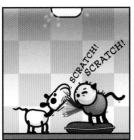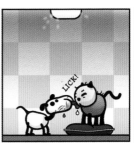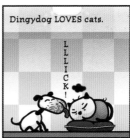

Dingydog LOVES cats.

T CAMPBELL A HISTORY OF ONLINE COMICS

Aesthetically, the first few webcomics had no template to follow – neither comic strips nor comic books were right for the challenges of low download speeds and a techie audience. The early online comic *Where the Buffalo Roam* was an adapted university newspaper strip, *Dr. Fun* was a one-panel joke in the vein of *The Far Side*, *Netboy* was remarkable for using Web issues as its theme, and *Jax and Co.* was notable for experimenting with JavaScript.

For lack of better terminology, this period, from about 1993 to 1996, was the 'Stone Age of Webcomics'. Its practitioners had plenty of pioneering enthusiasm, but bandwidth limitations and lack of training hampered the quality of the art, while the writing was directed either at too narrow an audience to prove popular – or at no specific audience at all.

Still, the Stone Age was a time when comics creators needed to try something new. The comic book industry had fallen into a terrible economic slump and the great comic strips of recent years – *Calvin and Hobbes*, *The Far Side*, and *Bloom County* – were all gone. These conditions make it a bit easier to understand why those who loved comics turned to the Web to practise their craft, even for an audience of only dozens, even for no money.

Webcomics kept developing, but the form was not generally recognized until 1996 and online cartoonists often didn't recognize one another. Even the word 'webcomics' didn't really exist yet. If you saw the word online in 1995, it probably referred to *Webcomics.com*, a creation of David de Vitry, who pioneered the webcomics collective years before its time.

Most of the well-remembered material from the Stone Age, though, was either well connected to the world outside webcomics or was an obvious and skilled celebration of the Web itself. The 'connected' strips included *Salon.com*'s *Kevin and Kell*, created by Bill Holbrook, who already had two syndicated newspaper strips. *Filler* was a little bit of both: this regular feature from the high-profile webzine *Suck* profited from an audience drawn in by *Suck*'s text articles, which shared *Filler*'s cheerfully anarchic cynicism about the Web (and everything else).

Helen, Sweetheart of the Internet by Peter Zale went directly for the Web audience. The eponymous Helen was a master of hardware, and the strip provided real insights into techie life without becoming indecipherable to the non-techie user. She was a woman who 'got' the Web, and that made her desirable to the strip's characters, online readers, and eventually to newspaper groups.

Finally, attention must be paid to the greatest visual feast of the Stone Age, *Argon Zark!* The title character starts experimenting – on himself, naturally – with 'Personal Transport Protocol', which sends him and his companions on a journey into the pages of the World Wide Web. This plot allows artist Charley Parker an opportunity to celebrate the Web as a thing of beauty.

By 1997, strips like *Zark* were getting attention from the mainstream press, even as print comics giant Marvel released a special 'cybercomic' featuring Spider-Man. Meanwhile, readers were beginning to surf for comics and compare their findings.

All this attention signalled the end of the Stone Age, and the next age, the Golden Age, was heralded by the introduction of five comics sites that would define the webcomics scene for the next three years and remain important parts of it to the present. Call them the Five Horsemen: *Sluggy Freelance*, *User Friendly*, *PvP*, *ScottMcCloud.com*, and *Penny Arcade*.

The Five Horsemen were each a commercial success – five of the very few such successes online. This made them influential in both the art form of webcomics and its developing commerce. And tellingly, each of them began its first strip in front of a computer screen.

Sluggy, for some years the world's most popular webcomic, is difficult to pin down. Its stories have sometimes been shaggy dog tales about the Internet, but cartoonist Pete Abrams has stirred in film and television parodies, melodrama, horror, holiday mythology, and more. The real constants seem to be Abrams's prodigious production rate and his special flavour of humour.

Despite their newness, webcomics have already attracted the attention of comics historians and critics, such as T Campbell, who have sought to mark their beginnings, chart their progress in multiple areas (formal, technological, cultural, economic, etc.), and predict their future as a form.

Sluggy Freelance

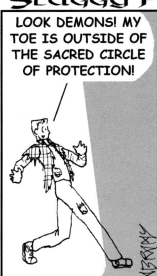

LOOK DEMONS! MY TOE IS OUTSIDE OF THE SACRED CIRCLE OF PROTECTION!

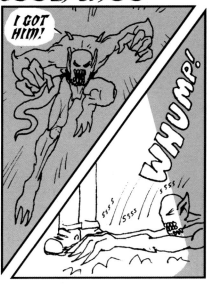

I GOT HIM!

WHUMP!

SSSS

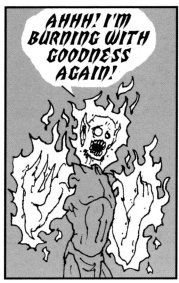

AHHH! I'M BURNING WITH GOODNESS AGAIN!

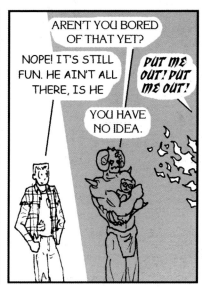

AREN'T YOU BORED OF THAT YET?

NOPE! IT'S STILL FUN. HE AIN'T ALL THERE, IS HE

YOU HAVE NO IDEA.

PUT ME OUT! PUT ME OUT!

SLUGGY FREELANCE

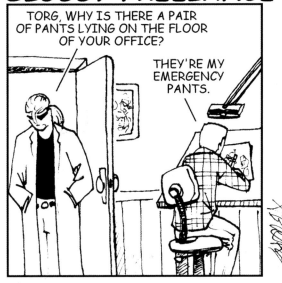

TORG, WHY IS THERE A PAIR OF PANTS LYING ON THE FLOOR OF YOUR OFFICE?

THEY'RE MY EMERGENCY PANTS.

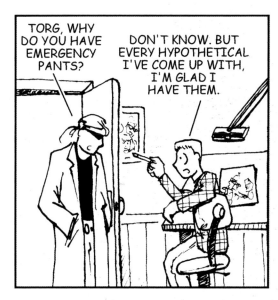

TORG, WHY DO YOU HAVE EMERGENCY PANTS?

DON'T KNOW. BUT EVERY HYPOTHETICAL I'VE COME UP WITH, I'M GLAD I HAVE THEM.

Kevin & Kell

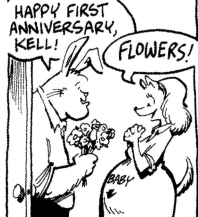

HAPPY FIRST ANNIVERSARY, KELL!

FLOWERS!

BABY

OH, KEVIN! YOU'RE SO THOUGHTFUL! OTHER HUSBANDS WOULD'VE BOUGHT A GIFT THAT WAS REALLY FOR THEMSELVES!

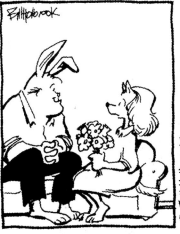

Bill Holbrook

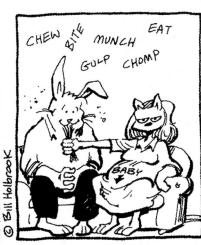

CHEW BITE MUNCH EAT GULP CHOMP

BABY

© Bill Holbrook

J.D. Frazer's *User Friendly* is easier to understand: it's a series of jokes for the working geek, and it rarely pretends to be anything else. *User Friendly* has kept pace with whatever concerned geeks in any given year: the dot-com crash, *Star Wars* films, caffeine addiction, and especially open-source software and Linux. As print comic strip *Boondocks* is to the politically concerned, *User Friendly* is to the technically inclined, which happened to be the hardcore Web-user demographic. Its approach is that of *Helen, Sweetheart of the Internet*, refined.

 PvP refines the approach still further. *PvP* is also a geek comic, with an emphasis on gaming humour. The characters are more well rounded than *User Friendly*'s but not as mobile as *Sluggy*'s. The majority of scenes take place in the offices of the videogame magazine that gives the strip its name. The personalities of Scott Kurtz's characters strike sparks against one another for chuckles, but most of the strip's laughs come from sharp-witted pop culture references.

 Of these first three strips, only *Sluggy* has really dabbled in formal experimentation. Scott McCloud has put this aspect front and centre on *ScottMcCloud.com*. Every comic on his

USER FRIENDLY by Illiad

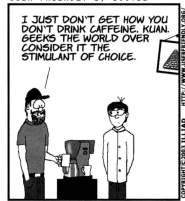

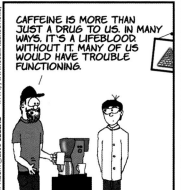

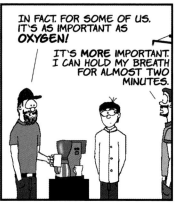

Above and opposite page: **Examples from J.D. Frazer's** *User Friendly* **(www.userfriendly.org) and Scott Kurtz's** *PvP* **(www.pvponline.com).**

Right: **From Scott McCloud's** *Morning Improv* **series (www.scottmccloud.com).**

site – *The Right Number, Porphyria's Lover, My Obsession with Chess, Zot! Online: Hearts and Minds, I Can't Stop Thinking!*, the *Carl* stories, *Ninety-Five*, and *The Morning Improv* – are all challenging exercises in the nature of what makes comics tick. His experiments include new kinds of visual transitions, greater interactivity with readers, and a 'branching' narrative structure. But his most influential notion has been the 'infinite canvas': the idea that comics on the Web can have dimensions much larger than that of any printed page. Many other webcartoonists have experimented with infinite canvas, and some have made it a regular part of their strips.

Finally, *Penny Arcade* further refines the template begun by *Helen* and continued in *User Friendly* and *PvP*. Its focus is even narrower: it features the antics of Tycho and Gabe, characters who spend a great deal of time playing videogames, intermixed with comics about specific games. Gamers identify with Tycho and Gabe's joint personality and enjoy Mike Krahulik and Jerry Holkins's parodies of games. *Penny Arcade* is likely the most popular webcomic in production. Its influence has been profound, as many of its imitators have become extremely popular strips in their own rights. The gamer comic genre has arrived.

To a large degree, the Five Horsemen heralded the existence of webcomics as a field. All are reportedly making a living from their webcomics and subsidiaries (such as merchandising, print collections, and lecture tours). Their audience numbers have rivalled and even surpassed those of print comic books: in 2003, *Sluggy Freelance* trumped best-selling print comic *JLA/Avengers*: 300,000 daily readers online compared to 200,000 copies sold.

Oddly, for such an aggressively independent medium, webcomics seem to be more prone these days to influence from large, loose collectives – not quite publishers and not quite syndicates. And the influence has been grounded less in art and more in commerce. From the early model of *Webcomics.com* emerged *Big Panda*. *Panda's* brief history was marked by service failures and political infighting, but it did bring together some highly productive minds that eventually joined together as *Keenspot*. For a couple of years, *Keenspot* proved that a large-scale webcomics collective could succeed, and then *Modern Tales* joined the picture to disprove the conventional wisdom that no one would pay for content.

At its most basic, the current competition between *Keenspot* and *Modern Tales* represents competing theories of the future of the webcomics business: *Keenspot* offers most of its content free, and *Modern Tales* charges subscription fees. In the *Keenspot* model, the content is the 'hook' to attract money from advertising, print collections, merchandise, and other derivative works. In the *Modern Tales* model, small free samples are the 'hook', and the main business comes from subscriptions, which provide full access to all content.

From this simple division, all kinds of variations have sprung. *Sluggy* has mostly used *Keenspot's* model but supplemented it with that of *Modern Tales. ScottMcCloud.com*, *01Comics*, and others have experimented with 'micropayments', extremely low prices charged through online services such as BitPass, to offer pay-per-view comics and features. Even *Keenspot* has experimented with pay content, and *Modern Tales* has experimented with advertising and merchandise.

For now, this experimentation is still the name of the game, both commercially and artistically. With all the raw creativity still pouring into the field from all sides, the future of webcomics is anybody's guess. It's probably all we can do to describe its past.

T Campbell is the editor of GraphicSmash.com *and the writer of the webcomics* Fans! *and* Rip & Teri. *Portions of this history appeared, in slightly altered form, on* www.comixpedia.com.

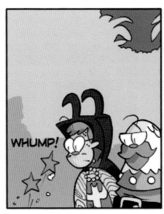
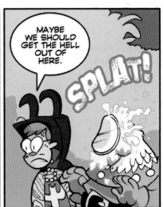

The comics version of 'old media' first responded to the Web with the same old material in a silicon package. *Marvel.com* launched a short series of 'webisodes' featuring Spider-Man. The strip syndicates often put a couple of weeks' worth of strips online – a remarkable move, considering the primary reason for their existence was to give newspapers exclusive content. Comic-book publishers and syndicates have refined their approaches in recent years, but the core philosophy remains: there are the *real* comics, and then there are the Web *versions* of real comics.

Why wasn't that enough? Why did Web-native comics end up finding so much larger an audience than properties with decades more experience? Short answer: because Web-native comics *come from* their intended audience…the Web-native audience.

At the time of writing, 600 million people use the Web, but just using it doesn't make you a native. Natives are truly involved with the Web. Natives look to it for entertainment and conversation.

And natives share other demographic traits. One of these is a resistance to demographic studies! Concerns about identity theft and spammers' tricks make them cagey with their personal information, and so percentages are hard to come by.

Still, an impressionistic picture is emerging. Most readers are young: school age to late twenties, with a significant number in higher education. The gender ratio appears more balanced than that of comic books, though not comic strips. They're well-off enough to have a fast connection and some leisure time, but not so settled they have no time to discover entertainment in out-of-the-way places. Predominantly white, socially and financially liberal, well-read, and media-savvy.

They have no patience for the bland Pleasantville presented by most newspaper strips: their sense of humour is smarter, cruder, and wilder. They have no patience for the clichés and conventions of superhero series; they won't reject superheroes, but they will reject the 'heroes meet, misunderstand each other, fight, and then team up' storyline that comic books have been selling since 1961. They have no patience for storytellers who pretend sex is always magical or that romance is as simple as Meg Ryan films claim.

They have no patience. But once you have them hooked – the critical part – repeat readers will follow you to the ends of the earth. Many strips that started as simple humour stories matured into far more ambitious projects, with the full support of the readership. It's inconceivable that something similar could happen in the world of newspaper comics – it'd be like *Garfield* becoming *Watership Down* for dogs and cats – but webcomics readers are much more flexible about genre, and much more prone to see the silliness in seriousness, and the serious side of silliness.

Their loyalty can translate into support when things get rough. Pete Abrams's *Sluggy Freelance* and R.K. Milholland's *Something Positive* both recently conducted successful 'save the strip' charity drives. On a smaller scale, when a cartoonist becomes too sick or overworked to draw, what pour in are not complaints but messages of support.

That support can become concern and worry if those messages meet no replies because webcomics readers are used to having access to their cartoonists. Though the most popular ones couldn't possibly answer every forum post, much less every e-mail,

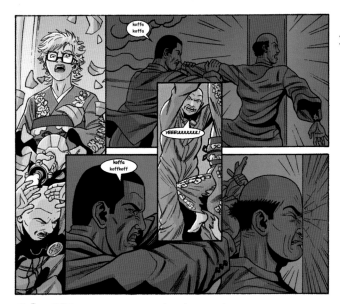

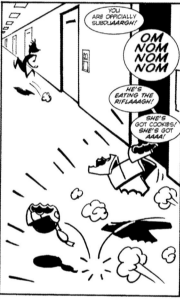

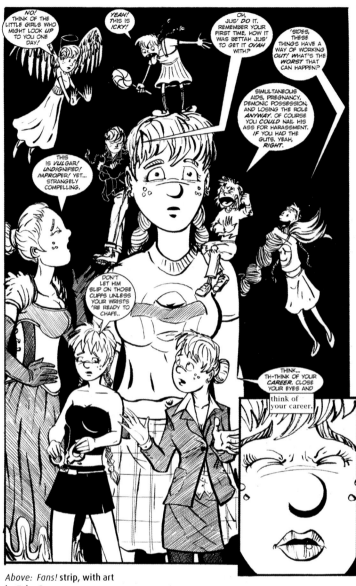

Left: Rip & Teri is a spy romance, equal parts oestrogen and testosterone. Story by T Campbell, art by John Waltrip, and colours by David Willis.

Above: Fans! mixes humour with drama, and occasionally swings to extremes. Story by T Campbell and art by Jason Waltrip.

Above: Fans! strip, with art by Tyler Page.

they often put out some kind of blog or general announcement. Because webcomics don't have many middlemen, readers feel they know cartoonists far more intimately than the most fervent Marvel Zombie knew Stan Lee or Jack Kirby.

This has transformed the writing of webcomics into an intensely personal activity, but not personal in the old ivory-tower sense that most novelists talk about. The best webcomics seem to have developed in a sort of conversation, a day-by-day process of stimulus–response between reader and creator. The creator often begins with a firm idea of who the characters are and where things will go, but learns from his or her readers – either their input or their visceral responses – how to implement those ideas in the way that affects them most.

Webcomics are still young, and therefore their readership is young, too: some things about that readership may change in the next 10 years.

But that does not change the fact that the current webcomics readership is important. Some of the traits that set them apart from other comics readers – their media savvy, their adventurous reading habits, their age range – make them the kind of demographic that advertisers covet, and their tastes might drive larger comics industries in the near future. Thanks to the creator–reader conversation, readers are getting used to having those tastes more directly served.

Comics' 'old media' should pay attention to all this. The definition of what 'real comics' are is shifting under their feet.

WEBCOMICS CONSIDERATIONS

A Starting Point

When setting out to be webcartoonists, we most often emulate the stories and strips we like to read. Even if we choose not to copy other artists outright, our approach to structure and substance is rarely outside the realm of what we already know well. When we gain some confidence in our abilities, we might experiment with elements of story and art that are not comfortable to us, as a personal or professional challenge, but seldom will we take a truly unexpected path. This is not a bad thing, actually. Since we're all trying to find what works, for ourselves and for our readers, it makes sense that we would gravitate to what has succeeded in the past and what is currently popular. Total originality isn't everything, after all, and few artists can defend their claim to it.

More important than seeking out novelty, however, is developing our skills so that, when we have something to say, we also have the tools at hand to say it effectively, whatever and however that something might be.

Which Genre Are You?

Webcomics cover just about every basic type of story that can be found in print comics – and more. And while it's expedient to categorize groups of comics – based on certain shared conventions of content, style, and theme – under such neat appellations as adventure, fantasy, sci-fi, comedy, romance, mystery, or autobiography, the works themselves are in practice much harder to classify. Each genre can be divided into countless subgenres, and hybrids of genres so abound online that we end up describing one strip as 'manga-esque romantic-comedic epic-fantasy-adventure aimed at gamers' and another as 'satirical gag-a-day personal journalism with a touch of absurdist magical realism'. Complex, indeed!

But there are benefits to acknowledging and participating in a system of genres:

Genre is marketable. Creators of comics that share similar elements can band together in anthology sites and/or cross-promote each other's work easily.

Genre is convenient. Webcartoonists can borrow, twist, and reverse well-established customs of story and design, trusting the reader to recognize these 'genre conventions' and respond (for example, the use of aliens in science fiction or monsters in horror fiction).

Genre is adaptable. As literature evolves, so do notions of genre. Even in the most 'overdone' genres, literary history has proven that there is always room for unforeseen exploration and expansion.

That said, a potentially dangerous effect of 'genre building' is the springing up of subcultures or cliques that play one type of webcomic against another like rival sports teams, asserting the unquestionable superiority of, for example, speculative fiction over naturalism, alternative over mainstream, or serialized gag strips over self-contained long-form stories. This brand of thinking can lead new readers to ignore large swathes of webcomics that they might otherwise enjoy at the urging of a few people on message boards who are fixated only on their favourites.

In the end, it all goes back to personal choice. Go online and tell the story you want to tell, in the way you want to tell it, and let the 'genre police' take care of themselves. Your readers might not know how to label your creations, but the best work breaks out of the boxes we sometimes place it in.

 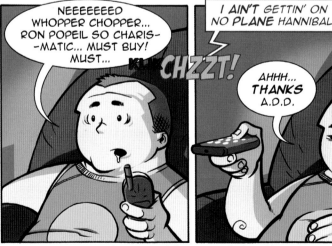

butternutsquash © ramon perez & rob coughler, a calavera studio production

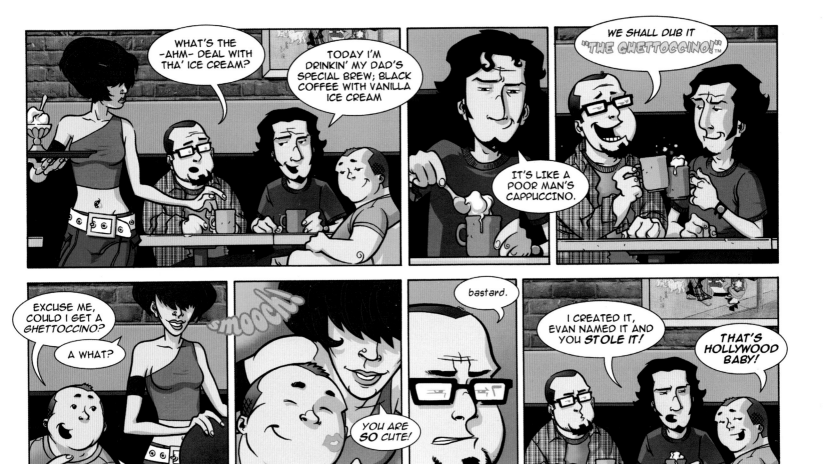

butternutsquash ©, ghettoccino™ ramon perez & rob coughler, a calavera studio production

butternutsquash © ramon perez & rob coughler, a calavera studio production

Images on this spread are strips from
butternutsquash by Ramón Pérez and
Rob Coughler at butternutsquash.net.

Writing encompasses *prewriting* (thinking, planning, researching, structuring) and *rewriting*, and it occurs at every stage of the webcartoonist's creative process. Each minor or major decision and action, from the initial impulse to the later steps of lettering and colouring, affects the shape and substance of a webcomic's story or message. In webcomics, even drawing is a form of writing – or is it the other way around?

With that in mind, ambiguity and all, let's briefly explore one aspect of writing as most people think of it – the art of working with words – using a script of mine as an example. For a broader view, I suggest consulting the titles in this book's bibliography to learn principles and practices of scripting and storytelling – from structuring and pacing to building worlds in detail and characters in conflict.

For various reasons, I prefer to write scripts and leave the shackled-to-a-drawing-tablet labour of cartooning to others more gifted and willing than I. While some critics have argued that a single author produces the most unified and untrammelled work, I believe that a close collaboration between a writer and an artist can yield webcomics of equal – and, once in a while, surpassing – value. But, in many cases, before this special chemistry can occur, a writer must confront a blank page or computer screen.

The story in question – 'Manuwahi' – began in the brain of New Zealander Roberto Corona as an idea for an original fable set on a mythic island in the South Pacific. Bob asked me to write the script, sending me a loose story outline, and we discussed (by e-mail) the story's premise and major themes.

I then went where I always go when I begin writing: a place within myself I call 'the space' – below conscious thought yet above actual sleep. What did I do there? I listened, closely, for the sounds my mind was making out of the raw material of the story. I listened for the first strains of music that would eventually become 'Manuwahi'.

For me this is the essence of webcomics writing. My singular role in the writer–artist partnership, as I see it, is to be the 'sound maker', while the artist is the 'sight maker'. Ultimately, the artist or artistic team focuses on what the reader will see on the screen, which leaves to the writer the task of engaging the reader's 'listening' mind – forming the parts that readers might speak aloud or in their heads. In my experience, writer and artist balance between them every other element of the narrative – intention and execution, structure and continuity, means and meaning.

In my conception of the art form, scripting webcomics is akin to composing poetry, involving the poetics of word choice, syllable sound, ambient sound (also called sound effect), and the full breadth of rhyme, metre, rhythm, emphasis, and cadence (the intersection of rhythm and content). Not to mention modulating between concrete and figurative language, hunting as much for what to hold back as what to express. I play the poet not for a lyrical, prettifying purpose only, but because I affirm that the strongest writing is attentive to the harmony and disharmony in its chorus of components: in the case of webcomics, word and line and shade and shape.

Penning webcomics is also analogous to crafting the beats, scenes, and sequences of plays for stage or screen. The writer becomes engrossed in the dramatics of voice, tone, speech (monologue and dialogue), tension, release, inflection, and exposition. Thought of in this way, it's apparent that webcomics are not merely a silent, picture-dominant form, as many critics have suggested.

When I wrote the opening two pages of the eight-page fable, I 'saw' a running series of visual impressions, choosing to include in the script only those images most integral to the story that had begun to develop, but I knew that it would be Bob's job to design the setting and characters, arrange the pages, and stage each panel. I concentrated on brevity, clarity, and musicality; in other words, the story had to succeed, at least as a first draft, in sense as well as in sound before I would share it with the artist. This draft took about a week to complete.

From my script Bob began to sketch and draw, and he soon sent along numerous questions and suggestions for revision, most of which I answered, argued, or allowed. Then the story was Bob's completely for a time. I moved on to another project quickly so as not to 'dwell' on the half-created story. Weeks later, after we reviewed the pencils, Bob and I made a few changes to the sequence of images and then tweaked the narration and dialogue directly on Bob's lettered pages. We were 'of one mind' by this point, as we could both see and hear the total story we were telling together. Bob's pictorial insight supported and amplified my sonic sensibility, resulting in a story that appealed to two sensory systems at once, where on the surface it might appear to be wholly visual. Once the story proper had found its shape, Nigel Dobbyn punctuated the production with his wonderful colouring work, and we launched the story online. Dark Horse Comics selected it for the short-lived Strip Search Contest, but it now resides on *01comics.com*.

In the end, my literary approach might not work for every writer, but it lets me sharpen and share my singing, tale-spinning voice. And in the graphic art that is webcomics, a little word music carries a long way.

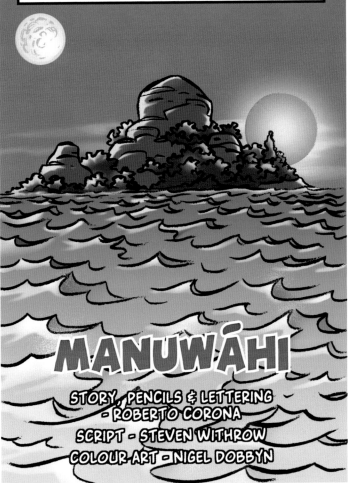

ONCE, ON THE TIDE OF ANOTHER TIME, THE TRICKSTER MOON AND HIS SISTER THE SEA DELIVERED TO MANUWÁHI -- ISLAND OF TWO LEGS AND FOUR -- A STRANGE, EIGHT-LEGGED CREATURE.

MANUWÁHI

STORY, PENCILS & LETTERING
- ROBERTO CORONA

SCRIPT - STEVEN WITHROW

COLOUR ART - NIGEL DOBBYN

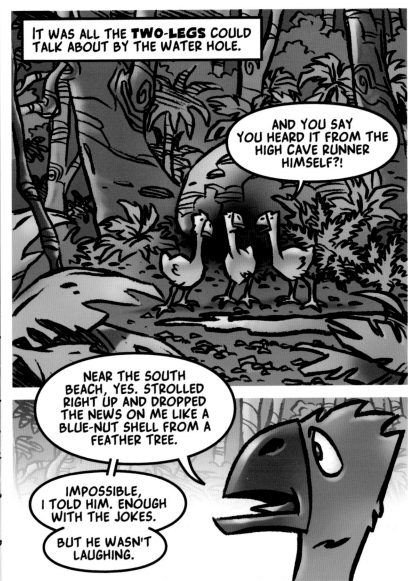

IT WAS ALL THE **TWO-LEGS** COULD TALK ABOUT BY THE WATER HOLE.

AND YOU SAY YOU HEARD IT FROM THE HIGH CAVE RUNNER HIMSELF?!

NEAR THE SOUTH BEACH, YES. STROLLED RIGHT UP AND DROPPED THE NEWS ON ME LIKE A BLUE-NUT SHELL FROM A FEATHER TREE.

IMPOSSIBLE, I TOLD HIM. ENOUGH WITH THE JOKES.

BUT HE WASN'T LAUGHING.

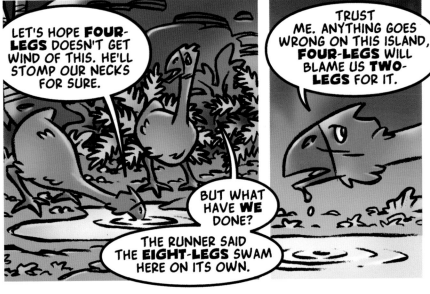

LET'S HOPE **FOUR-LEGS** DOESN'T GET WIND OF THIS. HE'LL STOMP OUR NECKS FOR SURE.

BUT WHAT HAVE **WE** DONE?

THE RUNNER SAID THE **EIGHT-LEGS** SWAM HERE ON ITS OWN.

TRUST ME. ANYTHING GOES WRONG ON THIS ISLAND, **FOUR-LEGS** WILL BLAME US **TWO-LEGS** FOR IT.

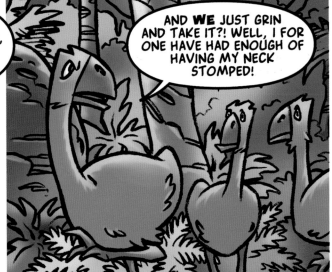

AND **WE** JUST GRIN AND TAKE IT?! WELL, I FOR ONE HAVE HAD ENOUGH OF HAVING MY NECK STOMPED!

..that'll
be one dollar,
please..

#TWO

A STRAND OF LANTERNS

Think of the computer screen as a window, as Scott McCloud has suggested, and each webcomic as the view beyond the window. Now pull far back and try to envision the vast digital darkness of the Web. Can you see the string of lights that represents the webcomics you read?

In this section, we will introduce six popular webcartoonists who work in differing styles, genres, and formats. Each featured artist presents a workthrough or in-depth tutorial. Rather than provide models everyone must follow, the artists intend merely to share a working method or creative process that they have found effective; reading these sections is no substitute for trying things out on your own. After each workthrough, you will find a quick technical piece to help you get started on the Web and in online comics.

SHAENON K. GARRITY

Like her character Helen Narbon, Shaenon Garrity is the mad scientist (some would say 'high priestess') of the online comic strip. Running daily since 2000, her flagship strip, *Narbonic* – a unique amalgam of daily jokes and story continuity – has become one of the mainstays of the *Modern Tales* anthology site. It has even inspired a convention of its own, Narbonicon. Shaenon is also the writer of the webcomics *Trunktown* (drawn by Tom Hart), *Li'l Mell* (drawn by Vera Brosgol), and *More Fun* (drawn by Bob Stevenson and Roger Langridge).

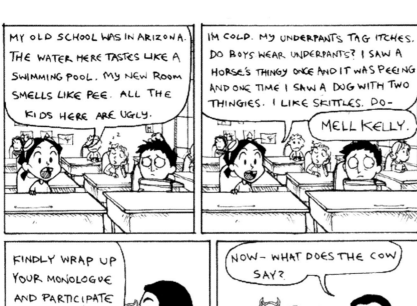

When and how did you begin creating comics?

I started drawing comics in high school in Ohio. I was chosen as my school's correspondent for the kids' section of *The Cleveland Plain Dealer*, but I hated it; interviewing people was constant agony for a socially retarded nerd like me. To wiggle out of this responsibility, I offered to draw a comic strip instead. This turned out to be pretty fun, so I kept it up until I graduated and they wouldn't let me do it any more. When I got to college, I started a comic strip for the campus newspaper, *The Miscellany News*. They'd print anything, so I was set.

When did you first post your work online, and what attracted you to webcomics?

As I was graduating from college, I realized that I would no longer have an excuse to keep drawing comic strips. At around that time, some friends introduced me to webcomics, and I got hooked on stuff like *Sluggy Freelance*. A new venue! I launched *Narbonic* a few months after graduation.

Which webcomics or webcartoonists do you read regularly or recommend highly?

I read nearly all the comics on *Modern Tales* and its sister sites. I'm also a big fan of Chris Onstad's strip *Achewood*. The Pants Press group is wonderful, especially Vera Brosgol and Bill Mudron, who have been kind enough to work on comics with me in the past. The best cartoonist on the Internet is, of course, Derek Kirk Kim.

What are some of your long-term goals for your work?

Narbonic is intended as my journeyman piece; my goal is to be ready to produce professional-quality work after I finish it. In the meantime, I try to use the strip to play around and learn how to make comics. I have grave doubts that I'm anywhere close to my goal, but I've got a lot better and learned a lot about cartooning, so I guess it's worthwhile.

The strip has a planned beginning and end. I think it'll last about six years, and then I'll move on to something else. Or I'll give up and write real books.

How often do you post new comics material on the Web?

Narbonic updates every day. I write a couple of other comics, *Li'l Mell* (drawn by various artists) and *More Fun* (drawn by Robert Stevenson and special guest star Roger Langridge), each of which updates once a week.

Your strongest skill as a webcartoonist? Your greatest challenge?

I'm very punctual. Drawing is HARD.

The images on this spread are from *Li'l Mell*, written by Shaenon K. Garrity and drawn by Vera Brosgol.

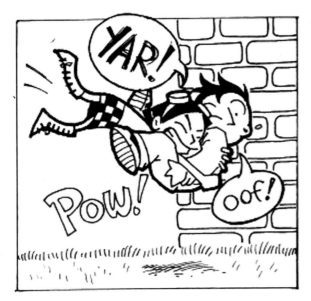

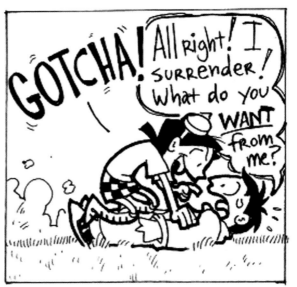

HOME: SAN FRANCISCO, CALIFORNIA

URLS: NARBONIC.COM, MODERNTALES.COM, SERIALIZER.NET, GRAPHICSMASH.COM

EDUCATION: BA IN ENGLISH, VASSAR COLLEGE

CURRENT OCCUPATION: MANGA EDITOR FOR VIZ LLC, INCLUDING ABOUT HALF THE COMICS IN *SHONEN JUMP* MAGAZINE

ARTISTIC INFLUENCES: I LOVE CLASSIC COMIC STRIPS. *BARNABY* AND *ALLEY OOP* ARE TWO OF MY CURRENT FAVOURITES; AS REGULAR READERS OF MY STRIP MAY KNOW, I'M ALSO A BIG WINSOR MCCAY FAN. I READ ALL KINDS OF COMICS VORACIOUSLY.

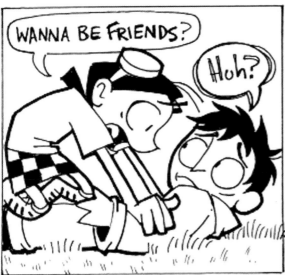

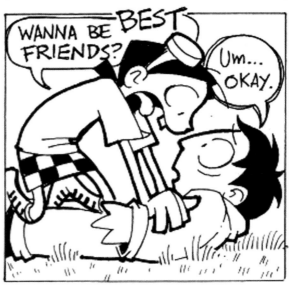

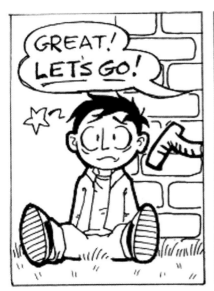

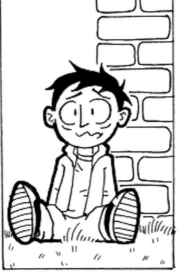

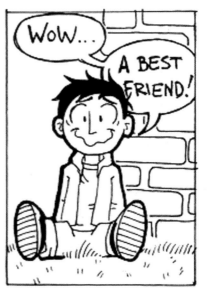

SHAENON K. GARRITY
WORKTHROUGH

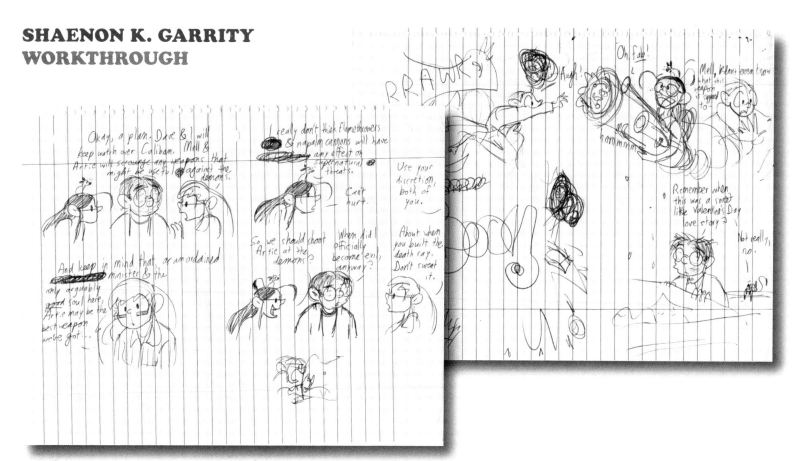

1 As you can see, I draw my thumbnails on notebook paper with a ballpoint pen. I try to work well ahead of schedule on the story part of *Narbonic*. I have folders full of dozens, possibly hundreds, of thumbnails for future strips. I won't use them all; I cut as much of the weaker material as I can. But I like to have as much of the plot as possible laid out in advance.

This particular sequence of strips takes place during a storyline in which our heroes, the evil employees of Narbonics Labs, are under attack by demons. In the midst of the fracas, two of the characters, mad scientist Helen Narbon and technician/henchman Dave Davenport, come dangerously close to declaring their mutual attraction. There's nothing like a ridiculously drawn-out, unrequited-love subplot to keep up my interest, believe me.

2 Anyway. With the thumbnails for the week ready, it's time, logically enough, to draw the strips. I draw a week's worth of daily strips at a time, so I start by drawing six sets of panels on three sheets of Bristol. I then pencil all six strips at once.

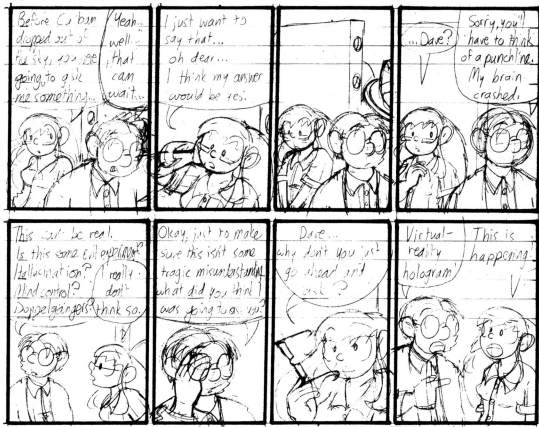

a strand of lanterns

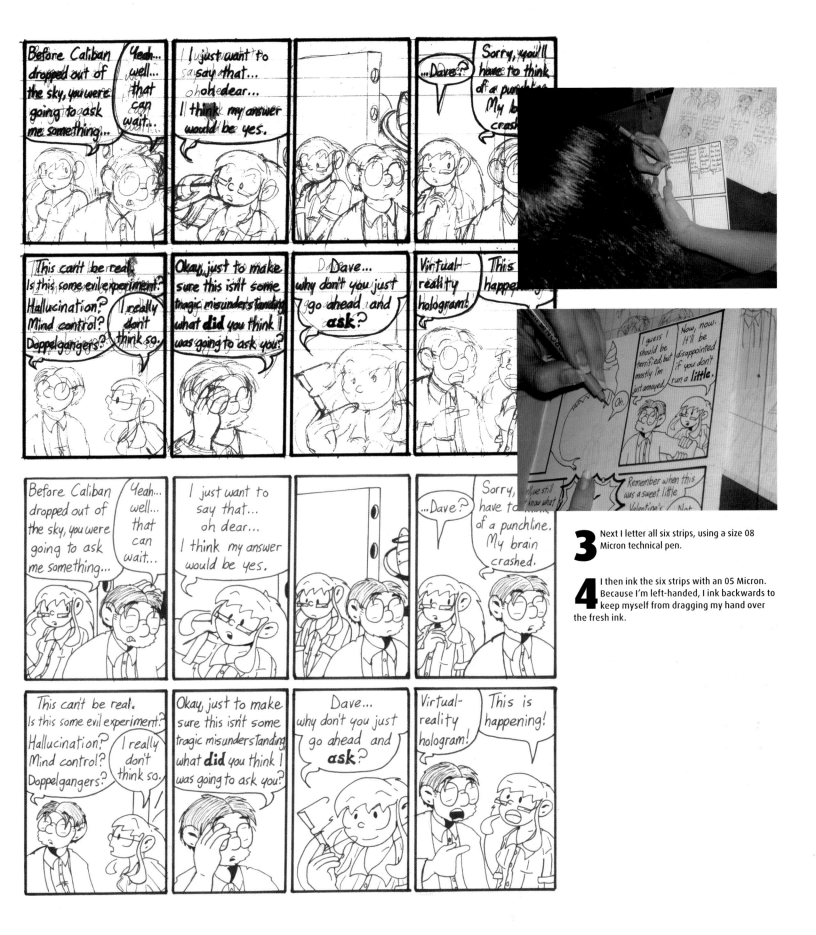

3 Next I letter all six strips, using a size 08 Micron technical pen.

4 I then ink the six strips with an 05 Micron. Because I'm left-handed, I ink backwards to keep myself from dragging my hand over the fresh ink.

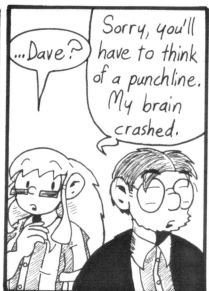

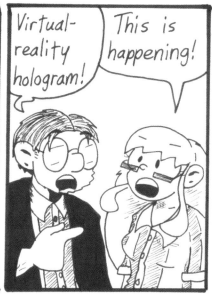

5 Finally, I go over the strips one last time and add some trimmings. I fill in the big patches of black with a Sharpie, do detailed shading and hatching with an 01 Micron, and fix errors with white-out and a white-ink pen.

6 Incidentally, I usually draw while sitting cross-legged on my bed with my portfolio balanced on my knees. A while ago I got a small sheet of Plexiglass from an art-supply store, and when I put it on the portfolio, I create a perfect drawing-while-watching-TV surface.

7 Okay, materials. For pencilling, I like a really hard, precise pencil, like a 4H, but most cartoonists seem to prefer softer leads or non-photo blue pencil. Like the total artistic wuss that I am, I ink with technical pens rather than dip pens or brushes. I buy Microns, which aren't perfect – they're on the expensive side, and they tend to run dry quickly – but I'm accustomed to them. As I mentioned above, I use three sizes of pen for *Narbonic*: a fat 08 for lettering, an average 05 for inking, and a teeny-tiny 01 for details. I recently broke down and got myself some circle and ellipse templates (actually, my ellipse template was a gift from my engineer dad), and I love them. At the very least, get yourself a circle template so you don't have to draw humiliating wobbly circles all the time. My big secret weapon is a white-ink pen, for drawing white-on-black lines and correcting tiny details. Those gel pens that teenage girls use to write on their notebook covers come in white, and they're the best white pens I've found. They're indescribably better than the pens the white-out people put out.

8 I also strongly recommend that cartoonists acquire two additional materials:
1. A whole bunch of DVDs to play in the background while you draw.
2. An attractive spouse to sit next to you and conduct crucial comics research.
These two resources will help prevent the silence and isolation of your work from driving you insane. Also acceptable: playing old videotapes of *The Simpsons*, listening to left-wing radio over the Internet, and having a mother who just got a mobile phone and calls you every time she gets stuck in light traffic on the way to Marc's Deep Discounts.

9 Using this method, it takes me two to three days to draw a week of strips; I can do a week in one day if I devote the whole day to it, but I have a job, so I don't get to do that too often. When the drawing is complete, my work is nearly done. I usually do only light touch-up on the computer, so my physical strips look similar to what you see online. I erase my pencils (probably an unnecessary step, as the scanner doesn't pick up much of the pencilling anyway) and stick the artwork in the scanner.

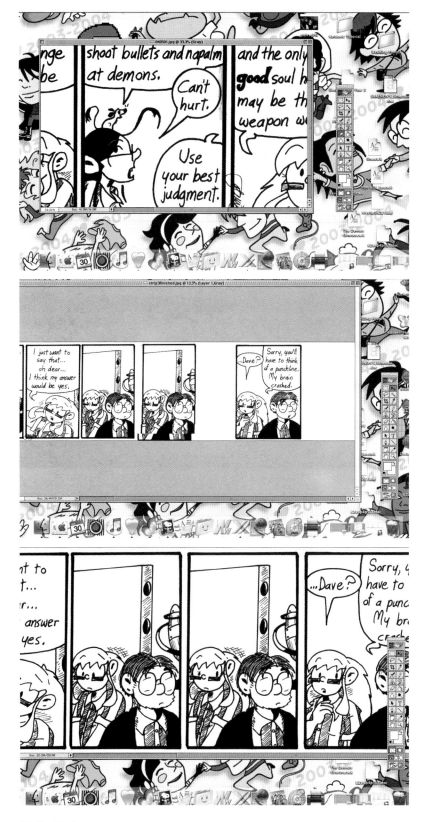

10 I use Adobe Photoshop. After scanning the strips, I zoom in and look for stuff that needs correction. With the eraser, the pencil, and the fill-bucket, I clean up the messes.

11 Sometimes I create simple effects in Photoshop. I don't do anything fancy because it wouldn't look right with the simplistic artwork in *Narbonic*, and also because I'm on a daily schedule and I don't have time to mess around. For one of these strips, for example, I want to repeat a panel and make one small change to the copied panel. Simple cut-and-paste job. Bang, we're done.

12 I don't do shading of any kind in Photoshop very often, and when I do, I keep it simple. Again, this is partly for aesthetic reasons, and partly because I'm just lazy.

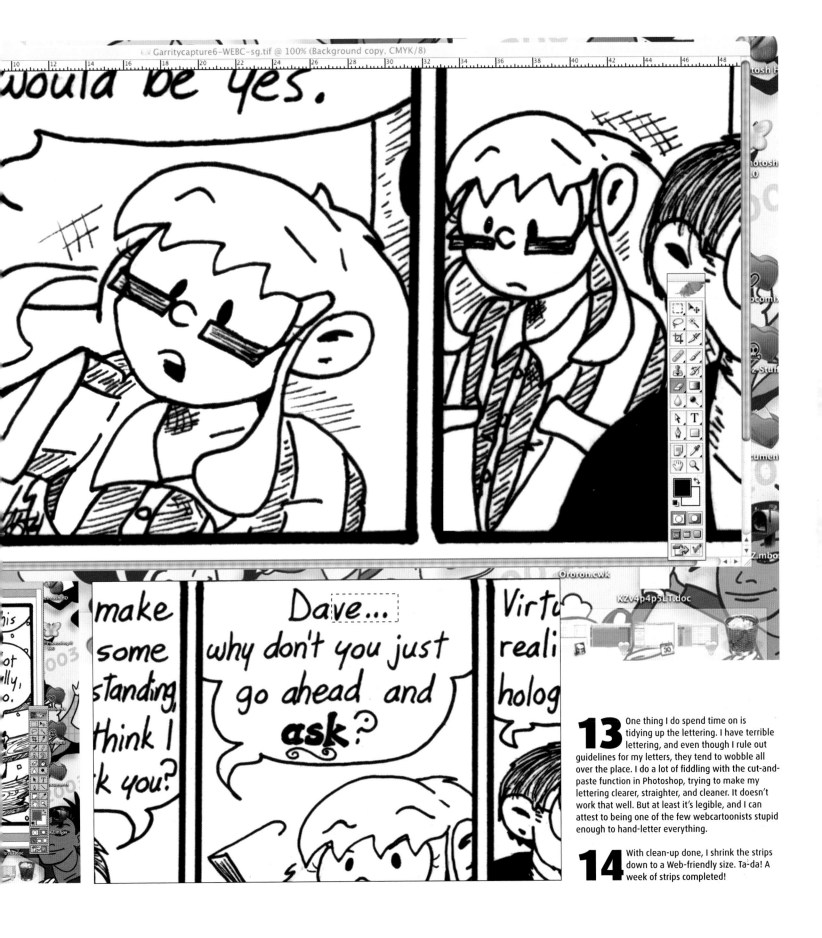

13 One thing I do spend time on is tidying up the lettering. I have terrible lettering, and even though I rule out guidelines for my letters, they tend to wobble all over the place. I do a lot of fiddling with the cut-and-paste function in Photoshop, trying to make my lettering clearer, straighter, and cleaner. It doesn't work that well. But at least it's legible, and I can attest to being one of the few webcartoonists stupid enough to hand-letter everything.

14 With clean-up done, I shrink the strips down to a Web-friendly size. Ta-da! A week of strips completed!

Publishing comics on the Web is much easier than getting a comic book into shops or a daily strip in a newspaper. You have greater freedom to make the type of comic that is of interest to you, the artist. Of course, this greater creative control means you're going to have to do some of the technical work yourself. Fortunately, creating a webcomic is fairly straightforward with the tools you'll have in a regular home office.

You'll need access to a computer. It doesn't matter whether you have a Mac or a PC, since you'll be saving your comic in a format viewable on either platform. If you don't own a computer, you can still create a webcomic, but you'll need someone with a computer to help you put it online.

If you've created your comic using traditional media, like pencils, markers, or paints, you'll need to have access to a scanner to digitize your comic. Scanners have become much more affordable in the last few years, and you can find a wide variety available. For most webcomic artists, a fairly low-cost scanner will do the job. If you've got very detailed artwork, you may want to use a higher-end scanner to get as accurate an image of your artwork as possible.

When scanning your art, consider whether you'll eventually want to print your comic. If you do, keep your artwork at a higher resolution (e.g., 600ppi). If you're sure you only want to publish on the Web, you can scan your artwork at a lower resolution. Keep in mind that the higher the resolution, the more detail you'll have to work with. Regardless of the resolution you scan your comic at, before putting your comic online you'll need to resize your artwork to 72ppi.

An alternative to scanning in artwork is creating your comic directly on the computer. You could use a computer tablet and pen to draw your artwork in an image-editing program like Adobe Photoshop. If you have a steady hand, you could use the mouse to create a pixel style 'sprite comic' with the look of an old-school video game. Some creators take photos of actors or even toys to use in their webcomics.

Once you have your artwork created and on your computer, you'll probably want to use some image-editing software to enhance your comic. Adding colour, effects, darkening line art, and creating speech balloons can all be done with most image-editing software. If you can't afford the professional packages, you might find the freely downloadable GIMP program to be a good alternative.

If you find the thought of lettering your comic by hand intimidating, you can add your dialogue, titles, and sound effects digitally. Professional quality comic lettering fonts are available online at places like www.blambot.com. Many sites even make a selection of their fonts available for you to download for free. Once installed on your computer, you can use these fonts in your image-editing software.

Before putting your comic online, you'll need to make sure the final image is resized so that it can be viewed easily on your viewers' monitors. Keep in mind that unlike a printed page, a monitor is wider than it is tall. This will mean your viewers will have to scroll down to see your entire comic. When planning out the panels in your comic, consider making your 'pages' in landscape format – making them wider than they are tall.

You'll also want to make your comic as quick to download as possible. In addition to making sure your users with dial-up connections don't need to wait all day for your comic to download, you might also save yourself some money. Many website hosting services limit you to a set amount of bandwidth your site can use each month. If you go over this limit, you'll either have to pay more for the service, or your site will simply become unavailable until next month.

You won't want either of these things to happen, so it's worth taking the time to make sure your comic files are optimized. Fortunately, the *Save for Web* function in programs like Photoshop should take care of this optimization for you.

Once you're ready to put your comic online, you'll need somewhere to host your files. You can create your own website, using software like Macromedia Dreamweaver. If you don't have a place to host your website, you can look into places that will host your files for you, including *Geocities*, *Blogger*, and *Keenspot*. If you don't want to go through the trouble of creating your own website, you could simply join an online community and post your comics there for other people to see.

Before you know it, you'll be publishing your comic on the Web and sharing your stories with people all around the world. Creating your own webcomic is a great way to get started on a career in comics, express yourself outside of the constraints of formal publication, or just have fun.

Stuart Robertson is a Web designer living in Ontario, Canada. He is the technical guru behind PV Comics.

The personalized, at-home workspaces of (clockwise from top-left) Bill Duncan, Joe Zabel, and Charley Parker.

URSULA VERNON

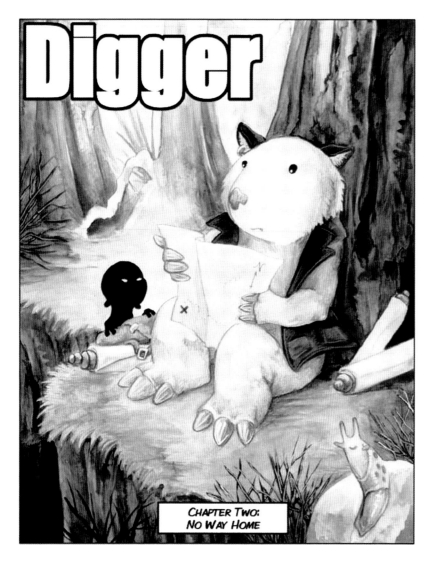

CHAPTER TWO:
NO WAY HOME

Ursula Vernon's *Digger* is one of the standout all-ages fantasy adventure strips on the anthology site *GraphicSmash.com*. Vernon's illustrative black-and-white style has drawn comparisons to Jeff Smith's *Bone* comic book series, but her storytelling ability and sense of character development are anything but second-rate.

When and how did you begin creating comics?

I grew up in Arizona and Oregon. I started creating comics as an adult, in a fit of insanity brought on by an argument and a doodle, and it just kind of snowballed from there. I'd do four or five pages completely on a whim and put it up somewhere online, and then people would badger me to know What Happened Next, which for some reason always surprised me, because I knew so little about comics that I didn't realize people would actually READ them. I've published art, book covers, etc. – I'm an illustrator by trade – but no printed comics yet.

When did you first post your work online, and what attracted you to webcomics?

Waaaaaay back in 1997, when my art was yet innocent of skill or originality, I put my art online because... actually, I'm not sure why; it just seemed like the logical thing to do. Once I was established as an illustrator online, though, it was perfectly logical to put comics online – it hadn't occurred to me to try to publish a whole comic book or anything, but putting up a page at a time online just seemed perfectly natural.

Which webcomics or webcartoonists do you read regularly or recommend highly?

Well, I read a lot of the standards – *PvP*, *Penny Arcade*, *Something Awful*, etc. On *GraphicSmash.com*, I really like *Skritch* and *Gun Street Girl*. *Guardians*, *The License*, and *Flick* are pretty darn nifty, too.

Briefly describe *Digger*.

The ongoing saga of a lone wombat to find her way home through a strange world of dead gods, live gods, talking shadows, homicidal hyenas, and the occasional oracular slug.

What are some of your long-term goals for your work?

Well, my big goal is to actually finish *Digger*, which is a VERY long-term goal, since we just passed a hundred pages and the ultimate plot is only starting to kick into gear. But I'd also like to get some print versions published at some point, too.

How often do you post new comics material on the Web?

Twice a week for *Digger*. Occasionally I'll come out with something else that's silly and comicky, but I'm mostly an illustrator, so I'm more likely to produce paintings than comics.

Your strongest skill as a webcartoonist? Your greatest challenge?

My greatest skill is probably my art – I've got seven years of pro illustration that I can draw on, and I'm fairly confident of my ability to draw just about anything *Digger* runs into. The challenge is actually getting her there – my writing tends to be rambling rather than tight, and occasionally I have to kick myself to get the story moving along instead of just stopping to smell the flowers. It's tempting to just throw things in at random because they'd look neat and be fun to draw, and so I have to exert some discipline there.

What's the advantage of working in black and white rather than colour?

Speed. When I was doing my initial webcomic in colour, a page could take me anywhere from six to 10 hours. But when I switched over to doing *Digger*, with the more scribbly digital black-and-white style, I could do a page in two to four hours, which is the reason I can keep up with updating on my schedule.

a strand of lanterns

URSULA VERNON © 2003

HOME: CARY, NORTH CAROLINA

URLS: METALANDMAGIC.COM, GRAPHICSMASH.COM

EDUCATION: BA IN ANTHROPOLOGY; COURSES IN ART

CURRENT OCCUPATION: FREELANCE ILLUSTRATOR

ARTISTIC INFLUENCES: JEFF SMITH'S *BONE* AND NEIL GAIMAN'S *THE SANDMAN* ARE TWO OF MY MAJOR INFLUENCES BY VIRTUE OF BEING SOME OF THE ONLY COMICS I'VE EVER READ. (WELL, I ALSO READ *PREACHER*, BUT IT'S EXERTED LITTLE INFLUENCE ON MY RELATIVELY TAME TALE OF WOMBATS AND GODS....) ARTWISE, HOWEVER, I LOVE JAMES CHRISTENSEN, A LOT OF THE PRE-RAPHAELITES, AND THE FAIRY-TALE ILLUSTRATORS AROUND THE TURN OF THE LAST CENTURY, LIKE ARTHUR RACKHAM. PLUS THE USUAL ROSTER OF GOLDEN AGE FANTASY ARTISTS, OF COURSE. I CAN PAINT A GIRL IN FUR BOOTS AND A METAL LOINCLOTH WITH THE BEST OF 'EM.

VERNON ON JOINING GRAPHIC SMASH

Funny story, actually. I was at a convention – I was the Art Guest of Honour at TrinocCon in Durham in '03. And T Campbell came by the art table that was set up, and looked at the work, and my husband James, who was minding the table while I was in a panel, recognized him as the person who did *Fans!* (which my husband loved). And while James is normally a quiet and reticent person, he had broken a tooth on the prime rib the night before, and it turns out that it's not possible to get a dentist in North Carolina on the weekends. So we had taken him to the emergency room, and they couldn't do anything – sucking chest wounds they're great with, but broken teeth are a whole 'nother deal. So they had given him a great deal of drugs and sent him back, and James was thus fairly loopy and happy, and pretty much collared poor T and started talking up my work and forced him to read the few samples of my comic work that I had at the table. Later on, T tracked me down and told me about *GraphicSmash.com*, which was just about to launch, and asked me to send in a submission. I had never given any thought to publishing *Digger* at that point – it was a complete lark that I was just noodling with to see where it would go – but I sent in the submission and wham! Obviously, the importance of dumb luck should not be ruled out.

WORKTHROUGH

And so, for the third time in as many days, I found myself setting out into the woods with only the vaguest notion of where I was going.

And for the seco...
found myself be...

(rustling bushe...

This is starting...

Rustle, rustle.

Throwing sequen...
descending, long panel of spinning pictane. THUNK!

REMEMBER TUNNEL SEVENTEEEEEEEEEEEEEN!

1 A page of *Digger* starts with the script. I have one long, rambling, disjointed Microsoft Word file where all the scriptwriting takes place. When I think of good lines that may or may not ever take place, I page down to the end and write them in. The end result is in no particular chronological order and contains a lot of jotted notes, but it makes sense to me, if no one else. When the time comes to actually do a page, then I may have the script already polished, it may be rough and in need of editing, or more likely I may need to write it from scratch.

Often I write just the text, particularly for future bits where I'm not yet sure of the page breaks and so forth. Sometimes, however, I'll include layout or art notes, particularly if I have an idea but don't think I'll get to it that day.

2 Once the text is written more or less to my satisfaction, I pull up a template page, an Adobe Photoshop document with the size, resolution, and page borders already laid out.

3 Then, using the Photoshop guide tools and a lot of layers, I fool around until I have a workable layout idea for the page, based on the text, my art notes, and whatever vague, fluid notion I have of how the page should go together. This can take under a minute or over an hour depending on complexity and whether or not my first idea works.

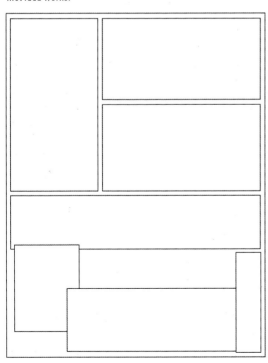

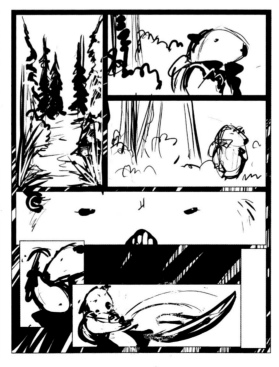

4 Then I take it over to Corel Painter, and using an Intuos 2 tablet and the Digital Scratchboard tool, I do very rough layouts for each of the panels. There's very little detail here, just basic scribbles to get the compositions done. I do this with my script in one hand (or at one side of the screen!) so that I know both what goes where, and how much space I'll need to leave dead for text. In the first panel, for example, I know that there's going to be a block of expository text at the top, so I leave that space fairly empty and don't put anything important into it. Likewise, I know the last panel is a sound effect, so I can leave it blank for now.

a strand of lanterns

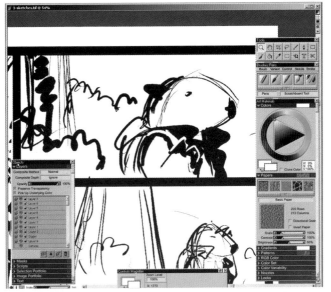

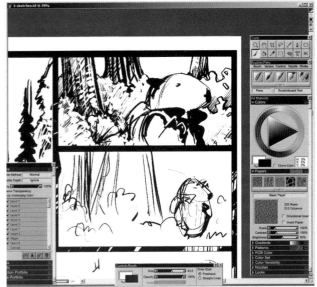

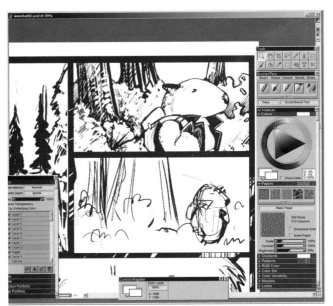

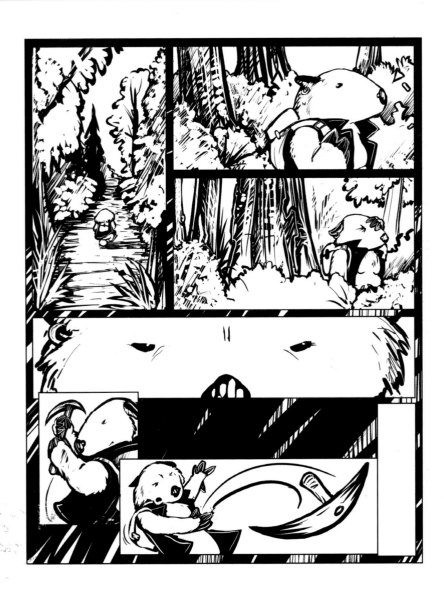

5 Some of these layouts are nearly done already – the close up, for example, will require only minimal refining. Generally, however, they will require a lot of clean-up. I pick a panel, zoom in, and start working, still using the Scratchboard tool in Painter. The technique, which, for lack of a better term, I call 'megascribble', basically involves layering black and white with the Scratchboard. Rather than using an eraser, if I make a mistake, I just cover it over again in white Scratchboard.

6 I usually start with the background first, layering hatching in black and white, adding more detail and scenery bits as needed. Once I've got that in, I start on the figure.

7 Finally, when everything's been laid out and tweaked, it's back over to Photoshop for text, both the narrative text and the dialogue.

For flavour text, I use '12 Ton Goldfish', a font from www.blambot.com. Go there. Many creators of webcomics are burning small offerings in thanks for the existence of *Blambot* every day. The text can be either black or white, depending on the dominant colour of the background – the important thing is that it stands out.

8 Once the text is in, I go back into Painter and touch up backgrounds so that the text stands out better. (I also add Digger's ears in the first panel, which I'd somehow missed last time.)

9 Next I add the dialogue text. To do this, I lower the opacity of the background so that the text can be easily read and placed.

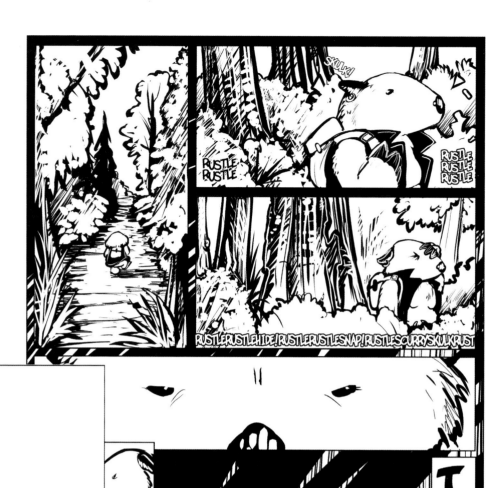

AND SO, FOR THE THIRD TIME IN AS MANY DAYS, I FOUND MYSELF SETTING OUT INTO THE WOODS WITH ONLY THE VAGUEST NOTION OF WHERE I WAS GOING.

AND FOR THE SECOND TIME IN AS MANY DAYS, I SOON FOUND MYSELF BEING FOLLOWED.

THIS IS STARTING TO GET RIDICULOUS.

I. HAVE. HAD. *ENOUGH.*

REMEMBER TUNNEL SEVENTEEEEEEEEN!

10 Then I just add another layer and insert the text balloons in under the text, using the round selection tools. Finally, I up the opacity, and there we have it – a finished page of *Digger*.

I do everything at print-quality size, and once it's all laid out, I shrink it to 600 x 800 pixels, save it as a GIF, and upload it. I don't do any Web design, since I'm hosted on *GraphicSmash.com*, which has its own layout and design.

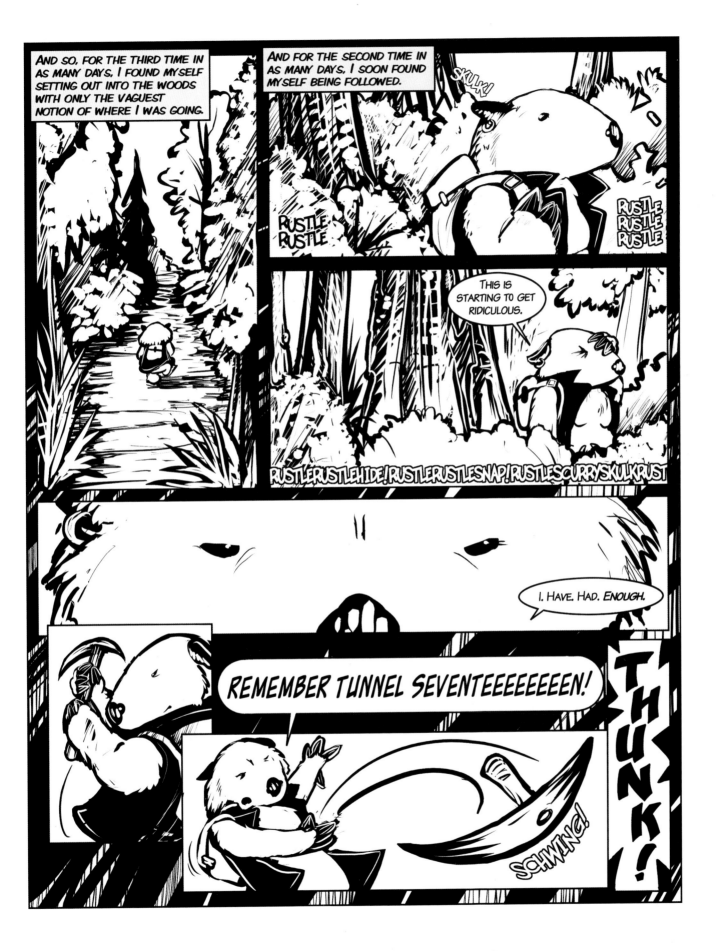

INTERNET ACCESSIBILITY

When you're creating comics for the Web, you should keep in mind that the bigger the comic's file size is, the longer it's going to take the image to appear in the reader's Web browser. People with slow Internet connections might not have the patience to wait for large images to download, but you have to decide where to draw the line between image size/quality and download time.

To make matters more difficult, Web standards change all of the time. Monitors get higher resolutions, average Internet connections speed up, certain plug-ins become normal parts of browsers, and so on.

People will disagree about what the standard should be. For instance, in 2005 many webcomics creators assume their readers will have monitor resolutions of 1024 x 768. This means that the monitor will be able to display 1024 pixels horizontally and 768 vertically. This is not reflective of the physical size of the monitor, just how that monitor's display works.

Some monitors might be set at 800 x 600 or even 640 x 480 resolution. When a user sets monitor resolution higher, the elements being displayed appear physically smaller. For this reason, many people will keep their monitors at a lower resolution, so things appear larger and easier to read.

Internet connection speeds are an important issue. Many imaging programs have a setting to export images for the Web, and these will often display how long it would take a reader to load the image at various connection speeds.

Processing power can affect the user's experience as well, especially when you're using tools like Macromedia Flash. If there's a complex animation in your webcomic, then it will play more slowly on computers with lower processor speeds.

There are no right or wrong answers when it comes to these issues. Once you've created your comics website, try reading it on different computers with different types of monitors, connections, and processors, and see how it works.

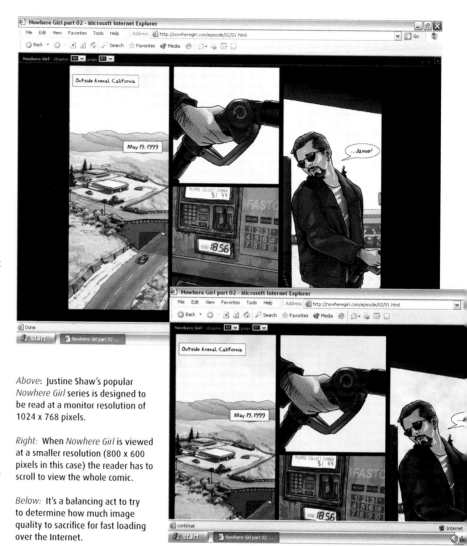

Above: Justine Shaw's popular *Nowhere Girl* series is designed to be read at a monitor resolution of 1024 x 768 pixels.

Right: When *Nowhere Girl* is viewed at a smaller resolution (800 x 600 pixels in this case) the reader has to scroll to view the whole comic.

Below: It's a balancing act to try to determine how much image quality to sacrifice for fast loading over the Internet.

a strand of lanterns

SCANNING

While many artists today create their comics directly on a computer, most begin with drawings made on paper, and this means having to scan the pages into the computer.

Scanners today are usually fairly inexpensive and of good enough quality to scan comics pages. The biggest problem is the physical size of the scanner bed. Traditionally, American comic book art has been drawn at 11" x 17". Unfortunately, scanners this large are often expensive and relatively hard to come by. If you're scanning your art, you'll have to buy a large-format scanner, scan your art in pieces and put it back together digitally, or draw at a size that fits on a smaller scanner bed. You'll have to experiment to see what works best for you.

There are three primary settings for your scanner: 'line art' (or 'bitmap' or 'black and white'), 'greyscale' (or 'black and white photo'), and 'colour' (or 'colour photo').

'Line art' breaks your art down into pixels of either black or white, with no other colour values possible. You can adjust at what point of darkness on your original the scanner decides what's black. This creates the smallest file size.

'Greyscale' gives you black, white, and 254 values of grey in between. This gives you continuous tones of grey and is perfect for scanning art where you've done ink washes. This is also a preferred setting for a lot of creators who want to get 'line art' images, but who also want to be able to adjust the black and white threshold in an image editing program like Adobe Photoshop. 'Greyscale' creates images with a much larger file size than 'line art'.

'Colour' is RGB (Red, Green, Blue) colour, the type of colour a computer monitor uses, as opposed to CMYK (Cyan, Magenta, Yellow, Black) colour used for printing. Once you've scanned it in, though, you can still convert your colour (in an image editing program) to CMYK. Colour creates the biggest file sizes but it is necessary for scanning images that you've already coloured on paper (if you've painted them, for instance).

If you have a black and white original that you want to colour on the computer, your best bet is to scan it as 'greyscale' or 'line art' and change the setting to 'colour' on your computer. This saves time and stops you from getting information in your image that you don't want – your lines might look a little blue to a colour scan, for example, but will only look black to a 'line art' one.

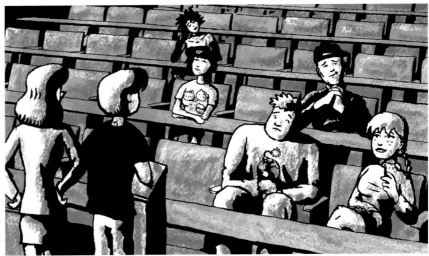

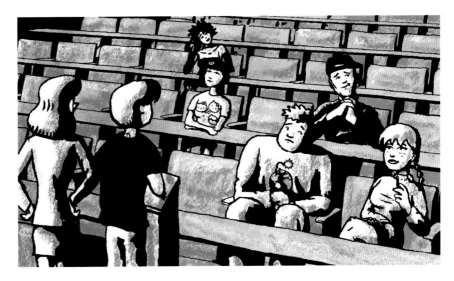

Top: A page from the T Campbell-written *Fans!* in bitmap (black and white) mode.

Centre: The same page in greyscale mode, with additional grey tones immediately visible.

Bottom: And finally the same art in colour. While the image was created and seen on the Web in RGB colour, to be printed in this book it was converted to CMYK colour.

AMY KIM GANTER

A relative newcomer to webcomics who started by promoting her own site and recently joined the anthology site *PVComics.com*, Amy Kim Ganter has emerged as one of the most gifted storytellers in the immensely popular webcomics genre of romantic fantasy drawn in a manga (Japanese comics) style. Her primary work, *Reman Mythology*, combines elements of legend, magic, romance, drama, and adventure. She has a strong design sense, and her detailed backgrounds often rival her character art in complexity and beauty. In a genre crowded with amateur rehashes of popular print comics, Amy's work appeals to readers – particularly teenage girls – because of the interplay of her distinctive, well-rendered characters.

When and how did you begin creating comics?

I grew up in Rochester, New York, and I've been drawing comics since I was about 10. I had a hamster named Butterball, and I drew a silly little comic strip about his adventures in our house with my other pet, a turtle named Skippy. My father would see me write and draw out my own little fairy tales starring various stuffed animals I'd owned, and he suggested I try my hand at comics. I haven't turned back since then. Except for the time I wanted to be a writer. And an animator. And a marine biologist. I blame those dreams on television.

Reman Mythology was initially self-published as photocopied zines and then sold at anime conventions. After I graduated from The School of Visual Arts, a small publisher serialized my comic in an anthology. Unfortunately, that didn't work out. I'm currently preparing the first book to self-publish as a graphic novel to sell from my website and at the few conventions I attend.

When did you first post your work online, and what attracted you to webcomics?

I've had my illustrations and comics online since 1999, but I didn't start *Reman Mythology* as its own online comic until November 2003. After a bad publishing experience and several rejection e-mails, I felt like I didn't belong in the comics publishing world, even though I still loved to make them.

Not wanting to stop working on this story, and not wanting to give up my dreams of having a printed book of it, I decided that putting the story online and self-publishing would be best for now.

I already had a small Web presence, and I knew there were many girls reading manga-inspired fantasy webcomics, so there was an audience for my story out there that probably wouldn't go to a comic book store. I could interact with my audience, control the way the comic was presented, control the atmosphere that surrounded the story through the Web design and the content, and I could work at my own pace. I didn't think any print publisher could offer such things unless I was a big star. Since putting my comic online, I've been more motivated to work on it than I was while working in print.

Which webcomics or webcartoonists do you read regularly or recommend highly?

I've been a huge fan and admirer of Derek Kirk Kim's comics at www.lowbright.com since I first discovered his work in my late college years. Some other comics that I highly recommend are: *Cascadia, Bolt City, kungfoolx.com, Comic Café* at Studio Cyen, *Nowhere Girl, HFT Comics, Urban Shogun, Demonology 101, Strings of Fate, File 49, Three Kingdoms Comic, 10K Commotion, Sourho.com, FuzzyFeather.com, Delineated Life, hellacomics.com, The Circle Weave, MentalTentacle.com, Vacant, Flight,* and *Chynco's Stuff.*

Briefly describe *Reman Mythology*.

Reman Mythology is a story about the death of religion on another world, as seen through the eyes of an earthling who gets trapped there (American high school student, Tabby Cohen). Tying the planet's elaborate history, religion, and social structure together, Tabby's story shows how her experiences on Rema and the uncontrollable events that unfold there shape her life and the lives of her friends.

What are some of your long-term goals for your work?

I have these big dreams of becoming the J.K. Rowling of comics, but I know that's next to impossible. For now, my goal is simply to complete *Reman Mythology* with all of my feelings poured into it.

How often do you post new comics material on the Web?

I put up a new page of the series every Monday and Friday.

a strand of lanterns

HOME: BROOKLYN, NEW YORK

URLS: FELAXX.COM, PVCOMICS.COM

EDUCATION: BFA IN CARTOONING, THE SCHOOL OF VISUAL ARTS

CURRENT OCCUPATION: ILLUSTRATOR AND ANIMATOR FOR GAMELAB

ARTISTIC INFLUENCES: LITERATURE: MADELEINE L'ENGLE, CARL SAGAN, VICTOR HUGO, PHILIP PULLMAN, CLIVE BARKER, ROBERT ASPRIN, GABRIEL GARCIA MARQUEZ, ISABELLE ALLENDE

FILM: ROBERT ZEMECKIS, CHRIS CUNNINGHAM, JIM HENSON, LUC BESSON, HAYAO MIYAZAKI, WALT DISNEY

COMICS: WON SU YON, PARK JIN YOUNG, CHUN GYE YOUNG, RIITI UESIBA, RUMIKO TAKAHASHI, BILL WATTERSON, HERGÉ, CARLA SPEED MCNEIL, JIM LEE

ART: JOHN WILLIAM WATERHOUSE, WILLIAM BOUGUEREAU

VIDEOGAMES: *FINAL FANTASY 5* AND *6*

THE ALLURE OF MANGA

My first experience of the manga style was from a colouring book my mother sent me from Korea when I was about 10. It was based on an old shoujo manga [Japanese comics marketed at girls]; I don't know what the name of it was. I remember treasuring that colouring book; it was probably only worth 50 cents, but to me it was priceless. Before I'd seen that book, I was into things like *Alvin and the Chipmunks* and *The Disney Afternoon*. It opened my eyes to a whole new level of drama and detail in drawing and storytelling. The details in the clothing, hair, and eyes were unlike anything I'd seen before; it was completely foreign and magical to me. I tried to emulate that look, but it was always in conjunction with whatever else I saw at the time (*The Muppets*, *Teenage Mutant Ninja Turtles*, pretty much whatever was on television). I'd see more and more manga and anime artwork from my brother's videogame magazines as the years passed, and eventually I really got into it after discovering *Ranma 1/2* (in Korean) and *Sailor Moon* (in English). I think that's when it had its biggest impact. When I got into *Sailor Moon* and *Ranma 1/2*, I was blatantly ripping them off and continued to do so for the next couple of years. I didn't try to shape my style into something more individual until I'd moved to New York City and manga became commonplace. This is why I don't worry too much when I see all the young artists emulating their favourite anime artists online. I see it as a phase, and hopefully those influences will work themselves into a unique style one day.

I think the biggest difference between American comics and manga is that in manga, moments are really, really stretched out. What could be told in a page in American comics is told in the span of several pages in manga, emphasizing character interactions moment by moment and savouring every emotion. When I read manga, I get the impression that the creators are more interested in how the reader will react to the overall experience of reading the book as a whole, paying attention to layout and how the panels flow, what it's like reading the book while turning the page and how the panels affect the speed of the reading, etc., instead of getting wound up in making each panel a perfect work of art.

Also in manga there seems to be a better balance between art and writing, each one supplementing the other, while sometimes in American comics I feel like too much emphasis is put on the drawing side of it, creating a rift between the art and the dialogue that hinders the reading experience. There's a delicate balance between art and writing that's so well understood in manga, the magic middle that makes comics so enjoyable to read, and above all else it's that understanding of sequence that makes manga so successful, in my opinion. I suppose, for collectors, the American way of storytelling with every panel being equally strong would be good for people who want a beautiful full-colour book for their shelves, but the manga storytelling style is better for reaching mass audiences who just want to be entertained with a fun story, since it's so easy to read.

1 STORY WEB/BRAINSTORMING

Even though I outline each of my story arcs in advance, I still have to plan out each beat (or dramatic moment) of each scene within that arc. Story webs are a great way to get a basic idea of the important moments, illustrating how each action relates to another, and how they all lead to the end result. Everything that's written at this stage doesn't necessarily make it to the final version, but it establishes the basic plan, and I refer to it often for inspiration and to get a better handle on where I am in the overall story arc.

2 THE SCRIPT

Scripting is probably my most time-consuming step, as the script for every issue will be rewritten many times before I'm satisfied. To leave time for this step, I try to stay at least one issue ahead of myself. My scripts are usually about 10 pages long, encompassing 24 pages of sequential art. Since I'm both the writer and the artist, I try not to be too descriptive beyond the bare action and dialogue. Doing this leaves room for my imagination to express itself more strongly in the visuals. Once the first draft is done, I show it to several close friends for feedback. Since I've been so close to this story for so long, sometimes I can't tell whether or not my points are coming across. My friends have been a great help with my writing process, and I couldn't do it without them. After eight drafts of the entire script, I have the final results for Book 2, Part III. Here is the script that I used for the example:

PAGE 17

PANEL 1
Philip looks down with a meek smile.

PANEL 2
He puts a hand on her shoulder; Tabby looks up.

PANEL 3
Water begins to draw from her clothes and form around Philip's hand. She's very still.

PANEL 4
More water is drawn from her.

PANEL 5
He holds the water in a small ball.

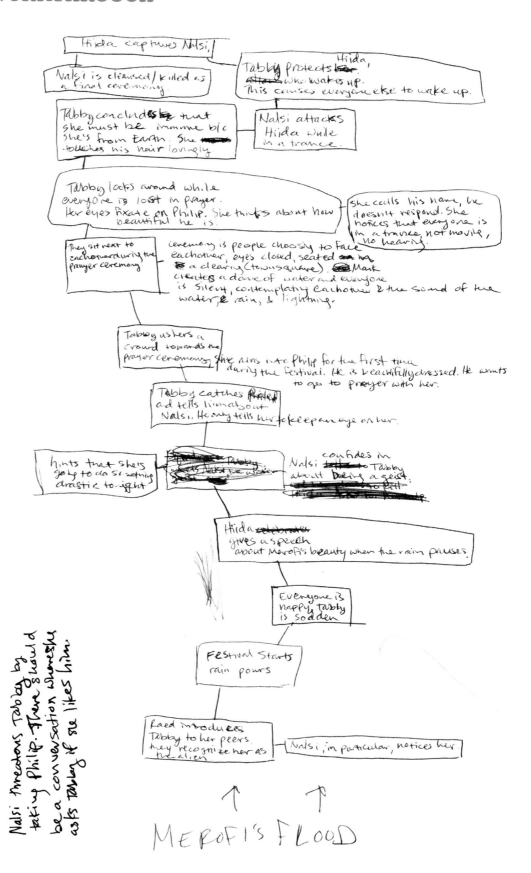

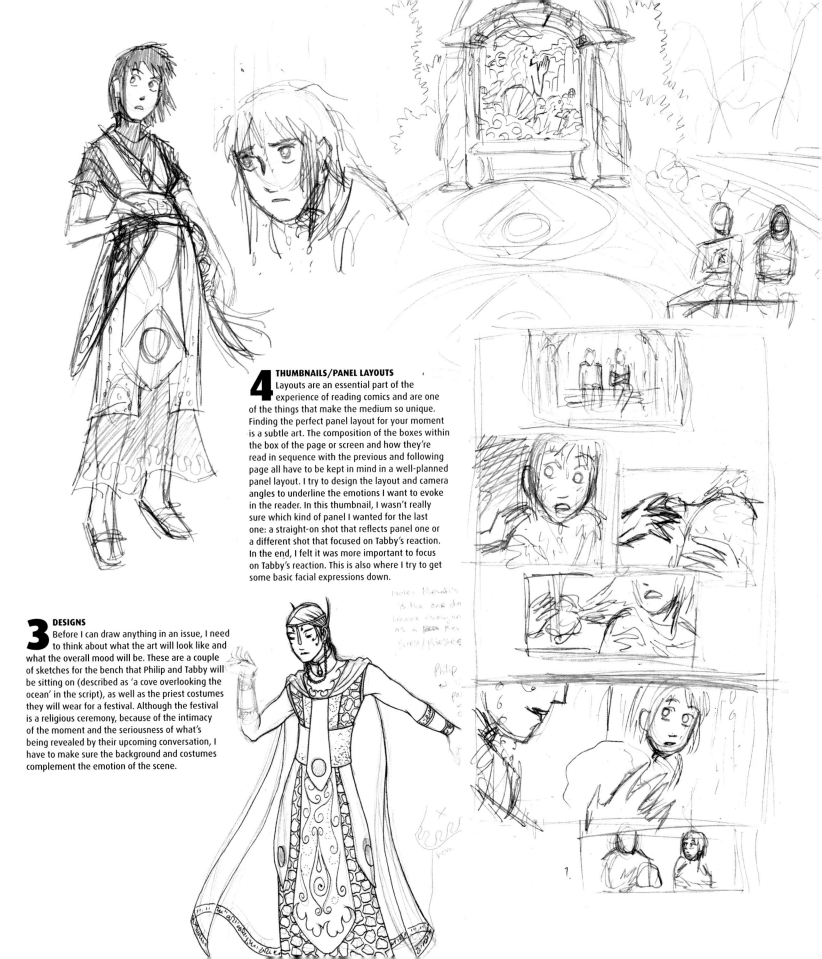

4 THUMBNAILS/PANEL LAYOUTS

Layouts are an essential part of the experience of reading comics and are one of the things that make the medium so unique. Finding the perfect panel layout for your moment is a subtle art. The composition of the boxes within the box of the page or screen and how they're read in sequence with the previous and following page all have to be kept in mind in a well-planned panel layout. I try to design the layout and camera angles to underline the emotions I want to evoke in the reader. In this thumbnail, I wasn't really sure which kind of panel I wanted for the last one: a straight-on shot that reflects panel one or a different shot that focused on Tabby's reaction. In the end, I felt it was more important to focus on Tabby's reaction. This is also where I try to get some basic facial expressions down.

3 DESIGNS

Before I can draw anything in an issue, I need to think about what the art will look like and what the overall mood will be. These are a couple of sketches for the bench that Philip and Tabby will be sitting on (described as 'a cove overlooking the ocean' in the script), as well as the priest costumes they will wear for a festival. Although the festival is a religious ceremony, because of the intimacy of the moment and the seriousness of what's being revealed by their upcoming conversation, I have to make sure the background and costumes complement the emotion of the scene.

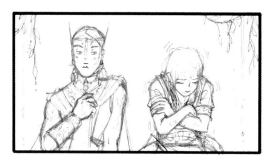

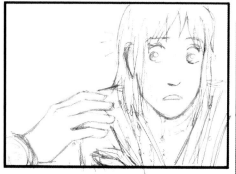

6 INK AND SCAN

I consider this a single step because I fill in my blacks on the computer. I ink using Micron pens of various sizes, faking the line weight to make it look more like brushwork in certain places and really getting particular on the details. After scanning, I clean up the lines in Adobe Photoshop and create a transparent layer for the linework so that I can shade the image without affecting the drawing. You can do this by double-clicking the layer with the linework on it, turning it into a separate layer, and going to the drop-down menu in *Layers* and changing it from *Normal* to *Multiply*, making all whites transparent on that layer. This is what the inks look like before I fill in the blacks. I ordinarily letter at this point, too (using *Blambot* fonts!), but there's no dialogue for this page.

5 PENCILS

There are few things in the world as wonderful as drawing with friends and colleagues, but when I pencil I have to have 100 per cent of my attention on what I'm doing in the page. I usually pencil when I'm isolated and alone so that I can really focus. Pencilling is almost like copying down snapshots in my head of what the place and moment looked like 'when I was there'. It sounds a little crazy, but when I think about my comics this way as I draw them, I enjoy them the most. After my pencils are finished, I usually show them to friends again and ask for their reactions. I have to thank the people at the *Flight* forums (www.flightcomics.com) for their excellent feedback on this page. Particular thanks to Neil Babra (www.neilcomics.com) for his suggestion to change Tabby's expression and to make her hair stick up a little with some static in the final panel. Initially, Tabby's focus was more on Philip and what he was telling her by using his magic, but Tabby is still too new to it not to be at least slightly shocked by what was happening! It was a perfectly-targeted critique that helped make this page work as well as it does, working more gracefully with the overall story.

7 FILLING IN BLACKS AND GREYSCALING

Using the *Magic Wand* and *Lasso* tools in Photoshop, I fill in the shades in a layer beneath the linework. I often reference the shades of the costumes in previous pages for consistency, using my own comic as 'character model sheets'.

This is what the page looks like when all the basic greys are laid down. It is important for me to zoom out often and look at the page as a whole. I keep in mind what the entire page looks like from a distance to make sure there's a good balance of light and dark in the right places. A lot of people don't like the look of gradients, but I think if you have enough texture on the inks, gradients can add a nice dimension to your pages.

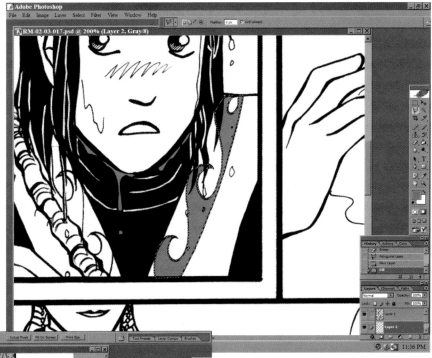

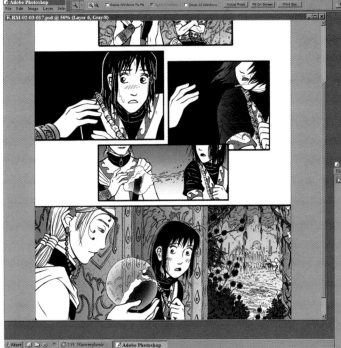

8 SOME SPECIAL EFFECTS

I save for the end the highlights, rain, and 'ciphrony' (the magical energy on Rema that's rendered using a low-opacity white airbrush). Each effect has its own layer, so I can play with the opacity depending on how strong I want each effect to be. The file for this page has 10 layers in all.

When the page is done, I save a copy for print (300dpi, 7.75" x 5.125") and a copy for the Web (72ppi, 530 pixels wide).

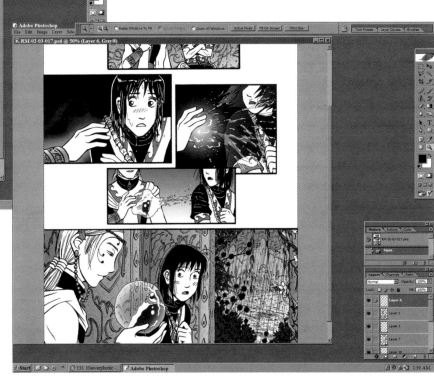

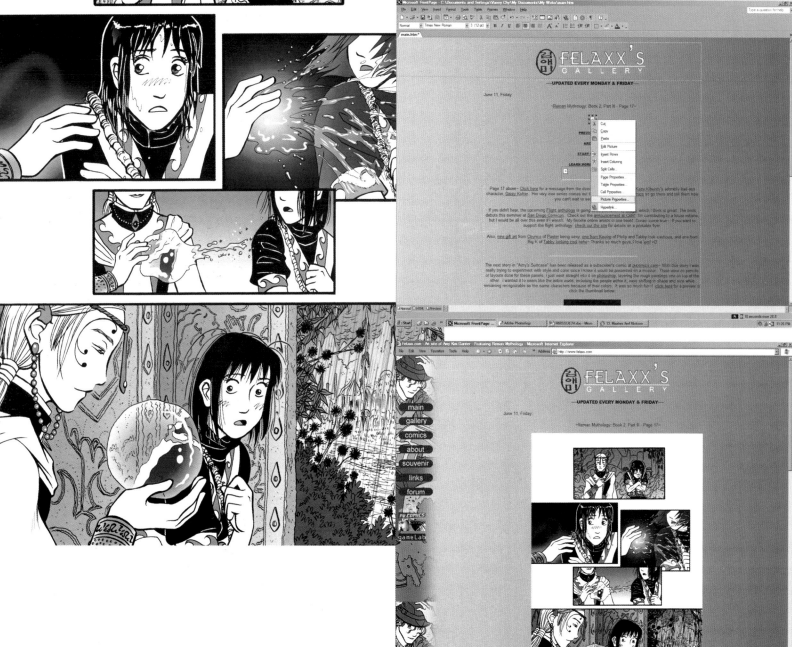

9 **UPDATING THE WEBSITE**
I use very basic HTML and Microsoft FrontPage 2000 to design my site. I update my site by changing the links on all the necessary pages with the current file name, and sometimes I blog beneath it, depending on whether or not I have anything comic-related to say. Otherwise, I try to keep unrelated things, such as my latest film review, on my forums.

Some notes on the site design:

I based the design of my site on a picture of one of my characters I did a while back. It's a breezy looking picture, laid back, and that's how I wanted my site to feel. Comfortable and clean. The newest pages are updated on my gallery site, but the comic has its own sub-site that delves further into the details of the characters and their world.

I tried to use the same picture in the forums, although the forum colours aren't as unified with the rest of the site as I'd like. It's been this way too long now to change it, though. I don't like the idea of constantly changing the look of the site, for better or for worse. Every time the site is changed, it loses a sense of permanence. I want my readers to think the site is stable and familiar.

I put more effort into the design of the *Reman Mythology* site than I did into my main gallery site because I wanted it to represent the comic. This site is darker and more intimate, using some alternating illustrations from the history book that Tabby reads to deepen the mood. The first thing you see is an illustration of the two main characters and a mysterious paragraph that introduces the story as if it were a legend. Major announcements about the comic are made below this, and the site navigation is at the bottom.

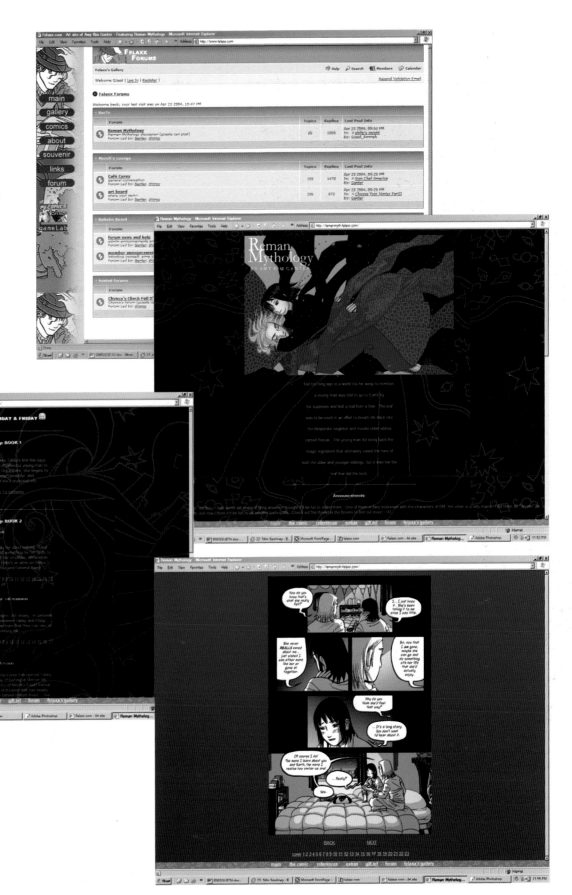

When I print the comics, they'll be in books that are divided into parts, so my comics online are divided the same way. Each book has its own section once it's archived, and the currently updating book's section is displayed in the main comic page.

For easy browsing and so as not to distract the reader, the comic itself has no background. You can advance to the next page by clicking the image, the word 'next', or the page number. Easy navigation is key in webcomics. The less your reader has to think about how to find the next page, the more they can think about what's happening in the comic.

RESOLUTION

When you're scanning your image or drawing it in a pixel-based imaging program (like Photoshop or Painter), you have to think about your image's resolution. Image resolution is essentially an imaginary grid paced over your comic. Resolution is measured in the number of grid cells (called 'pixels') that an inch of your image is divided into. This is called 'pixels per inch' or 'ppi' (a lot of people call this 'dpi', or 'dots per inch', but in traditional printing terms, 'dpi' actually refers to something else; still, it's commonly used as a synonym of ppi).

It's a good idea to scan – and work – at a higher resolution than your finished webcomic will be at, and then scale the image down after it's finished. You should keep a full-resolution version in your archives in case you ever need it. This is imperative if you ever want to print your comics – print requires higher resolution than computer monitors (and monitors of the future will only get higher in resolution). Remember: it's always possible to scale your images down (reducing their resolution), but scaling them up (increasing an image's resolution after you've worked on it) will always make your image blurry and/or pixellated. So if there's even a slight chance you'll print your comics, you should work in print resolutions (even though it will look really big onscreen and might make older computers run slower).

The standard for printing images like photographs and painted art is 300ppi, but in traditional printing methods (such as printing presses, not desktop printers), comics' lines will look blurry at 300ppi. It's best to keep black-and-white 'line art' comics (with no colour or grey tones) at 600ppi (or higher; higher never hurts, it just slows your computer down). For comics that use traditional comics-style lines but also have digital colour or grey tones, you should aim for at least 450ppi – higher if your computer can handle it. Desktop printers and Print on Demand publishers often produce satisfactory results with lower resolution.

For the Web, images are saved at 72ppi, but what's really important is the actual image size in pixels. Think about how your comic will look at different monitor resolutions – if you make your comic big, people will have to scroll to see the whole thing (which might or might not be something you want to have happen). Remember that your readers' screens will show not only your comic, but also the TaskBar, browser menus, and scrollbars – and the amount that will be taken up varies according to the operating system and browser that are used.

Below: This page is printed at 300ppi, a reasonable size for print (but far too big for the Web).

Bottom: The same image at a Web-sized 72ppi looks pixellated and unclear in print (but would look fine on-screen).

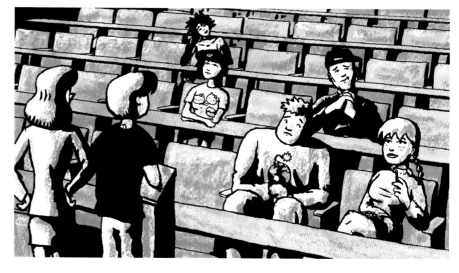

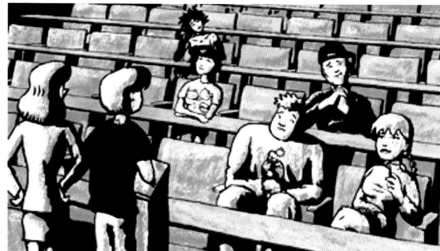

a strand of lanterns

ANTI-ALIASING

Black and white images in 'bitmap' or 'line art' modes will look jaggy on-screen, because they are not anti-aliased. What's anti-aliasing? Imagine a picture of a curved black line. When you place the pixel grid over it, some pixels will contain nothing but the black line, some will contain nothing but the white paper, but some will fall right on the border and contain some of both.

These border lines will contain some percentage of the black line, and in 'greyscale' or 'colour' modes, your scanner will make those pixels that percentage of black. For instance, a pixel that has 20% of its surface covered by the line would scan as a 20% grey colour; one that's 70% covered would scan as 70% grey.

This makes the image look great on-screen but blurs the line's edges when it's printed. 'Line art' mode won't anti-alias because it has to make every pixel either black or white. If the resolution is too low, this will make lines look jaggy in print, but at a high resolution, it will make them look crisp and sharp.

There are advantages to avoiding anti-aliased images when you're working with images for the Web, though. With anti-aliased line art, image editing tools like Photoshop's *Paint Bucket* or *Magic Wand* will tend to produce ugly gaps between the areas you select and the lines, because the tools select as much as they can before they run into a different colour, and (depending on the tool's settings) tend to consider the line's anti-aliased pixels to be another colour.

Starting in 'line art' mode, then converting to 'greyscale' or 'colour' – and turning off anti-aliasing on your tools (most tools in Photoshop have an anti-alias on/off toggle) – gives you crisp differentiation between lines and white space, so the tools don't get confused.

When you're using non-antialiased images for the Web, you should work with a larger image size than your final one, and when you're finished, you should flatten all your layers and resize to the final size – this resizing will cause the image to anti-alias and look smooth and clear on-screen, giving you the advantage of using non-antialiased tools with an anti-aliased image!

Top left: **This is a curve at 600 ppi without anti-aliasing.**

Top right: **This is a curve at 300 ppi with anti-aliasing.**

Above: **If you look more closely, you can see the difference better. On the left is a blow-up of a section of the non-antialiased curve, on the right a blow-up of the anti-aliased one. With a high enough resolution, non-antialiased images can be sharp and distinct on paper, but will always look bad on-screen.**

Left: **If you want to fill an area with solid colour with a tool like Photoshop's** *Paint Bucket* **or** *Magic Wand,* **you're better off avoiding anti-aliasing. Using** *Paint Bucket* **in combination with an anti-aliased image (left) will create unpleasant gaps between colour and line. A non-antialiased image (centre) will not create these gaps and will result in a cleaner image (right).**

JOHN ALLISON

What brought you into webcomics? Did you come from a comics background, a Web background, or both?

I drew comics for myself, and when I found a potential audience on the Web, I made comics for them. I have been a Web designer and I edited a section of my university's online magazine in the mid-90s, so I was better placed than some to give it a go – especially in the UK.

What makes a good webcomic? What is attractive to you about the webcomics you like?

I think a good webcomic has to surprise me in some way. Making comics myself, my brain goes through so many permutations of a joke that a lot of things seem predictable when I read them. The webcomics I enjoy are never predictable.

I enjoy comics on the Internet that make me laugh over comics that are purely dramatic; I think the delivery of one 'page' a day is to the detriment of dramatic effect. Of course, if you have a large backlog of material that is not a problem, but as people approach this material on a day-to-day basis, I think they lose a little of the intended effect.

It seems to me that *Scary Go Round* is built out of stories that also work as a day-to-day strip, while *Bobbins* seems as though it was (generally speaking because it evolved quite a bit, of course) a daily strip that worked in longer segments.

I think that's a very fair analysis, although toward the end of *Bobbins* you can see stories where I was reaching for this format, where I had a very clear end to work towards. What I do now is come up with the bare bones of a plot and attempt to fill it in week by week until I see the light at the end of the tunnel.

Is that how you approach *Scary Go Round*: take a longer story and figure out how to make it work a page at a time, or do the continuities grow as every page progresses?

There are problems inherent in this. Because it's daily, the deeper and more complex the plot gets, the more time I seem to spend explaining myself in case a new reader is lost. If this was a comic book, I wouldn't be trying to explain what had happened 10 pages before in case the reader had forgotten.

Another problem is that sometimes to move things forward, something fairly unexciting has to happen. In a comic book, no one minds two or three pages of rather dry exposition. But in a daily webcomic, those three pages take up 72 hours – it's death. I am still trying to get around these issues, but it's very hard. I have to maintain continuity, move things forward, and entertain you, and I only have four little boxes to do it in.

Do you see *Scary Go Round* as a finite thing, something that will evolve into a new series (as *Bobbins* sort of did), or something that you will continue for the foreseeable future?

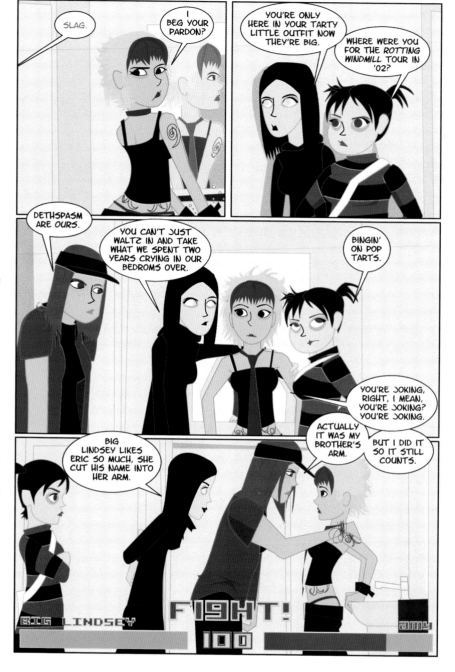

I don't plan things like this out at all. Common sense dictates that I stick with a recognizable name for as long as it is prudent to do so.

You're in a financially unique situation, making most of your money from your webcomics. How do you do it?

Merchandise – books and t-shirts. At the start of *Bobbins* in October 1998 I gave myself five years to quit office work, or announce my cartooning career a failure. In April 2003 I was laid off from my job at the time; by August I was financially stable through the comic alone. So I triumphed with only two months to go.

I'd guess the hard work of doing this day in and day out, getting better as you do it, and making genuinely cool merchandise is the secret. But is there some other insight into how you've made it work?

Two words: monastic existence. Long hours, few distractions. I like having a good time, but where I live, the opportunities for that are strictly limited.

You're in another rather unique situation, statistically speaking, of having left *Keenspot* and *Modern Tales*. Any acrimony, from any side, at any point?

Not at all! It was strictly a business decision in both cases. *Bobbins* is still hosted with *Keenspot*. As for *Modern Tales*, *Scary Go Round* was conceived of as a partner piece to *Bobbins*, a more arty experiment that I was going to collaborate on with a friend. When he decided not to do it, I rethought where I was going, ended *Bobbins*, and started *Scary Go Round* as an independent going concern.

What wasn't right about *Keenspot* and *Modern Tales,* for you?

Keenspot's Web servers were in a rotten state at the time, which was frustrating, but really I just wanted to strike out on my own at the time. When *Scary Go Round* became my main comic instead of a side project, I could see that keeping it on a subscription site [like *Modern Tales*] would limit my opportunities to reach readers.

When did the comic become financially profitable?

Profit has to be taken in relative terms. When I was hosted by *Keenspot* I wasn't paying for my hosting, and I was getting little checks, so that was profit back in 2000. Of course, I was working a lot of hours for a very small profit.

Do you think there's a split – real or perceived – between print comics creators and Web ones?

Yes, in the sense that most print cartoonists are probably more disciplined, and also their work is available in shops, and it costs money. But the crossover has started. Wherever there is money to be made, people who are good enough to make money will go there and try to make it.

Where do you see webcomics in general going in the future, and where do you see yourself within that future?

I have absolutely no idea. Almost everybody wants to be a little richer, a little better at what they do, a little more personally fulfilled. I imagine that most webcomic creators will tailor their efforts to the fulfillment of those goals. I anticipate some gratitude from the audience at large.

Do you feel there is a webcomics community, and if so, do you feel a part of it?

I have good friends in webcomics, but I don't think I contribute to any great extent to the overarching community. I make my strip on the computer, so my desire to go on the Internet for hours trawling message boards is limited.

HOME: OLDHAM, ENGLAND

URLS: SCARYGOROUND.COM, BOBBINS.ORG

CURRENT OCCUPATION: COMICS MAKE UP THE MAJORITY OF HIS INCOME, BUT HE DOES FREELANCE GRAPHIC DESIGN AND WEB DESIGN WORK.

ARTISTIC INFLUENCES: JAMES KOCHALKA, SERGIO ARAGONES, SHAG, J. OTTO SEYBOLD, S. BRITT, TONY MILLIONAIRE, CHRIS WARE, PETER BAGGE, JAMIE HEWLETT

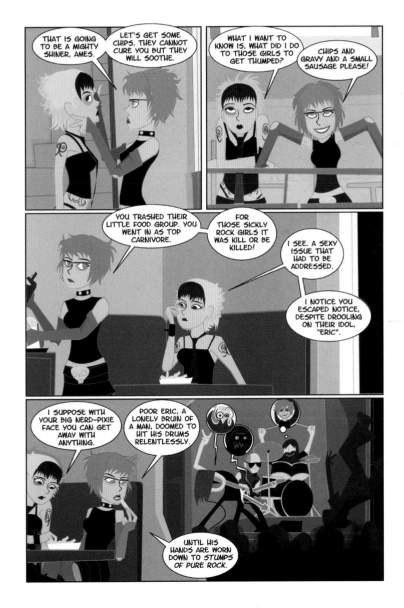

1 I like to prepare five comics (a week's worth) before starting the artwork. *Scary Go Round* is a story comic, and the stories usually last around eight weeks. I have a firm idea of how I will start, a vague idea of the end, and no concept of the middle whatsoever. All three are subject to radical change based on my whims and fancies.

2 *Scary Go Round* is drawn with Adobe Illustrator and a Wacom graphics tablet. When I started working this way (on my old comic strip *Bobbins*) it was to allow me to make the comic more quickly than was possible with pencils, inks, hand-lettering and computer colouring in Photoshop (as I had been doing). Initially, the characters were templates in a facing position who were almost poseable mannequins. I would move the round pupils of their eyes and their eyebrows, pose their arms, draw mouths and hands, and make any necessary minor adjustments to their form, drop in a rudimentary background, and consider the job done.

3 After the novelty of this wore off, I refined the mannequin system, but found it too constricting (or creatively bankrupt). By this time I had become proficient enough with a graphics tablet to work more organically, so I developed a more sophisticated system. The characters were drawn from five angles, and instead of posing them as I had done in the past, I threw away any parts of the image that weren't right and redrew them.

My five angles were taken from animation character sheets I'd seen. After a year or so, I started to find having to draw the characters from every angle unnecessary, so I just draw the heads and one body, so I have a reference for outfit colours. This has made the process of drawing the comics much more organic and fun.

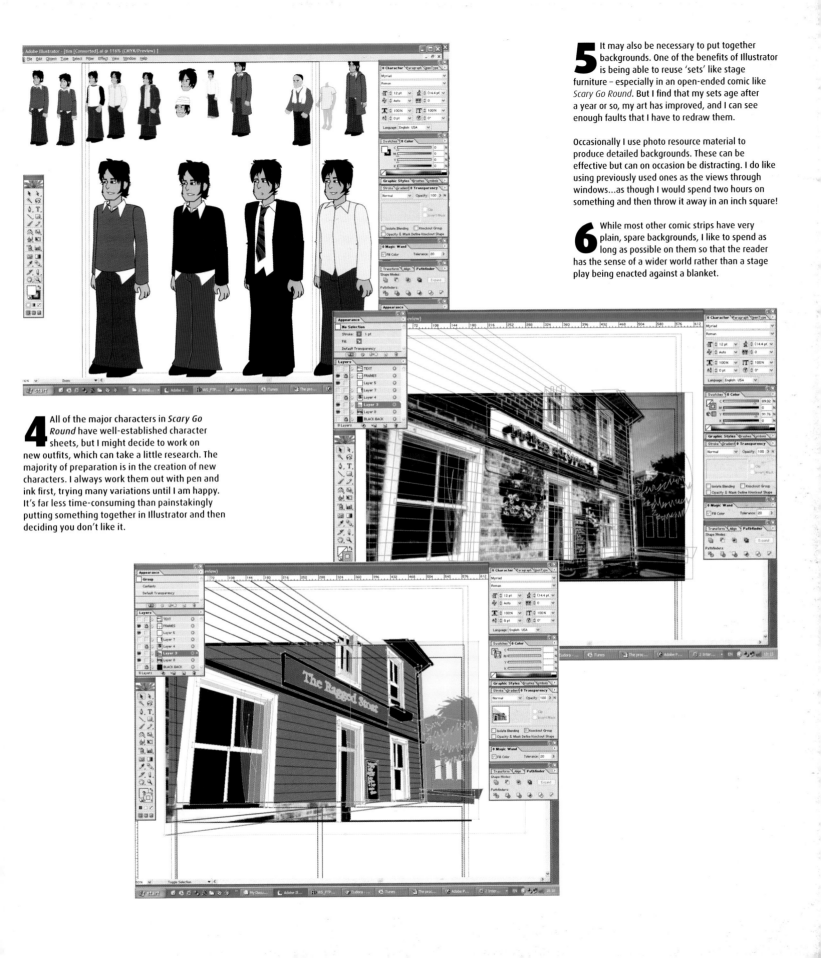

5 It may also be necessary to put together backgrounds. One of the benefits of Illustrator is being able to reuse 'sets' like stage furniture – especially in an open-ended comic like *Scary Go Round*. But I find that my sets age after a year or so, my art has improved, and I can see enough faults that I have to redraw them.

Occasionally I use photo resource material to produce detailed backgrounds. These can be effective but can on occasion be distracting. I do like using previously used ones as the views through windows…as though I would spend two hours on something and then throw it away in an inch square!

6 While most other comic strips have very plain, spare backgrounds, I like to spend as long as possible on them so that the reader has the sense of a wider world rather than a stage play being enacted against a blanket.

4 All of the major characters in *Scary Go Round* have well-established character sheets, but I might decide to work on new outfits, which can take a little research. The majority of preparation is in the creation of new characters. I always work them out with pen and ink first, trying many variations until I am happy. It's far less time-consuming than painstakingly putting something together in Illustrator and then deciding you don't like it.

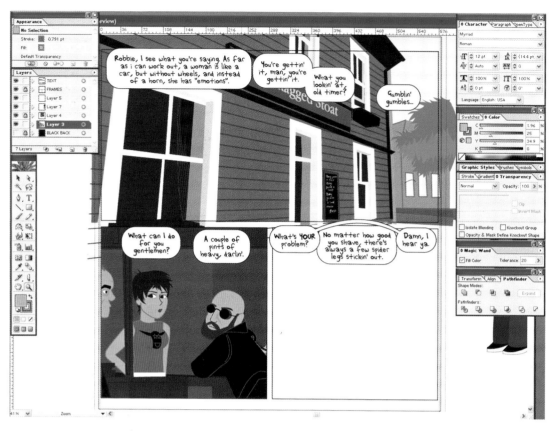

7 Since I work in Illustrator, the text is on a layer, the frames are on a layer, and the content of each panel gets its own layer. Unless an image is going to be particularly complicated, I don't do any rough layouts. If I began the writing in my sketch pad, there may be a few illustrations to work with.

This is not the perfect system. If a strip is four panels of talking heads, by the fourth panel I have probably begun to struggle to keep things interesting for myself. This is why many of my more talky strips feature the sudden appearance of an exciting imaginary object in one panel. I regard this as value for money. I am obsessed with providing value.

I don't work very methodically. Sometimes I will work at parts of an image until they are done and fill up the panel gradually; sometimes I'll slap everything down then tidy it up. Sometimes I will draw the background first and then put the characters on top; sometimes the background is an afterthought.

8 In the 2 x 2 grids I base my layouts on, I like to have two people per panel at least – otherwise things look very sparse. Once people are used to this, it adds to the distinct visual vocabulary of the comic, since one person in a panel is then an odd thing and therefore worthy of note.

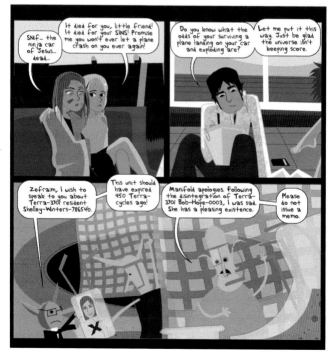

a strand of lanterns

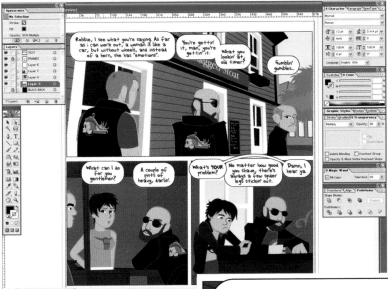

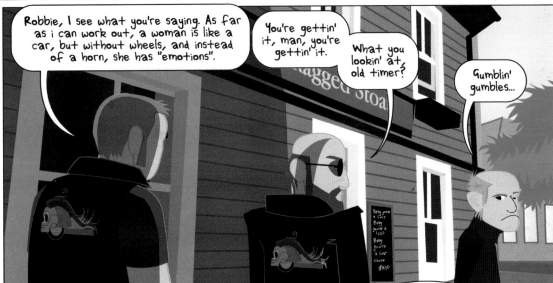

10 A downside of working the way I do is that you can't throw in a quick background character – they require the same amount of design as your regular cast. But again, given time, you build up a library of town inhabitants who wander around. Either that, or you draw people facing away from the reader – the coward's way out! (Signed – A Coward.)

11 Shadows add vital depth to a comic – they're particularly helpful on *Scary Go Round,* which has an intentionally flat appearance.

12 When I've finished, I upload the comic via FTP and it's done – for the day.

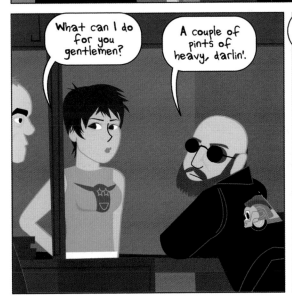

9 To draw the characters, I select a head from the model sheet; then I work out the body in linework, and add in any props or surrounding objects that impact the scene. Next I colour the character using the *Eyedropper* and my original character template (if the figure doesn't have a template, I've usually made a colour swatch for the outfit).

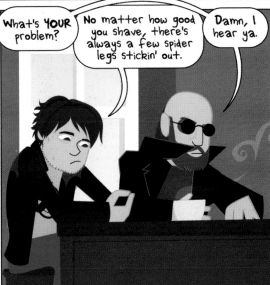

COLOURING WEBCOMICS

While there are certainly no set rules, comics colouring (when it isn't done on paper) is most often done in Adobe Photoshop, Corel Painter, or any one of the many other similar programs. Remember, if you have any desire at all to ever print your comics, then do all of your colour work at a high resolution – at least 300ppi, with the image size set to the size that you want to print your comic at. You can always scale a print-sized image down for the Web, but you can't scale a Web-sized image up for print (not if you want it to look good, anyway).

Photoshop is commonly used to produce slick digital colour – smooth gradients and bold solid colour. Painter, as the name implies, is more often associated with a painterly look. In Painter, 'brushes' (the tool you use, controlled by your mouse or drawing tablet) are designed to emulate real painting tools (such as watercolours, oils, coloured pencils, etc.), though these tools can often be used in ways that are impossible on real paper (coloured pencils can be applied to wet oils, for instance).

Above left: This image, by Brendan Cahill, was scanned in black and white.

Above: It's a good idea to 'flat' in your colouring first.

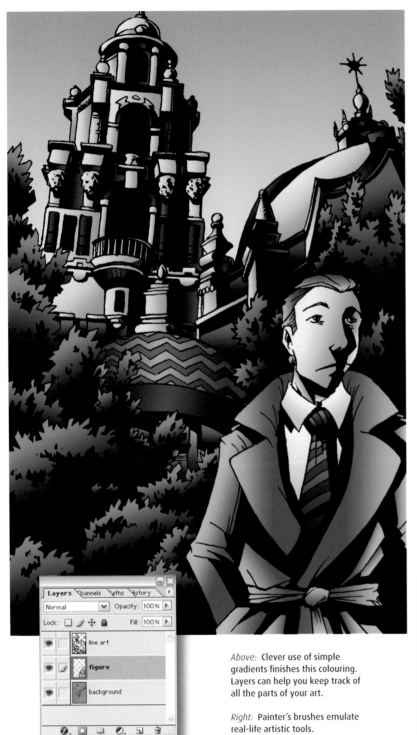

Layers are an important element of image editing programs. Layers are like invisible pieces of paper stacked on top of each other, allowing discrete parts of an image to be worked on without impacting other elements. Commonly, an artist might put his or her linework on one layer, colour the figures on another, and the background on a third. This ensures that mistakes won't affect other parts of the image, and allows fine-tuning details. Maybe, for instance, the characters recede into the background too much, and instead need to pop out. If the figures and background are coloured on separate layers, it's a simple matter to adjust the colour on one (say, darkening the background) without affecting the other.

Colouring is usually done first as 'flats' – areas of the drawing are selected using tools like the *Lasso* and *Magic Wand* and filled with solid colours on a layer separate from the line art. This lets the colourist get a feel for the general tone before going in and rendering the detailed colouring. It also allows individual colour sections to be selected with the *Magic Wand*, and lets the colourist work on that area without affecting other areas.

Once the flats are done, the colourist will go back in and add details, using whatever tools are appropriate for the artist's style – gradients, using the brush like an airbrush (creating soft modelling), using the *Lasso* or *Paintbrush* to create hard shadows (like traditional animation), or giving work a painted look. It's a good idea to flat in the colouring, even if you're going for a more painterly style, so you keep the overall shape of the piece in mind as you're colouring. If you just zoom in close and start to do fully-rendered art without figuring out your overall composition, it's easy for a comic to become disorderly and confusing, lacking a focus or an overall tone.

After you've coloured the piece, the colours can be altered by adjusting tones, using the brightness/contrast or more advanced adjustment options. It's a good idea to experiment with these tools. Also, Photoshop is replete with filters and textures, which can be appealing but are often the hallmark of an inexperienced colourist. Sometimes these effects can be nice, but it's easy to overdo them.

Above: Clever use of simple gradients finishes this colouring. Layers can help you keep track of all the parts of your art.

Right: Painter's brushes emulate real-life artistic tools.

KEAN SOO

Kean Soo is an independent – he might say 'reclusive' – webcartoonist who has attracted a faithful readership to his solo site, www.keaner.net, through his diverse collection of journal strips, short lyrical pieces, and even a few soundtracked experiments. An active member of the minicomics scene in Canada and the United States, Kean is also a contributor to the critically well-received *True Porn* and *Flight* anthologies.

When and how did you begin creating comics?

I was born in Romford, England, and spent the majority of my youth growing up in Hong Kong. I drew comics off and on throughout school, but they were pretty terrible things to look at. It wasn't really until I met Ben, a friend at university, that I began to take drawing comics seriously. We collaborated on several short stories and comic strips that never really went anywhere, but those comics certainly left their mark on me. It wasn't until soon after university that I began to focus on drawing my own comics.

When did you first post your work online, and what attracted you to webcomics?

I started seriously posting comics on the Web in the summer of 2002. I'm not sure what really attracted me to webcomics, though. Certainly, it was a much more affordable alternative to printing up minicomics, and the potential for a wider readership through the Web was certainly a bonus. At the time, I also liked the idea of having a regular audience (regardless of how minuscule it was) that kept me disciplined and forced me to produce work on a regular basis.

Which webcomics or webcartoonists do you read regularly or recommend highly?

I'll read just about anything by Patrick Farley (*Electric Sheep*), Kazu Kibuishi (*Bolt City*), Derek Kirk Kim (*Lowbright*), Jason Turner (Strongman Press), and those crazy Pants Press kids (www.pantspress.net). Other webcomics that I follow on a regular basis are John Allison's *Scary Go Round*, Neil Babra's *Cloud Factory*, Enrico Casarosa's *Haiku 5-7-5*, Joey Comeau and Emily Horne's *A Softer World*, Demian5's comics, Shaenon Garrity's *Narbonic*, Les McClaine's *Life With Leslie*...really, the list could go on and on.

Briefly describe *Elsewhere*.

Elsewhere is a little autobiographical story that broke away from my usual workflow. I had the story knocking around in my head for a long time, and when 24 Hour Comic Day rolled around, I showed my support for that event by drawing the entire comic in an 18-hour span. I subsequently lettered and coloured the comic in the week that followed.

What are some of your long-term goals for your work?

I think my only long-term goal would be to tell the best stories that I possibly can. I also have this crazy dream of somehow making a living off of my comic work, but I know I have a very long way to go before that ever happens, so I try not to think about it too much.

How often do you post new comics material on the Web?

As I've shifted towards drawing more self-contained stories, I usually post those on the Web either when they're completed, or I serialize them during the weekdays. I used to have a journal strip that was updated daily, but I've become increasingly frustrated with that format. Sometimes, when something interesting happens, or I have something I need to say, I update the site with a new strip.

a strand of lanterns

OKAY.

Vrrrt

VROOM

This usually happens at least once a week now, but updates have definitely become more sporadic.

Your strongest skill as a webcartoonist? Your greatest challenge?

Gosh, I'm not sure. I still feel like I'm learning something new every single day. I really don't know. Is never being satisfied with one's own work considered a skill?

As for challenges, I do that every day. I enjoy experimenting with different styles and techniques, and pushing myself as hard as I can to work on trouble spots that I know need improvement (like drawing hands and feet, for example). I don't think I would be able to learn anything if I didn't take any risks and make any mistakes in my work.

HOME: TORONTO, ONTARIO, CANADA
URL: KEANER.NET
EDUCATION: BSC IN ELECTRICAL ENGINEERING FROM QUEEN'S UNIVERSITY IN KINGSTON, ONTARIO. I DON'T HAVE MUCH FORMAL ART TRAINING; IT'S MOSTLY BEEN SELF-TAUGHT
CURRENT OCCUPATION: FREELANCE ILLUSTRATOR/WEB DESIGNER/CODE MONKEY

ARTISTIC INFLUENCES: MIKE MIGNOLA, STAN SAKAI, JEFF SMITH, BILL WATTERSON, KAZU KIBUISHI, JAMES KOCHALKA, JASON LUTES, PAUL SMITH, JASON TURNER, DAVE MCKEAN, CLAUDE MONET, AND WONG KAR WAI

SOO ON SOUND AND MUSIC IN WEBCOMICS

Music very much affects my own work, as I draw an endless amount of inspiration from a number of genres in music. So much so that it's started seeping into my own work. Things like incorporating a 'rhythm' to page layouts, or panel repetition, and so on.

I've been experimenting heavily with mixing music and comics together on the Web, using embedded MP3s combined with comics. My significant experiments (*Devil in the Kitchen*, *Bottle Up and Explode!* and my latest work, *Passing Afternoon*) use music either as the primary narrative device to drive the story forward or as more of a 'soundtrack' to help establish a mood.

The problem with these comics is that people tend to 'read' images at different rates, so as a result, the images don't sync up particularly well with the music. I don't like the idea of using Flash to limit the reader's experience – it would basically become a musical slideshow, which I think detracts from the overall experience of reading a comic. I'm still trying to figure out what works and what doesn't, so it's a fairly slow learning process for me.

I definitely think there are a lot of ways that sound and music can be combined on the Web without compromising comics, and I'm sure we're only just starting to scratch the surface at the moment. I'd love to see more comics experimenting with what can be done on the Web.

KEAN SOO WORKTHROUGH

1 For me, the story is the most important part of developing a comic. I have to be able to get behind the story 100% before I can even find the motivation to draw the comic. I usually kick ideas around and try to work the story out in my head and on paper over the course of several months (and in some cases, years).

Once I have a rough idea for a story, I sit down and begin to work out the thumbnails. I draw most of my thumbnails on a stack of old file paper, and once I get started, I usually work very quickly and very small, which results in near-illegible thumbnails. Although as long as I can understand them, I don't worry about it too much. Most of my time is spent trying to figure out the dialogue, the beats in the story, and panel layouts. I usually go through two or three drafts before I'm remotely happy with the layout.

When I was starting to draft this story, I imposed an additional restraint on myself – that each 'flashback' or 'present-day' section in the story should last for exactly two tiers of panels. Working on the thumbnails, I quickly decided that it wouldn't work and threw the idea out. However, much of the story still fits into the two-tier concept, but it's no longer a hard and fast rule.

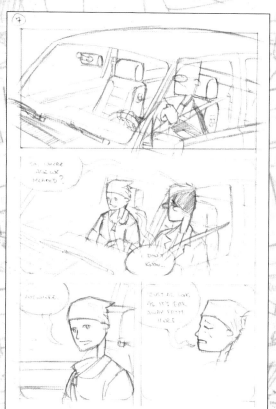

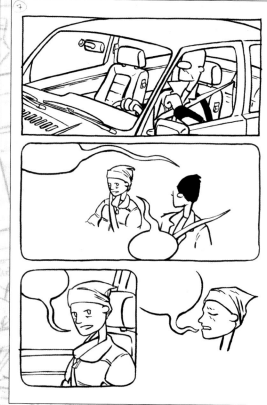

2 After ruling out the borders and panels, I begin to lay down the initial pencils. I use an old technical pencil and draw most of my comics on sketchpad paper – it's affordable, and once the image is scanned into the computer, it doesn't really matter what kind of paper I'm working on, as long as it takes the ink well.

For the purposes of this tutorial, I'll only focus on one page in my story *Elsewhere*. I usually keep the pencils fairly loose to give my inking a little more spontaneity. Of course, this is unless I'm dealing with a more technical drawing (the car, for example), in which case I'll tighten up my pencils and try to get the proportions correct at this

stage. When drawing things that I'm not entirely comfortable with, I typically work from reference photos. The lettering at this point is only used as a placeholder to determine the size of the word balloons to be drawn.

Also as a timesaving method, I sometimes dupe backgrounds in Photoshop. I wanted to use the same angle of the car in panels 1 and 2, so I simply throw the pencilled page on to a lightbox, and on a separate sheet of paper, I roughly copy out the car, and insert the characters into the copied second panel. The same thing is done in panels 3 and 4. So really, I'm working on two separate pieces of paper at this point.

3 I will then ink the page with a brush and erase all of the pencils. I don't worry too much about any mistakes I might make while I'm inking, as the problem areas will be touched up in Photoshop later.

The art is then scanned into Adobe Photoshop as a greyscale image, working at 300ppi. Once the page is in Photoshop, the *Levels* are adjusted to bring out the blacks and clean up the whites.

a strand of lanterns

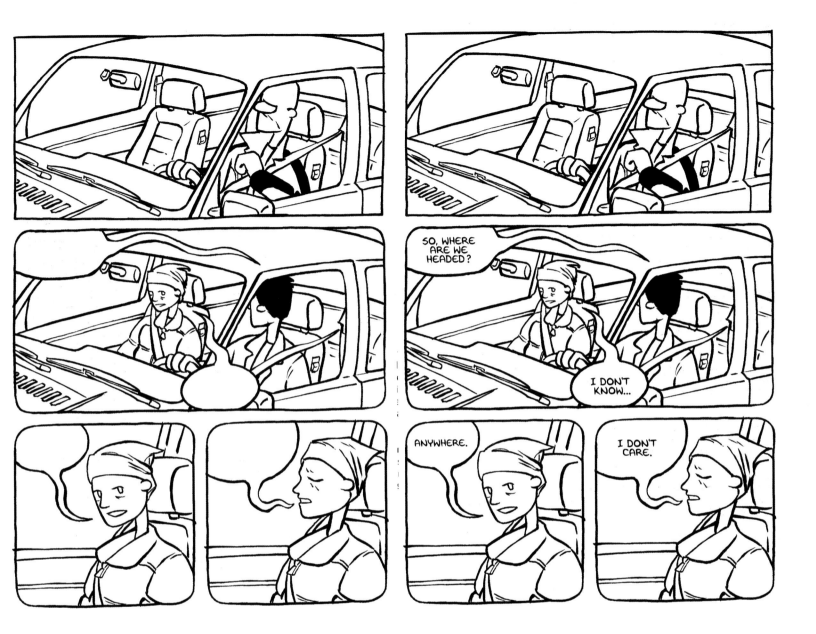

4 The background images are then copied and inserted into the page as separate layers. Occasionally, parts of the background may need to be drawn in or removed, depending on overlap. I will also correct any inking mistakes I might have made at this point. Once the backgrounds are properly lined up, and I'm happy with how everything looks, I flatten the image again.

5 At this point, the lettering is added using a font created from my own handwriting. I may also do some rewrites to the dialogue if I'm not entirely happy with it (note the change made to the dialogue in the fourth panel from the initial pencils).

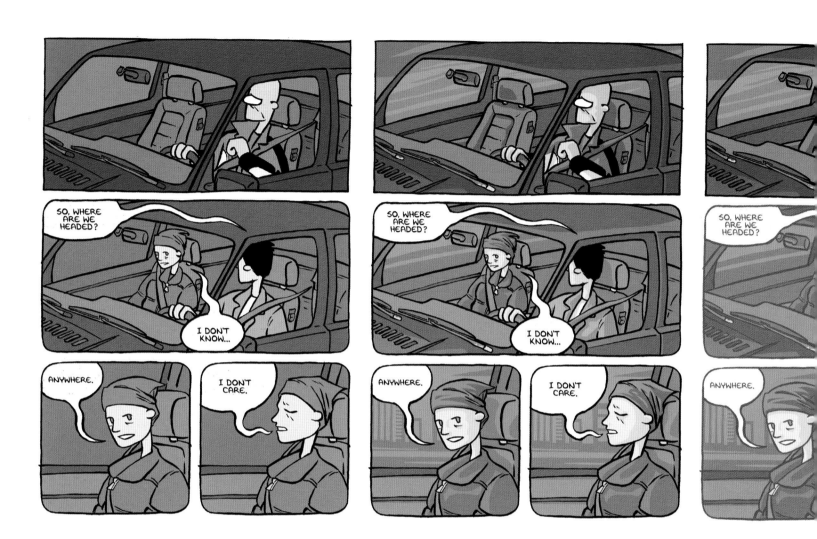

6 In preparing to add the colours, the image mode is switched to *RGB color*. Creating a duplicate layer of the line art and setting it to *Multiply*, I then delete everything on the background layer. On this blank background layer, I begin to block in the colours for the page. Since this page includes both 'flashback' panels and a panel in the 'present', I chose to use two different colour palettes to represent the differences between the two – a cold blue colour for the panels in the present, and a slightly warmer green/yellow palette for the flashbacks.

7 Once I'm happy with how the flat colours look, I add shading with the *Paintbrush* tool to complete the colours. When choosing the colours for the shading, I use Photoshop's *Color Picker* to pick a colour that is darker and slightly higher in saturation for shadows, or vice versa (a brighter, low saturation colour) for the highlights.

I tend to work with the standard round brush set at 100% hardness, and occasionally use the *Magic Wand* tool to prevent me from colouring 'outside the lines', depending on how sloppy I'm feeling that day.

8 For the flashback panels, I decided to colour the line art as well, to match with the alternate colour palette. Using the *Magic Wand* tool and the *Select similar* command, I select the line art on the line art layer and remove any selections for the 'present-day' panels. I then use the *Paint Bucket* (or a brush set to the largest size) to colour the line art. The text colour is also adjusted to match the new line art colours.

a strand of lanterns

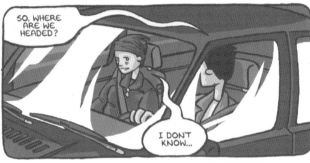
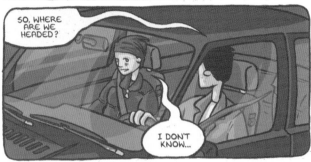

9 Any 'special effects' for this page will be added at this point. In this case, reflections in the windows need to be added, so I will use the *Magic Wand* tool to select the blank areas of all the windows of the car. Then, using the *Quick Mask* tool, I will select all of the linework and black areas that overlap the windows.

Once that's done, I will create a new layer above both the line art and the background layers. Leaving this new level as a 'normal' layer, the window reflections are then painted in white. I switch between the *Paintbrush* and *Eraser* tools quite a bit as I work on the reflections.

10 Once I'm happy with how the reflections look, I drop the opacity of the reflection layer to 15%–25% to allow the details underneath the reflections to still be seen.

The image is then flattened, reduced to 72ppi and saved as a low compression (i.e., high-quality) JPEG for Web consumption. The JPEG is then added to the webpage along with the rest of the other pages so that the comic can be read in one long scroll.

NATE PIEKOS LETTERING WEBCOMICS

As the comics medium moves into the online realm, lettering, like every other aspect of the process, needs to be tailored to the delivery method just a bit. In lettering for print comics, you can get away with using smaller point sizes for dialogue, as well as more stylized fonts. Not so for the Internet. The primary concern in lettering is legibility – and this goes doubly online. You're designing for pixels, not ink on paper, and usually the webcomic pages are small so they load faster.

I do all my lettering in Adobe Illustrator, and the compositing of the lettering/art in Photoshop. These programs are the letterer's best friends. Once the art and colouring is done, I make a low-resolution (72ppi) version of my art in Photoshop – something I can take into my Illustrator template without unnecessarily slowing down Illustrator. I save this file to my desktop and open Illustrator.

When lettering comics in Illustrator, the easiest method is to make a template with your layers set up. Save this file and use it over and over for every comic you do. For the Web I typically just use four layers: Lettering, Balloons, SFX, and Art. I place the low-res art and drop it in the bottom layer. I then lock this layer so the art can't move.

Now comes the actual lettering, and probably the single biggest difference between lettering for print and for the Web. On the Web, you have to think in bigger point sizes. Print comics are typically lettered with fonts between 5pt and 8pt. For the Web I usually go to between 14pt and 17pt.

Make sure you choose fonts that are angular and easy to read, with loose kerning (the distance between individual letters) and spacing. I've designed some fonts specifically for Web lettering – Web Letterer BB and Digital Strip, both available from www.blambot.com.

Once all the dialogue is in, I select the *Balloons* layer and lay in my balloons with the *Oval* tool and/or the *Freehand Pen* tool. The *Freehand Pen* tool is ideal for tails (the little things that point at the speaker) and the irregularly shaped, manga-inspired balloons that I use for my own strips. You will need to set the Stroke (the line around the balloon and tail) to about 1.5pt–2pt (in print comics it's usually about 1pt).

One thing you don't have to worry about is trapping your lettering. Trapping is the process by which you tell the computer which lines and fills need to overprint other lines and fills. This is so you don't get freaky white halos around the balloons on the printed page. With the Web you can forget all that – there's no printing mistakes when there's no ink or paper!

I treat sound effects like I treat the dialogue – think big and simple. Lay off the crunchy, craggy fonts (unless the sound effect is really gigantic, no one's going to see all that detail) and keep your colour treatments simple so that the effects pop out on the screen.

Once the lettering is typed and the balloons are created, delete the art from the art layer, select all your lettering and *Convert to Outlines*. Now save your lettering as an EPS file to your desktop.

Open up your original, high-resolution artwork in Photoshop and go to *File > Place* and select the EPS file – your lettering appears on top of your art. Move it with the *Move* tool or arrow keys (on the keyboard) to properly align it. If the colours look a little washed out, bump up the colours using the *Levels* and/or *Saturation* menus. Now you're ready to flatten your image, resize it, and save it in a Web-ready format.

Do some experiments! Type some dialogue at several sizes and bring it into Photoshop. Once you've resized the image to its final size, you'll see which sizes are most legible.

Since 1999, Nate Piekos has been working in the field of comics as the director of Blambot Comic Fonts & Lettering. His work has graced the pages of comics from Marvel, Dark Horse, Oni, and Vertigo, as well as TV advertisements, feature films, theme park rides, and more.

Above: Simple dialogue, balloons and SFX for an installment of *Atland* by Nate Piekos (blambot.com).

Left: Illustrator offers many useful tools for lettering a comic.

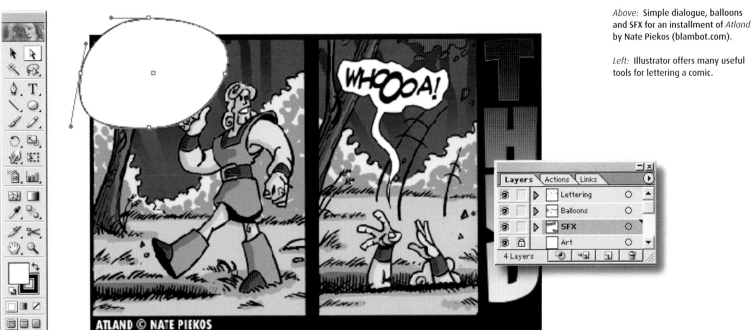

JUSTINE SHAW

What brought you into webcomics?

I grew up reading comics – graphic novels, magazines, *Mad*, newspaper strips, etc. I liked to write and to draw, so making my own comic was an idea that I always wanted to follow up on. I finally got around to doing it and decided for financial reasons that just putting it online would be the way to go for me. I then drew it in a wide aspect ratio to fit computer screens better.

I've been making a living on the Web for several years now, so I had a much better idea of how things would work in terms of Web publishing, rather than print publishing, which is a strange exotic practice only those with enough midichlorians in their blood can master. My familiarity with the Web probably pushed me toward just making whatever I did a webcomic as well. Not that I didn't make a lot of mistakes on the Web side as well.

Do webcomics have particular advantages or disadvantages in relation to print?

Lack of printing and distribution costs is the big advantage as far as I can tell. Also, I think you may tend to see a broader spectrum of different types of characters and stories online. Not that I'm saying I think one printed publication is like any other, but the Web, for good or ill, lets anyone, including yours truly, put their stuff out there, no editor (more than likely), no compromises in the way you want to do what you do. Ultimately, the only person who can mess it up is you. Lots more people might see your stuff online.

Have your fans mostly been direct-market comics readers?

You know, I don't know…a lot of the people who've written to me haven't mentioned what else they read. Some long-standing comics they've mentioned, you know, *Strangers in Paradise* [Terry Moore's print comic], the Hernandez Brothers' stuff [such as the print comic *Love and Rockets*], all of which go through direct retailers I think, not to newsstands.

Does creating comics make you any money?

Nope. I'm a big dummy. It's amazing I've survived in this world. Actually, I just remembered: I did do one comics project for money, which was a one-page strip I illustrated/coloured/lettered for *Spin* magazine a couple of years ago. They were great to work with; they only knew of me because I'd put *Nowhere Girl* online, and at that time it was only one issue.

Would you do more comics if it paid better, or are you happy with comics' place in your life?

I would choose to do comics full-time and put out one every six to eight weeks if I could afford it time- and money-wise. San Francisco is not an inexpensive place to hang your hat, unfortunately.

Do you feel that either writing or drawing comes more easily or naturally?

Used to be drawing, hands down. However, the older I've got, the less I've come to like drawing. If it doesn't come out perfect the first time now, I get frustrated and have to walk away. I've lost all my patience and continue to lose reservoirs of patience I didn't previously know I had.

Writing, though still hard for me, comes much easier now. It's a devil to get it out and on the page, but I can see the whole story through in my head really well. It's just that it's on fast forward and sometimes I can't slow it down enough to get it written down. I have to think really fast in my day job, so it's hard for me to switch modes.

Was there always a big *Nowhere Girl* graphic novel in your head?

I came up with the central characters of what became *Nowhere Girl* in 1992, and I first wrote part one in early 1994.

Initially, it was going to be much more fantastical; one of the characters was going to be the devil; it wasn't set in the really real world. Then it narrowed down to the issue of someone who was

"One of those people who knew everyone, in every social circle."

Lindsay actually seemed to think i was cool. Her only flaw was she tended to talk a lot, gossip, never shut up about people, you know."

"....Ivey."

abused, who is no longer abused, but still abuses herself. And I did a hastily drawn black-and-white version of that story 10 years ago. I thought I was done with the characters (who all had different names then, by the way), until about 1996, when I just started doodling them again and wondering what happened to them after the end of that comic. So, that coupled with impressions I got from some of the people I met in the second half of the '90s led me to rewrite part one, redraw the whole thing, and colour it in (that's the version that I put online in 2001, of course), and plan for a series.

What kind of a fan-base does *Nowhere Girl* have? Did you get any support from the gay-and-lesbian community (outside of comics and/or inside)?

All kinds of people read the two comics when they were each released. People from all over the planet wrote to me. I got as many as 70 e-mail messages a day at the height. That may not be a lot to pros, but to me, coming out of nothing, it packed a wallop. Which was very cool, very flattering, but also very strange.

As for support from the GL community, I'm not sure. I've met some very nice people at conventions over the last two years who were gay or gay-friendly and were very kind to me. Also, I don't think I'm outing anyone by saying the first person who ever interviewed me was gay. And I have had an e-mail correspondence with Kris Dresen for the last five or six years, and it was great to hear her encouragement. That's about it – I wasn't, like, on the cover of *Attitude* or *The Gay Times* or what-have-you.

Do you feel there is a webcomics community? And if so, do you feel a part of it?

Well, I don't socialize much over the Internet, so, no, if there's a webcomics community, I wouldn't say I am part of it. I'm not a big 'joiner' anyway. I tend to keep to myself. Though everyone I've met or spoken with has seemed really cool, and I've struck up a couple of real-life friendships with people I've met over the Internet.

The impression I've got from listening to people is that there was a webcomics community, and it may still exist, but it's not really exclusively a webcomics community any more, as just about everyone publishing has a website now, with its own message board or whatever. So, it's more like the webcomics community has been absorbed into a larger comics community. That was the impression I got after the Alternative Press Expo. I remarked how there was no webcomics panel any more, as there was a few years back. I forget if it was Patrick Farley or Scott McCloud who told me to look around at all the tables: everyone there, zines, small press, bigger publishers, all had a Web presence. There was no way to distinguish webcomics from just 'comics' anymore.

HOME: SAN FRANCISCO, CALIFORNIA
URL: NOWHEREGIRL.COM
CURRENT OCCUPATION: WRITES PHP, HTML, AND CSS FOR AN INTERNATIONAL COMPANY BASED IN SAN FRANCISCO

ARTISTIC INFLUENCES: COMICS: ALISON BECHDEL, KRIS DRESEN, CHRIS CLAREMONT *X-MEN* COMICS FROM THE '70S/'80S, ALAN MOORE (*V FOR VENDETTA, LEAGUE OF EXTRAORDINARY GENTLEMEN, WATCHMEN*), PATRICK FARLEY (*SPIDERS*), WARREN ELLIS (*TRANSMETROPOLITAN, GLOBAL FREQUENCY*), ARIEL SCHRAG
FILMS AND TELEVISION: STEVEN SPIELBERG, JEAN-PIERRE JEUNET AND MARC CARO, MAMORU OSHII, GEORGE LUCAS, PETER JACKSON, RONALD D. MOORE, M. NIGHT SHYAMALAN, RIDLEY SCOTT, JOSS WHEDON, BRYAN SINGER

JUSTINE SHAW ON THE FUTURE

I find it difficult to think of the future of webcomics, or any online content, without thinking of the future of the Web first and foremost. In vast regions of this planet, people are primarily connected to the Web and therefore each other via smaller and smaller devices: cell phones, PDAs like the Blackberry, etc. These have necessarily smaller screens and are highly specialized instruments. To get content to them, it's got to be quick, meaning small file sizes and small dimensions. Short, one-panel comic strips with little detail (no cross-hatching, for instance), things that could be downloaded and read while someone's on the train in the morning on the way to school or work, or they can instant-message to each other during meetings. Little time-killers.

As the Web evolves past the limits of the modern setup (browser-on-client-computer-displays-HTML-and-graphics), I'm pretty conscious of the fact that I've basically made my work on the modern equivalent of an eight-track tape deck or a Betamax machine. Whether or not these images can be transcribed to whatever's next (and how silly it will or won't look) is impossible to guess. However, if the 'micro' revolution catches on further, I think people may have to start considering 'getting small' to reach people, if that is their goal.

One day Jamie was beaten outside of school by athletes from the school. No one got in trouble.

That was when Jamie met Daniel, who was a senior at the same school at the time. He tried to befriend her; his only reason he said was because he was African and he'd learned his lessons well. So that's how Jamie met Daniel, and they were friends throughout the rest of the school year. Then Daniel graduated, and she was alone again. For 3 years, during which time, any time she was noticed, she was harrassed and often beaten up. Her only respite came in hanging with some of hte kids who drove out to the desert in one boy's truck to smoke pot, and she could be out in the desert under the stars and be safe.

Jamie says that her parents eventually found out. They lived uneasily with it at first, but later it was mutually agreed that she should leave.

Ana says she's really sorry for what happened. But it's not the end of the world. She nonchalantly mentions she's gay too in fact. Jamie, horrified by this, gets up and runs off.

Ana starts after her; Jamie reaches Daniel screaming at him for making a fool out of her and "trying to set her up or something" and yells she never wants to talk to him again, then storms off. Ana reaches Daniel and Rosie; everyone around is staring awkwardly. They don't say anything, just look at one another —

Jamie storms off through the drizzle, and Ana catches up with her; Jamie tells her to "go to hell, pervert". Ana grabs her by the arm and yells at her, saying that she's tried to be nice to her, to listen, because Daniel felt she might be able to help, might be someone to whom she could talk.

But Daniel did no such thing as try to "set her up". For one thing, Ana is happily married, and Jamie is just obsessed with replaying the horrors of her high school years. Jamie is crying, trying to get away, screaming at her to leave her alone. Ana says she doesn't even think she's been entirely truthful, with her or with Daniel: she just said it was a "mutual decision" between her and her parents for her to leave home, yet told Daniel (who told Ana) that she'd been thrown out.

And Ana has questions: how is Jamie affording an apartment, and college? She never goes to work, is enrolled in 1 class, and almost never goes to that. Jamie breaks down sobbing, admitting that her parents didn't throw her out, and don't even know she's gay.

She's just been trying to distance herself because she can't tell them; she's so ashamed she can barely admit it to herself. Her parents know where she is, but she is estranged from them and minimizes contact. They want more contact, but she doesn't. She ran off after high school, got a shit-job and is taking one class in college (that she's failing cuz she never goes to it) and is living mostly off the money her grandma left her when she died, $4000; which is almost gone. What makes things worse, is that after the last time she didn't show up for work, she got a phone call from her boss saying to never come back. She's been fired. She just hangs out in a goth club, around people she doesn't know, so she can pretend what it's like to have friends and belong somewhere. Jamie is hysterically crying, and talking about how she's a freak, and she can never be happy in this world. Ana is getting desperate, and tells her that look, never mind about Ana herself, but Daniel's not a freak, right? And HE IS GAY. And Jamie stops crying, and freezes for a few moments, then pulls a Luke-from-end-of-Empire: no, no no nonono... Jamie "knows" Daniel - if he was gay she'd know because he is her BEST and ONLY friend... Ana, unknowingly adding fuel to the fire, says no, it is true - that's how she and Daniel met, when she was a senior and he was a sophomore - they thought they were the only 2 gay people under 35 on the planet and made each other feel normal by being around each other. Jamie completely loses it, hearing the truth of Ana's words and realizes how much she's deluded herself - Daniel is no more her best friend than he is her brother. She doesn't know him at all and she's just made it all up in her head to convince herself she's not alone. Denials the ultimate expression of what she's done with the goth kids in the club.

Ana, seeing her mistake, and becoming really scared by how much worse she's making things with each new thing she says, tries to comfort her, giving her her phone number, saying she can call if she needs to talk. She tries to get her to come back to see Daniel, but Jamie won't and runs away crying.

1 For me, creating a comic is a very organic, flexible process – every single rule and trick I describe, I have broken more than once when I felt it was appropriate. None of this is exactly how I work, all the time; but this is generally how I work.

First off, I don't write a traditional script. I write in two media pretty much simultaneously, and not as a complete script; since I'm the one who'll be drawing it I reckon I can pretty much just do what feels right to me.

I start with a raw plot document – a detailed synopsis. This is the sweep of the story, what scene follows what, etc. This I bang out in Notepad on my computer. I don't worry about spelling or whether or not it's all perfect, and I don't emotionally attach myself to the idea that what I'm writing, in terms of scenes or dialogue, need be exactly what I put in the finished comic.

2 Next I move to my sketchbook. I draw a line down the middle of the page; the left-hand side will be thumbnails for a couple of pages based on the page breakdowns from the printout; the right-hand side is where I rough out the dialogue. Doing storyboards and dialogue at the same time helps me put the characters' physical 'acting' in sync with what they're saying and gives me a better idea of how much space I have for pictures and how much I need to leave open for dialogue or narration balloons.

Visualization for me is how I write – I see the story unfold like a little film in my head. There are (gosh, this'll get me committed) little voices in my head that act out the entire story. If it's a particularly intense scene, this can be very jarring; it's like getting yourself into character as an actor, like method acting. I retreat inside my own head, and there's this whole other world. Once I get it kick-started, it just kind of goes on its own.

a strand of lanterns

3 I draw *Nowhere Girl* at actual size on 8.5" x 11". This makes scanning easier for me. I start drawing in non-photo blue pencil. I can be as rough and sketchy as I like with this, as when I scan the page, it won't pick up any of the blueline.

4 Next, out come my mechanical pencils. I generally have a .5 and a .7 for thicker lines. I draw in all the frames on the page and do my finished pencils. I make my pencils as clean as possible, treating them as if I were inking the page. I have an electric eraser for erasing fine details, since I work on relatively small pages.

I try not to leave any gaps when I'm drawing shapes. I connect all the lines together, giving the finished line work a 'colouring book' kind of look (and a 'colouring book' is in essence what I'm making, since I'll be colouring the whole thing in Photoshop later on, so I want to make sure my drawings make the colouring process as easy and quick as possible). This sacrifices some of the fluidity of the artwork, and might not look as good, but it makes my rendering work a lot easier later on. And once the drawings are rendered, the line work recedes in importance for me anyway.

5 While doing my second issue of *Nowhere Girl*, I found myself needing to reuse complex backgrounds. There were certain panels that were much easier to draw on tracing paper rather than straight onto the finished pages. In Photoshop I work with layers, so this is kind of a physical, paper-driven version of using layers.

On the pages I still draw the spot that the 'layered panel' will appear in; I just leave it empty and tape a piece of tracing paper over the top, and then tape them both to my lightbox so that the existing line work will show through the tracing paper. I draw an extra half-inch around the background so that, when I composite it, there's no chance that it will be slightly too small.

The next big step for me is scanning everything. I scan into Photoshop as 300ppi, black and white, 50% threshold bitmaps. This will take only the whitest and blackest pixels in the image, so all the non-photo blue pencil work I did earlier will not scan. To scan the elements I've drawn on tracing paper, I cover them with a piece of blank white paper on top so that the scans come out as clean as possible.

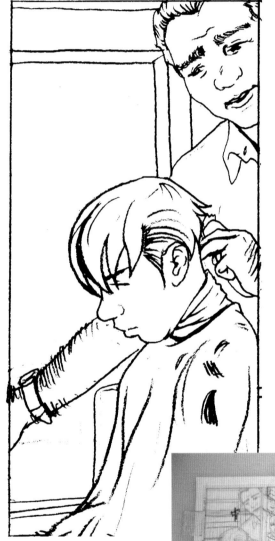

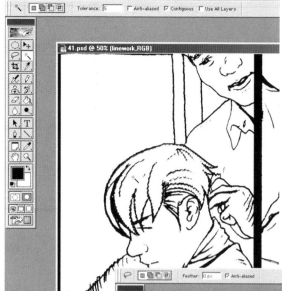

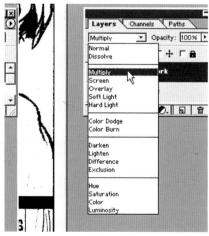

6 Now I've got the images in my PC. Because I'm not inking my work, there are inevitably small areas of white, sometimes just a pixel or two, that break up the black line work. I use the *Pencil* tool in Photoshop to touch up the images.

The next step is cropping every finished page so that each will be the same size. I use a separate file that's set to the correct size, and one at a time I copy and paste each scanned image into it, position the art relative to the edges of the image, and then save each as a new file.

Now it's time to start colouring – I can't colour in black-and-white bitmap mode, so I need to change the mode of the image to RGB (going to *Image > Mode > Grayscale* then *Image > Mode > RGB Color*, because you can't jump directly from Bitmap to RGB in Photoshop).

7 I render a page with two main layers: one for line work (the black-and-white line work I scanned in), which is on top of the layer I'll actually colour on. If needed, I'll have a third layer above the line work that will be for special effects that would realistically obscure parts of the line work.

To set up my layers, I rename the *Background* layer as 'linework' and I create a new layer (which I name 'colours') and drag it underneath 'linework'. I set the layer mode of 'linework' to *Multiply*, which keeps the black line work opaque but makes the white areas transparent.

8 I then use the *Magic Wand* tool to select areas of the 'linework' layer (this is when having filled in any gaps in the line work before starting to colour becomes really handy). My *Magic Wand* settings at this point are: *Tolerance*: 32px; *Anti-aliased*: unchecked; *Contiguous*: unchecked; *Use All Layers*: unchecked.

After I've made a selection, I select the *Colours* layer and fill the area with a flat colour. On some pages it may be advantageous for me to have more than one layer for colours; for instance, I may choose to lay down all the flat colours for the characters on one layer, to keep the characters separate from the backgrounds and make it easier to reselect them later when I add shading.

9 Here we come to what is for me probably the most labour-intensive part of making a comic: the rendering – shading, detailing, and making the art look finished. It's easy (for me anyway) to get lost in the rendering. Photoshop is a tool for photo manipulation, so it's possible, if you have the talent, the skill, and the time to render something to the point where it's photorealistic. Figure out what level of realism versus abstraction you want, and go from there. For my money, I aim towards an animation style: richly detailed backgrounds and abstracted, simple-looking characters.

When rendering something in the foreground (either a character or object), I'll generally want a shadow or highlight with a hard edge to it, so I'll use the *Magic Wand* again. This time I use the *Wand* on the *Colours* layer, selecting the areas of flat colour I created earlier. By holding down Shift and clicking on different parts, I select multiple areas at once (for instance, if I want to apply the same shading to someone's trousers as well as to their shirt).

10 I then select the *Lasso* tool, and, while holding down the Alt key (which causes the *Lasso* to subtract from selected areas), I draw the shape of the area I don't want to alter. When done, I am left with the area to be rendered. This is where it gets really organic: I may want to shade using the *Gradient* tool (usually an opaque colour to transparent) or do *Image > Adjust > Hue/Saturation* and play with the settings there.

You can render until your eyes are bleeding, but take into account that even though you can magnify your image to colour small areas up close, no one else is going to see them that way. In an obsessive-compulsive's version of a 'moment of clarity', I rendered the license plate, complete with correct state colours, on a tiny little car in the background of one page of *Nowhere Girl* part 2. When I went to save the page, looking at the whole thing at actual size, of course the beautifully done licence plate was too small to be seen!

11 Now I have to bring in the backgrounds that I've set up to be reused multiple times. I render these individual panels separately from the rest of the pages that they'll be used on, and then I duplicate the file and flatten it, select all, and move back to the page that the background will appear in. I then select the empty panel area using the *Magic Wand* tool and do an *Edit > Paste Into* (Shift+Ctrl+V). Voilà! The page starts to come together.

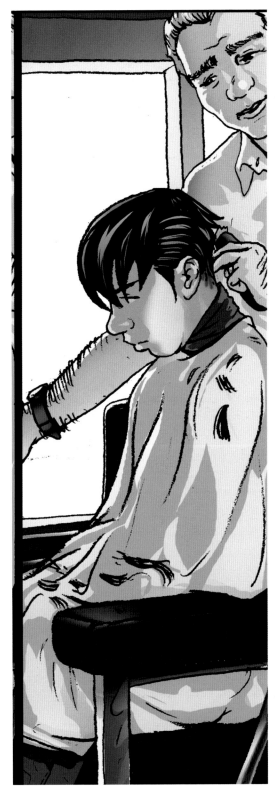

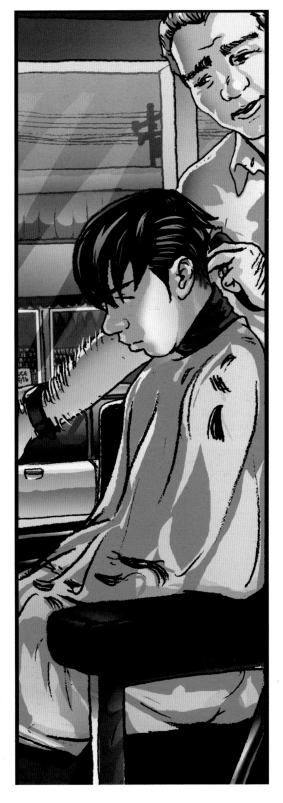

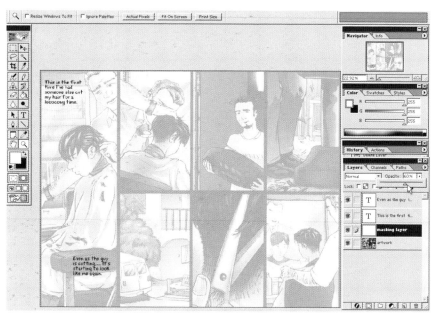

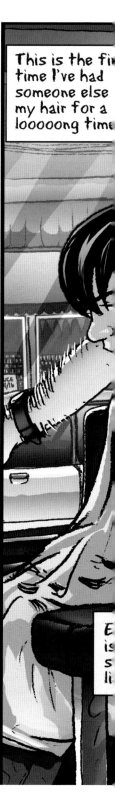

12 Now we come to the lettering. I letter after all the artwork is finished. I take the finished Photoshop file, duplicate it, and flatten the duplicate. Next, I create a new layer that will serve as a 'mask' layer. I fill it entirely with white and then turn the opacity down to help me see the lettering that I'm about to type, but still have enough of the artwork visible to position the balloons where I want them.

If I have typed up a version of my dialogue, I can open up that file and start copying/pasting from the file into the *Text* tool in Photoshop. I then align the new text (centre-aligned for dialogue; left-aligned for narration) using the *Character/Paragraph* palette.

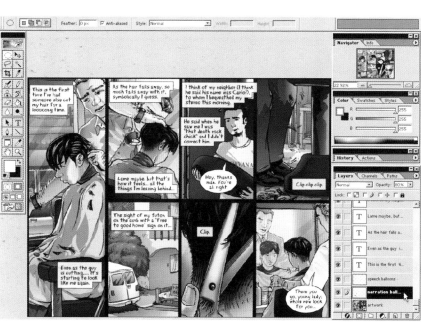

13 When I've got all my text ready and placed about where I want it, I create another new layer beneath the text for making word balloons. I use the select tools to select either oval or rectangular shapes for the balloons themselves, using the *Lasso* tool to add the portions of the balloons arrowing out to the character speaking. Then I fill the whole thing with white, and with the same selection still selected, *Edit > Stroke* the outside of the balloons with three pixels of black.

Next I resize the image for the Web, changing the resolution from 300 to 72ppi. If the image looks slightly blurry after sizing it down, I apply an *Unsharp Mask* filter: *Filter > Sharpen > Unsharp Mask* with the settings: *Amount*: 50%; *Radius*: 1.5 pixels; *Threshold*: 0 levels (you may want to play around with these values, but you don't want it to sharpen much more than a 1px radius).

14 Then I go to *File > Save For Web*. I use JPEGs saved as *Medium* quality (around 33%), with *Progressive* and *Optimized* both checked. This gives me images around 100KB in size, down from an original file size of anywhere between 20 and 60MB (100KB is still pretty big for a webpage, but if I take it any smaller, the text in my word balloons is not legible). Presto, a Web-ready image. Ready for upload via FTP.

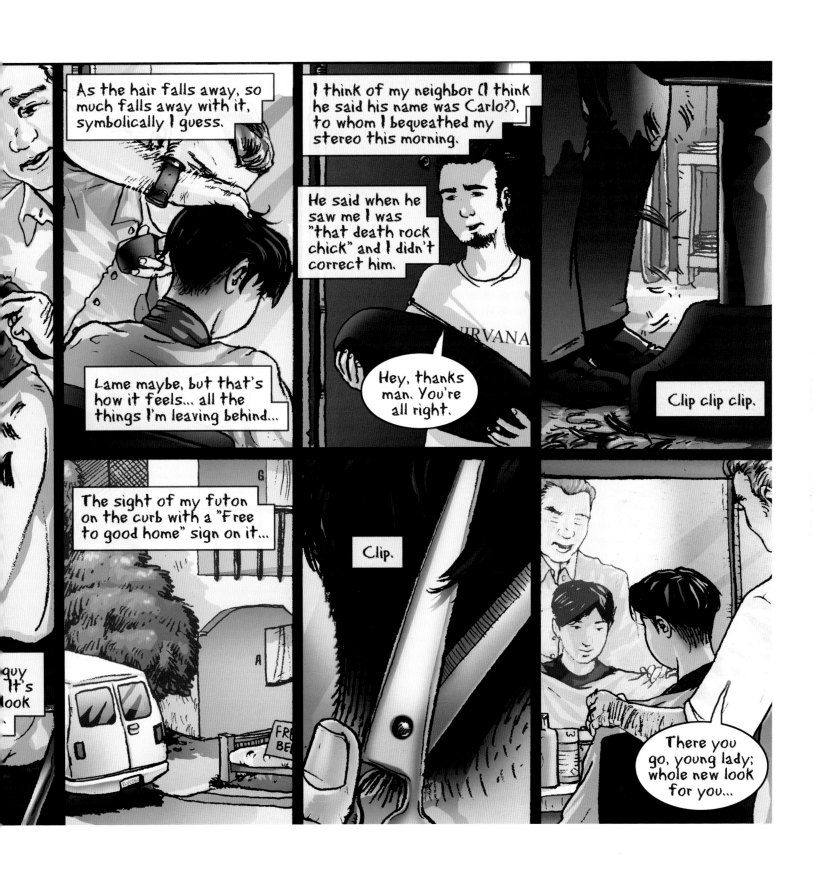

WEB FILE TYPES

Once you've finished colouring and lettering your comic, it's time to export a Web-ready version. Step one is to flatten the image, if it has layers, and resize it to the final pixel size you want it to appear on screen (if you resize before flattening, edges of lower layers might sneak out from under layers that were covering them). Make sure you keep your unflattened, full-size original, in case you ever want to change something!

Your file should be set at 72ppi resolution (though many imaging programs will automatically set this when you Export for Web). You'll be saving your comic in one of four formats: GIF, JPEG, PNG-8, or PNG-24. These four choices are much, much smaller than other formats (such as BMP or TIFF, which are not intended for Web use). They get smaller by compressing the image in different ways.

GIF and PNG-8 both use 8-bit indexed colour. This means they allow for up to 256 colours in a single image, and they compress solid areas of colour for smaller file sizes. PNG-8 uses more advanced compression methods, which may result in smaller file sizes, but the format isn't supported by all browsers.

These file types work best for images with flat colour, with little or no gradation. They also allow for transparency, which is good if you want, for instance, a figure to break out over your website's background. GIFs also allow you to create looping animations, which are good for pushing the boundaries of what can be considered 'comics'.

JPEGs allow for a much wider range of colours (about 16 million colours) but lower file size by throwing out image information. You can control the amount of information that's thrown out by adjusting the image quality – the better looking the image, the higher the file size, so there's a delicate balance.

PNG-24 gives the colour range of JPEGs but with 256 degrees of opacity – images can be semi-transparent, allowing for fades and anti-aliased edges. But PNG-24s tend to be much larger than JPEGs. Also like PNG-8s, not all browsers recognize them. PNG-24s are excellent for importing into Flash, which can apply its own JPEG-style compression to PNG-24s, giving you the transparency options of a PNG-24 and the file size of a JPEG.

The rule of thumb to remember is that for images with flat, solid colours, use a GIF or PNG-8, and for images with graduated tones, use a JPEG.

A JPEG is the best image format for continuous-tone images like this digital painting by L.J. Ruell (www.digi-digi.net).

This is the same image saved at a low quality. The smoother and more pristine the JPEG, the larger the file size.

For a continuous-tone image, a high-quality GIF (like this one) can come close to a JPEG's quality, but will often have a larger file size.

A smaller, lower-quality GIF will often produce visible banding in gradients.

Smoother colour transitions can be simulated by using dithering, but this often produces dotting in solid colours.

A PNG-24 allows you to have a smooth, continuous-tone image with transparency.

a strand of lanterns

WEB DOMAINS

Before you post your webcomic, it probably goes without saying that you need somewhere to post it. You need a website.

There are lots of free webhosting services (such as www.geocities.com or www.angelfire.lycos.com) that can provide homes for your webcomics. Alternatively, a quick Internet search can provide hundreds of possible hosts that charge monthly or annual rates. Free services tend to have bandwidth limits, meaning that if too many people visit your site, it will (temporarily) shut down. Most pay services also have bandwidth limits, and depending on what you agree to, they may shut down your site or charge you for bandwidth overages. Be careful to read what you agree to! Not all hosts are created equal, so be wary of signing a long-term agreement with a host you're not familiar with – you never know if the host will have inferior servers (which will cause your comic to load more slowly) or frequent outages (causing your site to be down).

www.keenspace.com is a popular, reputable site dedicated to hosting webcomics for free. There is a large community of *Keenspace* creators and readers who are already extremely interested in webcomics. Additionally, *Keenspace* has built-in automations for updating your comic, which is extremely helpful if you aren't a Web whiz and if you update frequently. *Keenspace* runs banner advertisements on all its pages; that's how they make money. You have no control over the content of these ads.

www.webcomicsnation.com is another option for hosting webcomics; there are no advertisements (unless you want to sell ad space yourself), but the hosting costs money. *WebcomicsNation* has many features that help artists with no Web background organize and format their sites, but the price is steeper than most webhosts who don't provide those services.

Some hosts will allow you to register a domain name through them – this is where you get 'www.YOURNAME.com' instead of 'YOURNAME.keenspace.com'. You register domains for a limited duration (a year, for instance). If you register a domain name through your host, you will have to renew the domain through that host, even if you change hosts down the line. You can also register a domain through www.networksolutions.com and set your domain name to point to the IP address of your site (which your host will provide you).

Some hosts (particularly the webcomics-based ones) will have special ways of allowing you to upload your files. Others will provide you with an FTP address, username, and password. Internet Explorer can act as an FTP program, and newer Macintosh computers can do this through the Finder, but there are other FTP programs available for free or for sale. These programs copy your files from your computer to your host.

Most FTP programs allow you to simply drag-and-drop files from folders representing your computer to ones representing your host. Unless you're using *Keenspace* or *WebComicsNation*, you'll usually create your entire website on your computer (where only you will be able to see it – and where you can make sure everything works) and then upload the site via FTP.

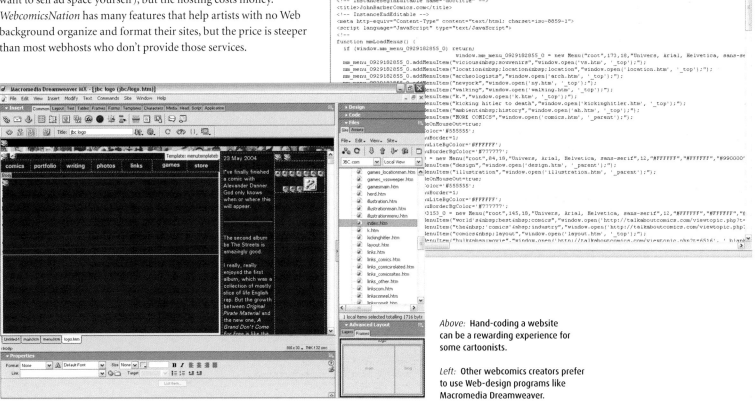

Above: Hand-coding a website can be a rewarding experience for some cartoonists.

Left: Other webcomics creators prefer to use Web-design programs like Macromedia Dreamweaver.

#THREE

STELLAR CARTOGRAPHY

We've entertained the notion that each webcomic is a sort of lighted lamp in the dark. To carry the metaphor a step further, and taking a telescopic view, we might imagine all the webcomics in existence to be constellations of stars, appearing and disappearing at every moment. Mapping the total mosaic of stars is on-going work, but in the meantime we can enjoy as many as we can of these messages that travel by light.

In this section we'll meet eight more webcartoonists (two of whom are a team). You will find that many of these later workthroughs are more complex compared with those in the last section, as are the technical pieces that accompany them. But no matter your level of skill or experience, you should find techniques that are worth emulating, or simply admiring. To round off the section, we showcase artwork from 21 talented webcartoonists in our Webcomics Gallery.

CHARLEY PARKER

When Charley Parker launched *Argon Zark!* in 1995, he noted that the emerging Internet was devoid of worthwhile comics material beyond reprints or retreads of newspaper funnies. Along with other digital pioneers such as Steve Conley and Scott McCloud, Charley has been taking full advantage of the Internet as a medium for comics. His experimental techniques – incorporating a range of digital tools for drawing, creating effects, and animating – have earned him a place of esteem among webcartoonists worldwide. His solo site, *Zark.com*, remains a valuable resource for beginning and established creators.

stellar cartography

When and how did you begin creating comics?

I was born and grew up in Claymont, Delaware, in a house a few hundred yards from the house of O.C. Darley, the father of American illustration. The area is part of the Brandywine Valley, home to Howard Pyle, N.C. Wyeth, Elizabeth Shippen Green, and many other of the great American illustrators, so I got exposed to some great stuff early on. When I was 12 or 13, I started doing *Mad Magazine*-like parody comics for my friends and myself.

When I was in my twenties, I started trying to break into the comic book industry. I did a few comics for a small company (Dagger) but never worked for the majors directly (I did some work for Marvel's *FOOM* magazine).

When did you first post your work online, and what attracted you to webcomics?

I posted the first *Argon Zark!* page in June 1995. As far as I can tell, it was the first comic created specifically for the Web. When I was introduced to computers and the Internet the previous year, it just seemed like a natural thing to 'publish' a comic on the Web. I started looking for some kind of comic on the Web that I could use as an example, but I couldn't find anything.

I was amazed because it just seemed like a natural match to me. There were comics posted, but they were mostly scans of newspaper comics that had been posted as GIF files, the way you might tape one up on your refrigerator. Without anything to use as a guide, I reckoned I'd just have to dive in and make it up as I went along. The browsers were so crude at the time (Netscape 1 had just come out) that I had to tell people how to download a plug-in just to view JPEG images. As new technologies appeared on the Web, like animated GIFs, JavaScript, dynamic HTML, and Flash, I started incorporating them into the strip.

Argon Zark! now has one print edition. The first complete story was collected and published in 1997. There is also a print collection of my dinosaur cartoons from *Asimov's Science Fiction* magazine and elsewhere.

Which webcomics or webcartoonists do you read regularly or recommend highly?

Scott McCloud, Steve Conley, Peter Zale, Pete Abrams, J.D. Illiad Frazer, Cat Garza, Gareth Hinds, Patrick Farley, Jim Zubkavich, Mike Manley, John Heebink and Link Yaco, Kazu Kibuishi, Derek Kirk Kim, Jason Little, Jenn Manley Lee, Nitrozac and Snaggy, Gerry and Vicky Mooney.

Briefly describe *Argon Zark!*

Argon Zark! is a multilayered, interactive webcomic about a computer geek, his personal digital assistant (read: robot) Cybert, and his friend Zeta Fairlight, as they are physically transported around the Internet via Argon's invention of PTP, Personal Transport Protocol. The current storyline has them encountering Pharaoh Portal, the online avatar of a hyper-rich megalomaniacal software magnate, and the virtual council of 'The Nine or Ten Guys Who Secretly Run Everything'.

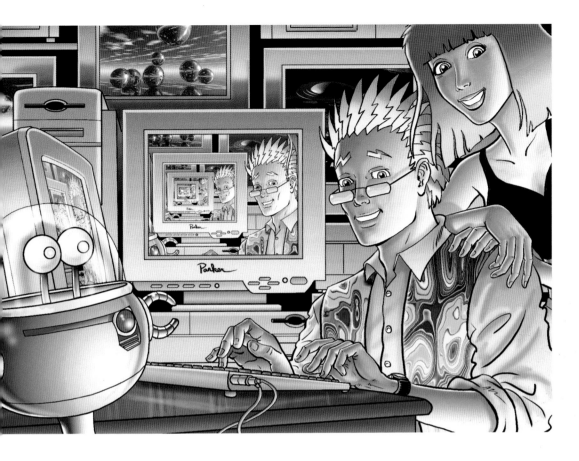

HOME: NEAR PHILADELPHIA
URLS: ZARK.COM, CPARKERDESIGN.COM, DINOSAURCARTOONS.COM
EDUCATION: THE PENNSYLVANIA ACADEMY OF THE FINE ARTS, THE DELAWARE ART MUSEUM SCHOOL, THE FLEISHER ART MEMORIAL, THE PHILADELPHIA SKETCH CLUB, AND THE PLASTIC CLUB
CURRENT OCCUPATION: MACROMEDIA FLASH TEACHER, DELAWARE COLLEGE OF ART AND DESIGN; FREELANCE WEBSITE DESIGNER/ILLUSTRATOR/ (WEB) ANIMATOR

ARTISTIC INFLUENCES:
COMICS: HARVEY KURTZMAN, WALLY WOOD, JACK KIRBY, MOEBIUS
ILLUSTRATION: N.C. WYETH, HOWARD PYLE, JOSEPH CLEMENT COLE, FRANKLIN BOOTH, VIRGIL FINLAY, BOB WALTERS, KARL KOFOED
ART: REMBRANDT (THE DRAWINGS), JOHN SINGER SARGENT, VERMEER, MAX ERNST, DALI, MAGRITTE
FILM: *FANTASIA, FORBIDDEN PLANET, 2001: A SPACE ODYSSEY, RAIDERS OF THE LOST ARK, STAR WARS* (THE ORIGINAL), *THE MATRIX* (THE ORIGINAL)
ANIMATORS: MAX FLEISHER, CHUCK JONES, TEX AVERY, HAYAO MIYAZAKI, KATASUHIRO OTOMO, MASAMUNE SHIROW
LITERATURE: PHILIP K. DICK, A.E. VAN VOGT, WILLIAM GIBSON, NEAL STEPHENSON, LEWIS CARROLL, ANDRÉ BRETON, THOMAS PYNCHON, TOM WOLFE, TOM ROBBINS, KEN KESEY

What are some of your long-term goals for your work?

I'd like to continue my exploration of the intersection of comics, digital art, and Web technology. I think interactive digital comics could eventually occupy their own space, somewhere in between games, animation, and traditional comics, as a major form of entertainment.

How often do you post new comics material on the Web?

Once a month if I'm lucky, several months apart if I'm too busy making a living to have the time to work on *Zark*.

Your strongest skill as a webcartoonist? Your greatest challenge?

My strongest skill is that I'm a jack-of-all-trades. I can write, draw, and colour; I'm proficient in multiple computer graphics media; and I'm enough of a Web geek that I can write all of my own HTML, JavaScript, and Flash ActionScript, so I have complete control over every aspect of the strip and its presentation. I'm in my natural element on the Web; and so is *Argon Zark!*, both as a digital comic and as an interactive multimedia crossbreed.

The downside is that, since I do all of it myself and I tend to be playful with the technical side, it takes me a long time to do a page, with all of its attendant rollovers, animations, subpages, and so on.

My greatest challenge is making some income from the site so that I can devote more time to it and update more frequently.

CHARLEY PARKER WORKTHROUGH

STORY OUTLINE

I usually work from a very rough text story outline that I refine as I'm working on the page. Since I both write and draw, I don't do a polished script.

Page 72:
Panel 1: Downshot. Argon typing on Cybert's keyboard – still calculating answer to Zeta's question about being harmed by web robots while they're physically in the web. He 'gets it'.
Panel 2: Argon says yep, goes on and on about it. Zeta is looking behind him out window of space station, trying to get his attention.
Panel 3: Argon: 'Pretty cool, huh?'
Zeta: (still looking past him out window): 'Well...'
Panel 4: Upshot. They both look up and back at window. Cancelbots manifest outside window, and the lead one transitions through, just about to step on them.
Zeta: 'That depends...'

THE FILES

1 ROUGH SKETCH
I draw the entire comic on the computer using a 6 x 8 Wacom tablet. I rarely do thumbnails any more because drawing on the computer is so flexible. I do a full-size rough sketch directly in Corel Painter, using a custom variant of Painter's *2B Pencil* tool that I set to an opacity of 6% and call my '2H Pencil'. I use the pencil and eraser tools much as I would the 'real-world' tools, except that when drawing on the computer I can copy, select, move, delete, undo, flip, transform, and magnify while I'm drawing. I love it.

2 FINAL PENCILS
I changed panel 2 in the process. Since I do my own inks, I don't do 'pretty' pencils. I can also do a fair bit of my drawing in the inking phase rather than slavishly following the pencils. I can get away with this both because I ink myself and because digital inking allows me to revise my 'ink' drawing as much as I like. I sketch in placements for the balloons while I'm doing the pencils, so I have a good idea of how much room I have in the panels.

3 PANEL BORDERS AND PRELIMINARY LETTERING
I create the panel borders with vector line tools in Painter. I lay in the lettering very early (sometimes a preliminary version) so that I can draw the balloons early and know exactly where my drawing stops. (Much nicer than doing a finished panel and having the writer and letterer cover up the drawing with dialogue.)

HARDWARE:

Mac Dual-450 G4, 1 GB RAM
Mitsubishi Diamond Pro
1010e 21" monitor
Wacom Intuos 6 x 8 tablet

SOFTWARE:

Mac OS X 10.2
Corel Painter 8
Adobe Photoshop 7
Corel KPT filters
Macromedia Flash MX

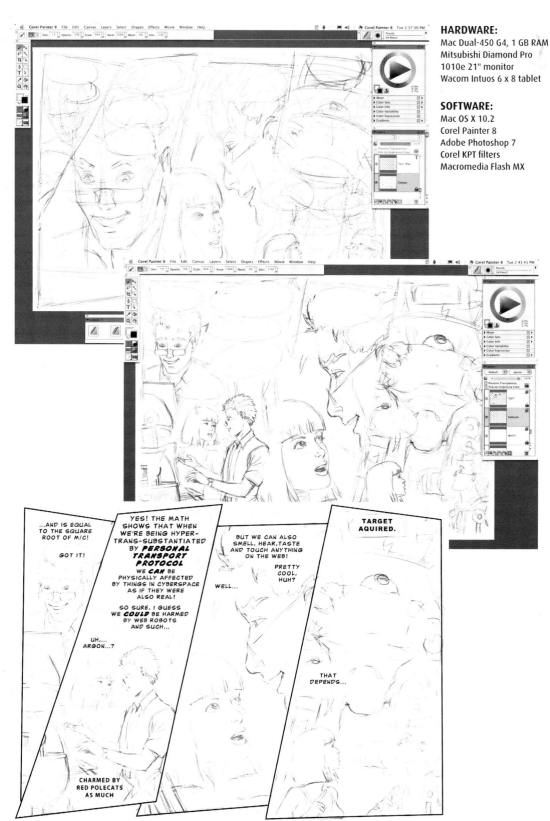

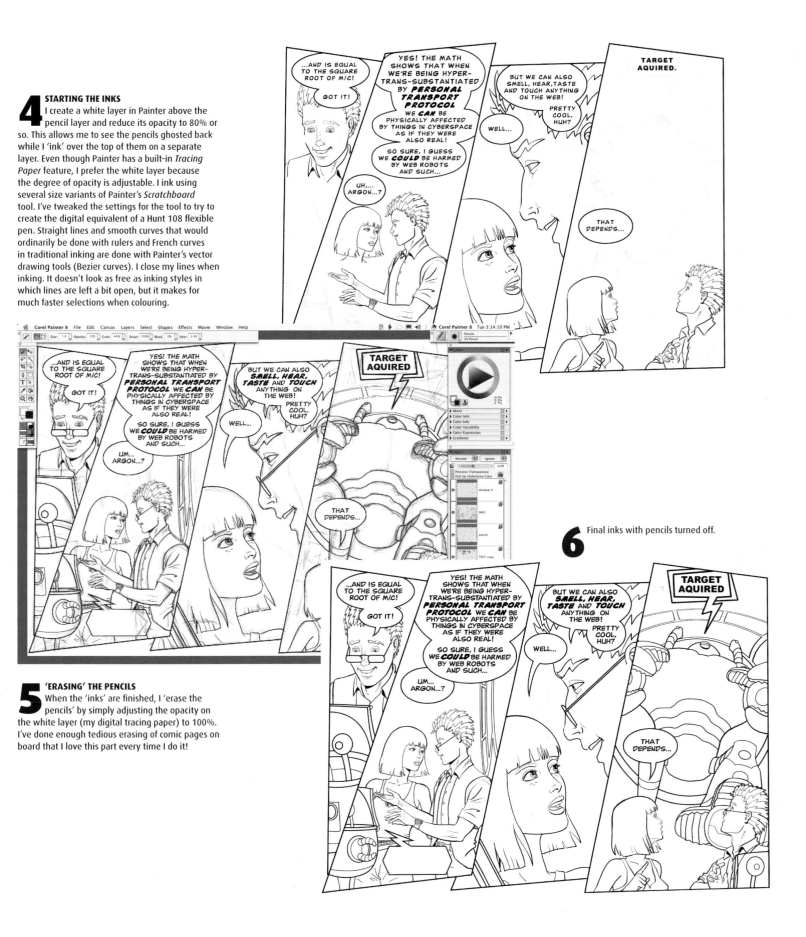

STARTING THE INKS

4 I create a white layer in Painter above the pencil layer and reduce its opacity to 80% or so. This allows me to see the pencils ghosted back while I 'ink' over the top of them on a separate layer. Even though Painter has a built-in *Tracing Paper* feature, I prefer the white layer because the degree of opacity is adjustable. I ink using several size variants of Painter's *Scratchboard* tool. I've tweaked the settings for the tool to try to create the digital equivalent of a Hunt 108 flexible pen. Straight lines and smooth curves that would ordinarily be done with rulers and French curves in traditional inking are done with Painter's vector drawing tools (Bezier curves). I close my lines when inking. It doesn't look as free as inking styles in which lines are left a bit open, but it makes for much faster selections when colouring.

'ERASING' THE PENCILS

5 When the 'inks' are finished, I 'erase the pencils' by simply adjusting the opacity on the white layer (my digital tracing paper) to 100%. I've done enough tedious erasing of comic pages on board that I love this part every time I do it!

6 Final inks with pencils turned off.

CHARLEY PARKER 2

7 STARTING COLOURS
I often move into Adobe Photoshop when colouring (or jump back and forth between Photoshop and Painter) because Photoshop's selection tools are still quicker and easier to use than Painter's. I lock the 'inks' layer and start my colours on a new layer below that. I use the *Magic Wand* tool set to *Use all layers* to make quick selections. This lets me make selections within the 'inks' layer's lines while applying colours on the 'colours' layer below it. I alter the selections with the *Lasso* tool or *Quick Mask* mode, which allows me to use the painting and erasing tools to modify the selection.

I usually start by filling the selected areas with gradients, often using *Darken* or *Lighten* mode to add multiple gradient passes to one area. I then modify the colours with painting tools, using multiple passes of low-opacity brushes. I sometimes use the *Blur* tool or *Smudge* tool to blend colours and the *Dodge* and *Burn* tools to alter tones. I also select areas and vary their hue and saturation or levels with the colour adjustment controls in Photoshop or Painter. When I want a more painterly approach, I'll move into Painter and use various oil or watercolour brushes.

8 SELECTION OF CANCELBOT IN PHOTOSHOP'S
QUICK MASK **EDITING MODE**
In this panel I wanted a second cancelbot outside the window behind the first. Rather than draw a second bot, I copied and composited the first one. In this view, I selected the finished inked and coloured image of the main bot.

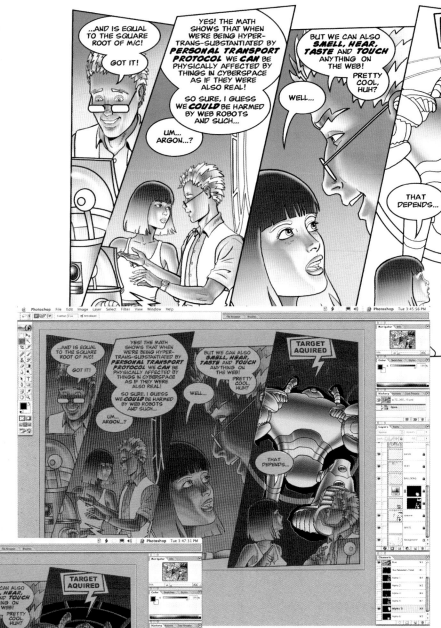

9 COMPOSITING THE SECOND BOT
Selection shown in *Quick Mask* mode.
By temporarily turning off the 'colours' layer, I can easily make selections in the 'inks' layer again. In this case I created a selection of the 'space' area behind the window, cancelbots, and figures, and composited in the copied selection of the original bot using the *Paste Into* command. I reduced the pasted image in size with the *Free Transform* tool. I then added an adjustment layer to darken the second bot and knock it back.

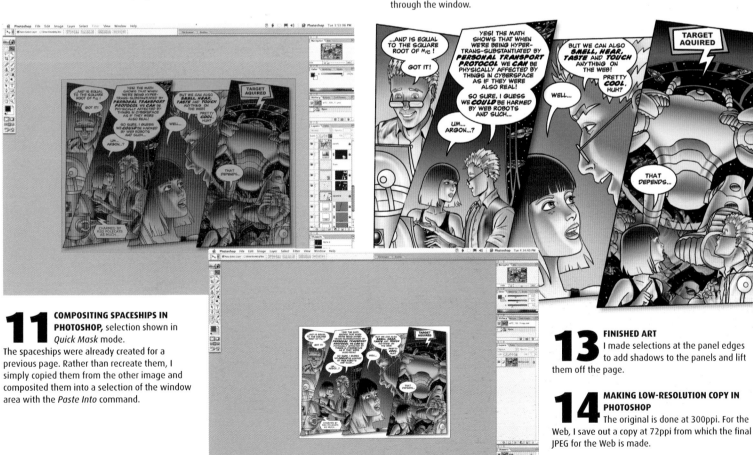

10 USING KPT GRADIENT LAB FILTER TO ADD DESIGN TO ARGON'S WAISTCOAT
Argon's waistcoat is filled with a pattern that is different in every panel, usually created with one of the KPT filter plug-ins.

12 *ZIG ZAG* FILTER IN PHOTOSHOP
A selection was made of the window and second bot behind the main bot, and the Photoshop *Zig Zag* filter was applied to give the appearance of the main bot transitioning through the window.

11 COMPOSITING SPACESHIPS IN PHOTOSHOP, selection shown in *Quick Mask* mode.
The spaceships were already created for a previous page. Rather than recreate them, I simply copied them from the other image and composited them into a selection of the window area with the *Paste Into* command.

13 FINISHED ART
I made selections at the panel edges to add shadows to the panels and lift them off the page.

14 MAKING LOW-RESOLUTION COPY IN PHOTOSHOP
The original is done at 300ppi. For the Web, I save out a copy at 72ppi from which the final JPEG for the Web is made.

FLASH

I use Flash to create interactive features in my recent pages. (I used to use dynamic HTML and animated GIFs before Flash became popular.) I'm pretty conservative about not forcing the user to download a plug-in or choose between versions to view the pages.

I place the SWF (Flash movie file) into an HTML page using the Flash MX template for *Detect for Flash 5*. This contains a JavaScript that queries the browser for the installed version of the Flash Player. Failing to find the Flash Player version 5 or above, the script will substitute a static image, in this case a JPEG version of the page, for the Flash file. If JavaScript is turned off in the user's browser and the script can't run, the NOSCRIPT tag will also substitute the static image.

15 **IMPORTING JPEG INTO FLASH**
I used to build complex DHTML layers of transparent animated GIF rollovers to add interactivity to the pages. These days I usually add a layer of animation to the image by importing the JPEG into Macromedia Flash, adding a Flash animation layer, and saving the page out for the Web as a Flash SWF. The animation is set to trigger when the user hovers their mouse over the page.

16 **FINAL IMAGE IN WEB BROWSER**
The final image is placed in the webpage as a Flash SWF, including a small preloader and the added animation.

17 **SECONDARY PAGE IN WEB BROWSER**
The image is also usually linked to a 'hidden' secondary page, in this case a parody of recent Microsoft ads featuring a cancelbot being empowered to be 'creatively' destructive, and a little poem in programming syntax. This image was composited from a previous image of a cancelbot and a background made from a stock image manipulated with various filters.

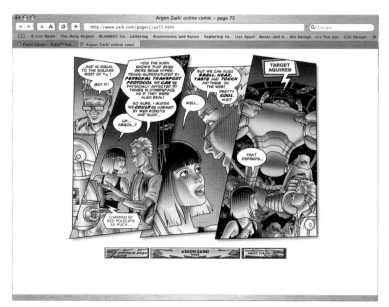

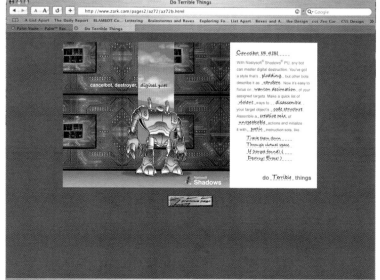

PAGE SIZE

The *Argon Zark!* comic pages have always been designed to fit in a browser window rather than on a printed comic page. They are sized to be viewable in 800 x 600, but they actually work best in 1024 x 768, which allows the navigation buttons to be seen.

With some variation, I've maintained the same general size for the sake of consistency. Most of the pages are about 612 x 459. Page 72 is 728 x 523 pixels, which is stretching things a bit for 800 x 600.

COMPRESSING IMAGES

I create my pages at high resolution (300ppi) so they are suitable for printing, and save out a copy for the Web at 72ppi. I use the Photoshop *Save for Web* or Fireworks *Export Preview* to compress the images for the smallest possible file size without sacrificing image quality. In image editing applications without previews, experiment with the settings and compare the results. If the pages take too long to download, your readers may lose patience with them.

CREATING HTML PAGES

You don't need a lot of high-end HTML software to create webpages. I write my HTML in BBEdit, which is basically a high-powered text editor for the Mac. If you want a fully-fledged, professional-level HTML editor and site management program, the best ones are Adobe GoLive and Macromedia Dreamweaver. I use Adobe GoLive for site management. It allows for easy rearranging of directory structures without tedious search-and-replace and file renaming.

I don't recommend Microsoft FrontPage. It generates non-compliant code, adds unnecessary file size, and can make your pages unreadable in many non-Microsoft browsers. There are also a number of good, inexpensive shareware HTML editors. Check www.download.com, www.tucows.com, or www.versiontracker.com.

You should also look for a good shareware FTP application, if you don't have one, for transferring your files to the server. BBEdit, GoLive, and Dreamweaver have FTP applications built in. I prefer a dedicated FTP app, though, and use Captain FTP to upload my files. It also allows me to easily open a file from the server and edit it directly in BBEdit.

Equipment and Costs

It's not necessary to have the latest and greatest equipment to do good digital comics. The first 30 or so pages of *Argon Zark!* were done on a faithful little Quadra 610 with a 25MHz processor, 250MB hard drive and 16MB of RAM with a 15" Sony monitor. It's easier on a modern, high-powered system, of course, but the point is it's not necessary. Similarly, while Painter and Photoshop are my tools of choice for creating comic pages, you can use much less expensive alternatives like Paint Shop Pro on Windows and ColorIt on the Mac. You can write HTML in Notepad or SimpleText and post it with a freeware FTP application.

If you want to draw directly on the computer, a Wacom tablet is a must. The small Graphire model is relatively inexpensive and works well.

I set the original size at a time when Web browsers (Mosaic and Netscape 1) had less 'browser chrome', the extra toolbars, favourites bars, and so on that have gradually eroded vertical screen space in the browser window. With some variation, I've maintained the same general size for the sake of consistency. Most of the *Argon Zark!* pages are about 612 x 459.

If you must have a format that will allow printing your comic in traditional 6" x 9¼" comic book format, consider splitting your page in half: making it 6" x 4½". Half a printed comic book page makes a reasonably horizontal webcomic format. The *Zark* pages would work this way, although I prefer them printed the way they were meant to be viewed on the screen.

Comic Book Fonts

These days, you don't have to hire a professional letterer to put in the dialogue. You can buy professional comic book fonts on the Net. See www.comicbookfonts.com for the high-end, and www.studiodae.com/whizbang.html and www.blambot.com for less expensive alternatives.

Design Your Site

Learn enough about Web design to create a site or get someone else to create your site for you. A good book on basic HTML and site creation is *HTML for the World Wide Web, a Visual QuickStart Guide* by Elizabeth Castro.

If you tackle it yourself, try to learn a little bit about good site design in addition to learning enough to put your images into HTML pages. An excellent book on designing usable sites is *Don't Make Me Think* by Steve Krug.

All images: From Charley Parker's website *Zark.com*.

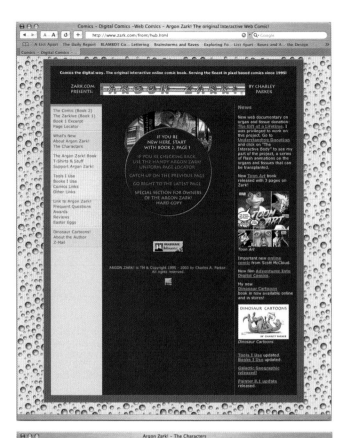

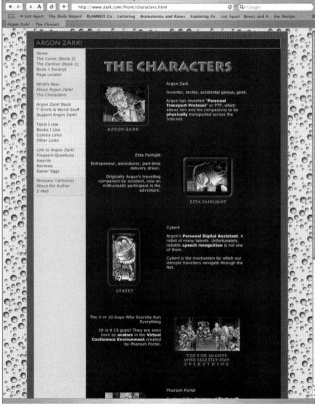

Provide a clear, simple introductory page that tells visitors what your site is about and shows a clear link to the comic. Resist the common temptation to put six million things on the homepage! Provide links to more information, but keep the homepage as simple and clear as possible. If you have to have a lot of news and info (as I do), organize it away from your main entry to the comic. The more you have competing for the users' attention, the less they'll see. Make it confusing enough and they'll click away before even looking at your comic.

Ideally, create an 'About' page that introduces your characters and the general premise of the comic for potential readers who only have a few minutes to decide whether or not to read your story.

It's extremely important to provide your visitors with simple, consistent, easy-to-understand navigation. If they get lost, they'll go away. Provide a link to your hub or homepage from every page.

Ideally, provide an index page from which visitors can easily navigate to any page. I have a graphical 'Page Locator' that uses thumbnail images of the pages. It's extra work, but my readers say they like it.

Promotion

Optimize your pages for search engines. Take a look at the site www.searchenginewatch.com for info. Try to get your site listed on other sites about comics. Swap links with other comics creators and fans. The best advertising is good word of mouth from people who like your work, but you have to get them there in the first place.

Making Money

There are various models for making money from digital comics. Some show promise, but none of them is practical for making a living just yet. Not to say that day won't come, but for now, don't give up your day job.

Additional Resources

I've had so many people write to me over the years, asking for advice and information, that I've created two sections on the *Argon Zark!* site specifically for those interested in creating their own digital comics: 'Tools I Use' (www.zark.com/front/crayons. html) and 'Books I Use' (www.zark.com/front/books.html). They contain long lists of annotated links to information and books on all aspects of creating digital comics.

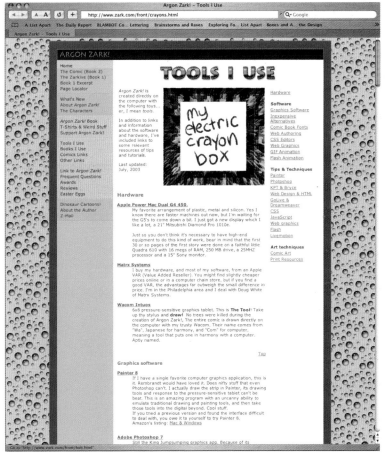

WEBSITE DESIGN

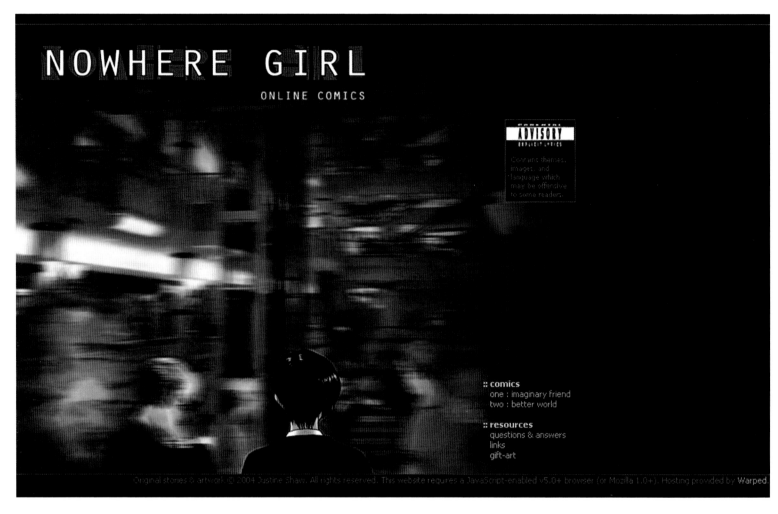

A good website is crucial to your webcomic. Unfortunately, it is difficult to get anybody to agree on what a good website is. Still, there are a few guiding principles that you should definitely keep in mind.

First is to keep the reader (or potential reader) in your mind. Imagine a reader arrives at your homepage for the first time. The reader's first thought is going to be 'what should I do?' You should have something for the reader to do – something that doesn't require a lot of effort to think about. For instance, a daily comic would probably be best served by putting today's comic right on the front page. You're hoping to build a habitual readership, one that will come back day after day, and that readership will surely appreciate you making it easy to find the current dose of your strip.

A comic that updates rarely – or complete works that aren't going to update – might be better served with a cover page that sets the tone or provides a teaser image – like a print comic's cover.

Whatever you do, it's best to provide a simple choice for the novice reader – even if you have 12 different comics, instead of just creating a list of all the different comics, it might be a good idea to create a big link to one comic. That way a reader who knows nothing about your site can arrive, find something to click on and read, and hopefully enjoy the comic enough to read other comics as well.

While comics are a visual medium, putting an image-heavy home page might turn off readers who don't want to wait for images to load. Likewise, opening with a Flash animation is a turn-off to many readers. On the other hand, many other readers are attracted to Flash animations, and some people enjoy being greeted with a Flash movie (but you should allow regular readers to bypass having to see the same animation every time they visit).

The truth is that there is no right or wrong way to create a website. Your best bet is to think about what you like about other websites, and create something you enjoy. Trying to second-guess what hypothetical readers will want can only lead to madness…or at least to creating a site you're not happy with – and if you're not happy with your site, the reader won't be, either.

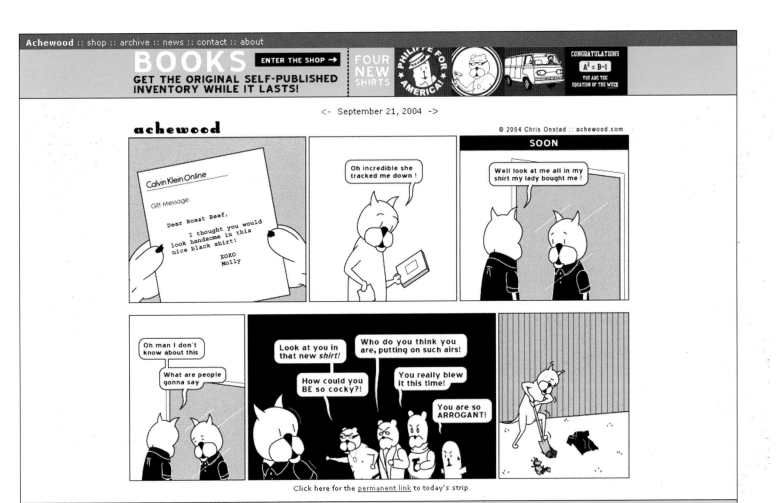

Left: Justine Shaw's *Nowhere Girl* is updated irregularly, but the site is very user-friendly.

Above: The homepage of Chris Onstad's *Achewood* is a simple and effective design for a daily strip.

Right: Avoid turning off your potential readership by giving them too long to wait.

JENN MANLEY LEE

Jenn Manley Lee is one of the most popular cartoonists on the female-focused webcomics site *Girlamatic.com*. She is known for her masterful colour use, the intense interplay of her complex characters, and her focus on accuracy and consistency in storytelling. She labels her signature work, *Dicebox*, as 'futuristic fiction', a subgenre of science fiction in which the story's premise is rooted more in sociopolitical matters than in technological exploration.

When and how did you begin creating comics?

I actually started doing minicomics back in the late '80s and early '90s. Then I went through a seven-year pause, during which I played with some ideas for comics and even began to draw some but never finished any. My serious return to comics was in 1999, when I returned to the story now known as *Dicebox*; I had first conceived of *Dicebox* around 1990 and had put it down around 1995.

When did you first post your work online, and what attracted you to webcomics?

I began to post *Dicebox* online towards the end of 2001. Scott McCloud had actually been prodding me for years to do comics online before I finally came to the conclusion that it was indeed the way to go.

What I saw in the Internet was a venue that would allow me to distribute my comic more freely than more conventional means. I realized that those people I saw as my audience for *Dicebox* have probably never even stepped inside a comic book store.

For me, comics on the Web are all about breaking out of ghettos, cliques, and preconceptions. Not only in story types or interactive possibilities but also in how one approaches the story itself, even how to tell it. By publishing *Dicebox* online, I have the freedom to execute the art and story as I see fit.

Dicebox always demanded to be a colour work – something that is untenable for the average self-publisher, and I couldn't envision a publisher that could afford colour being at all interested in *Dicebox*. And by publishing on the Internet, I felt I had the chance to experiment and find the style I wanted to work in; I felt free to explore and play around with my approach. When I finally decided on the direction I wanted to take the art – more specifically, the colour rendering – I could always just adjust all previous pages and upload them again.

As for the story, I feel free to build the story as slowly as I please – as long as I keep my audience entertained. And I can treat each chapter as just that, a chapter, as part of an entire story instead of a standalone issue. I can let the page count be what it needs to be, not what works with the four-page signatures of a printer's spread.

I do work on *Dicebox* with the idea that it might see print one day, from building the pages at a 300-ppi resolution to actually composing the comic in pages, though I do keep in mind what I need to do to have it display on a monitor in a pleasing way. I have no concrete plans to get it into print; right now the most important thing is to keep producing pages.

Which webcomics or webcartoonists do you read regularly or recommend highly?

Christopher Baldwin, Vera Brosgol, Barry Deutsch, Kris Dresen, Daniel Merlin Goodbrey, Patrick Farley, Derek Kirk Kim, Scott McCloud, Dylan Meconis, Erika Moen, Bill Mudron, Justine Shaw, Jen Wang, Drew Weing, and Gene Yang.

Briefly describe *Dicebox*.

Dicebox plays out an eventful year in the lives of Griffen and Molly, a couple of female itinerant factory workers in a space-travelling future. It's a fantastical science fiction story – as opposed to a hard science approach, which really wouldn't let me move out in space beyond the Oort Cloud, given that we have no feasible way to travel faster than light. Though I try to keep my science grounded, I'm more concerned with a setting that allows me to deal with certain themes, culture, and symbolism in a way that integrates with the story as a whole.

THE AESTHETICS OF COLOUR

Colour is near vital for me in *Dicebox*. Not only for aesthetic reasons but also for its symbolic uses, as a compositional aid, for story cues, such as suddenly shifting location, or setting a mood. There was a time I thought *Dicebox* was to be a black-and-white comic for economic reasons. I can't even conceive of that now.

As an example of the special emphasis I put on colour, here is a response I gave to the question of why Griffen and Molly wear a bit of red at all times:

I've acknowledged to myself ages ago that *Dicebox*, beyond being a story about Molly and Griffen, is a call and response to all the stories I grew up with and ever encountered. So I spent some time exploring certain recurring and dominant themes of classic tales and myths, researching them, and forming my own response to them. Forget Joseph Campbell. You won't see most of this directly addressed within *Dicebox* – it will often be even more than subtext, more like third sub-basement text. It's the flavour and my personal unifying force.

Naturally I was going to delve into colour symbolism – and this was still when I thought *Dicebox* was going to end up being black and white. Each colour represents a combination of aspects and meanings for me; the colour red is first and foremost blood to me.

I don't think it's any secret that I am interested in female energy and roles in stories, along with other border walkers such as tricksters and the like. Repeatedly, blood is aligned with women and border places. Death, birth, the river surrounding Faerie, blood on the snow, blood in the shoe. And then there's the whole idea of blood as guilt by association. Can't trust a woman 'because they bleed three days a month and don't die of it'. And of course the whole Dicebox–Peorth–Womb connection.

And, yes, so far in *Dicebox*, Molly and Griffen have worn some scrap of red, be it a shirt, the trim on a pair of trousers, knee patch, or coat lining. And the red will vary from a maroon to a pink – from dried blood to a blood partially rinsed from a white rag.

Now, all that said, this is a standard I am setting up so I can break it at the appropriate time.

HOME: PORTLAND, OREGON

URLS: JENNWORKS.COM, GIRLAMATIC.COM

EDUCATION: BFA IN ILLUSTRATION, CARNEGIE-MELLON UNIVERSITY

CURRENT OCCUPATION: GRAPHIC DESIGNER

ARTISTIC INFLUENCES: IVAN BILIBIN, SHARY FLENNIKIN, TRINA SCHART HYMAN, MOEBIUS, SCOTT MCCLOUD, BARRY MOSER, ARTHUR RACKHAM, LYND WARD, T.H. WHITE, FRITZ EICHENBERG, TOM WAITS, ALISON BECHDEL, THE COEN BROTHERS, GUY DAVIS, VITTORIO GIARDINO, HAL HARTLEY, DYLAN HORROCKS, LINDA MEDLEY, HIROKA SAMURA, AND CRAIG THOMPSON

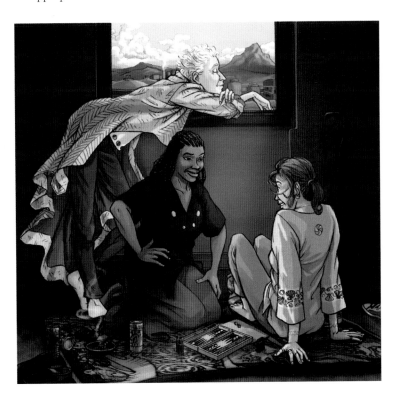

What are some of your long-term goals for your work?

My biggest goal is to actually see *Dicebox* to completion; it's a story that's going to end up being at least 900 pages – four books, for a total of 36 chapters. To that end I hope to find myself in a position where I can devote much more time to creating comics.

How often do you post new comics material on the Web?

A page of *Dicebox* is scheduled to go up every week. As I write this, I am about to begin a story called *Wode* that will have an incredibly erratic update schedule, as I will only release installments in discrete segments and it will remain secondary to *Dicebox*, my primary comics commitment.

Your strongest skill as a webcartoonist? Your greatest challenge?

I would say my strongest skill as a webcartoonist is that I understand many constraints of publishing online and can work well with them without being limited by them. Also, I don't believe there is a prerequisite style or approach to doing a comic online and so have allowed myself to develop an unexpected style that people seem to respond to.

My challenge is to keep hitting my weekly deadline with the constraints of a day job and other commitments while keeping my art at the highest quality I can.

OUTLINE

The Griff/Grae, Rande/Molly alliance should start becoming obvious. In fact, they decide to split up to ease the tension. They nix couple and couple, they mix it up, picking an obvious landmark to meet up. First some of Molly and Rande, Rande complaining about Griffen, Molly not quite disagreeing. R: Don't know how you can stand her. M: I get that a lot. Rande lets slip that Griff barged into the room, Molly not pleased about that.

Donny and Griffen have stopped to rest, Griffen has started writing in her journal. Donny comments on it, asks why she uses a pen and paper when a cheap electronic equivalent is available at the same cost. Griffen comments that someone would have to physically steal the journal to find out what it says, the cheap electronic could be tapped. They argue about the possibility. Griffen finally asserts that she has done so herself. She goes on to rattle some specs and confesses it's been a few years since she's done so, that she's run away from all that. So she doesn't know if the latest securities could be cracked, yet, but is confident that a cheap electronic could be.

1 OUTLINE AND SCRIPT

I have already created an outline for the four books of nine chapters each that will comprise *Dicebox*. The amount of detail varies – each chapter has at least its main action or purpose defined. Unsurprisingly, the chapters for Book 1 have the most detail, several paragraphs apiece, while the chapters for Book 4 have the least, sometimes only a sentence. This outline is a live document; I continue to fill in and expand details and story, rearranging whole sections. I don't really change the essence of the story, but I do alter how I will tell it.

It's from these outlines that I generate my scripts. I review what I've written in the outline for the chapter I'm about to script for, as well as the next couple of chapters, and the one previous. This is so I keep a good sense of the chapter's place in the whole story. Then I write a very rough draft of the script, usually two chapters ahead of the chapter I'm drawing. I will continue to work on this script until I begin to draw it. Even then, I will continue to fine-tune things as I actually draw the pages.

2 LAYOUT

After completing a script for a chapter, I'll review it while marking up how I think it'll break down in terms of pages and panels, which I do scene by scene.

Dicebox is a page-based comic, and as with most page-based webcomics, no matter how fast the Internet connection, there is always a pause as you click between pages. For my own work, I find that pause undesirable, especially between pages within a scene.

I define a scene by a shift in location, situation, or attitude. Scenes were something I was always aware of but didn't really overly concern myself with as a unit until I started publishing online. I consider *Dicebox* to be a straddling comic, that is, one published online with certain print conventions in place, such as presenting it in pages with the traditional portrait, or vertical, orientation. More than the desire to eventually print *Dicebox* in book form (I could always do a horizontal book, after all), I chose my layout as a response to how I experienced stories growing up.

So I have chosen to organize pages into one vertical scroll per scene, and must divide a scene into discrete pages. Naturally, there is still a pause as you click between scenes, but I find that more acceptable than having a specific conversation or set of actions interrupted.

After I break the chapter into scenes, I determine my page count. For about five to seven of these exchanges, I need to allow a whole page, exceptions being when I have determined I'm going to use half a page for an establishing shot or a panel group. A panel group is a set of specifically interlocking panels, usually those that complete an action or moment, ranging anywhere from two to five panels. This is sometimes a row of panels, but doesn't have to be. Making these decisions gives me a rough idea of how many pages a scene or chapter will take, but not necessarily my true page breakdown.

A page needs to begin and end at a certain point so that it will be a satisfying unit of story – rather like a paragraph in prose. Even in printed form, there is that beat, that transition, when you get to the end of one page and then move your eyes up to the beginning of the next, or physically turn the page. Online, I update one page at a time, and that page is up for a week, so the single page becomes very important, much more important than when it's released in a book along with 30 to 100 more pages, all at once.

SCRIPT

Start with Grae glaring at Griffen sitting on a log, writing in her journal.

Grae: We should probably get moving.

Griffen: (not looking up) In a minute, I'm almost done.

Besides, you said our route would get this to the rendezvous quicker.

Grae: I'm really not thrilled about splitting up.

Griffen: It wasn't my idea.

Grae: Well, after you smacked Rande in the eye with that –

Griffen: Look, again and again I say it was unintentional. Whereas your Rande punched me in the eye with great purpose. That, apparently, required no special measures afterwards.

Grae: It would've been better if you hadn't hit him.

Griffen: And it would've been best of all if Molly and I never got on that damn ship with you two lunatics.

But what's done is done, push on, push on.

Grae: What are you doing anyway?

Griffen: We call it writing where I come from, Donny.

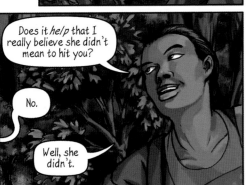
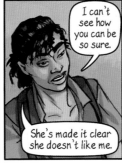
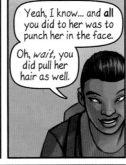
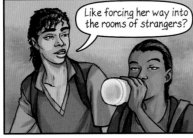
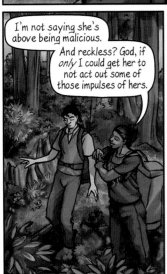

In the case of the sample page here, page 30 of *Chapter 3: Forest for the Trees*, its place within the scene was of special significance to the layout choices I made.

I have adopted the convention of signifying the beginning of a scene by beginning with an offset panel with extra space around it, in the manner that some prose book designers might use a decorative raised cap at the beginning of a chapter.

Page 29 was actually this scene's first page, and so got the beginning offset panel. But this was a scene determined by a situation as opposed to a location change, the situation being two different conversations between two different couples. I wanted to visually acknowledge this jump in the layout of these two pages.

So I created a bit of space under the last panel of page 29 for my first visual cue. Then on page 30, not wanting the make the first panel too important, I decided to leave some extra space after page 30's first panel, either below it or to the right.

Then I executed some quick thumbnails exploring all these concerns as well as incorporating certain visuals I had in mind since scripting this page; actually, ever since I described this scene in the outline: specifically, Grae with arms crossed leaning against the tree, an L-shaped panel of Griffen sitting on a fallen tree, and the last inset panel with Griffen's snarky rejoinder – which I had always seen as being an inset panel, though having no idea where it would fall.

A lot of what will determine the actual layout of the page is the type of panel I want to use or the shape of one panel in particular that I need to use for a given action or moment. Sometimes one panel or, rather, the action or moment contained in one panel, will dictate the rest of the page. If that one key panel needs to be a long horizontal in the middle of the page or a square at the end, all the rest must follow. Which can be a challenge, because I want the page to feel good as a whole – as well as work with the rest of the pages of the scene that this page will live with, online, in that long vertical scroll.

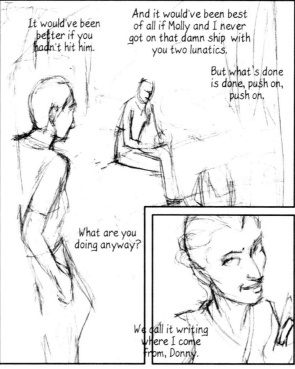

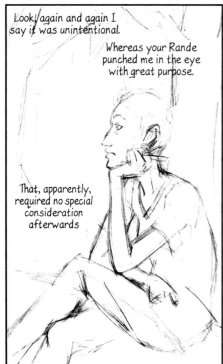

ROUGHS

3 I start creating a page by copying and renaming an Adobe Photoshop template file I've made that contains my general guides and basic layers already in place. Then I go into Adobe Illustrator and create my panel shapes, following my thumbnails for the page. It's very easy for me to break out the number of panels I want and keep a consistent gutter with the *Rows & Columns* menu, all within my standard page dimension, 9.75" w x 13.125" h.

I arrived at this working size for my pages by first taking the generally agreed-upon page size for viewing in a Web browser, a horizontal page about 7.5" x 5", stacking it two high and then scaling it up to a size I found comfortable to work on that fit in the ready-made size of 11" x 14" for Strathmore Bristol. This gave me a page proportion I liked, plus a constant reminder of what is easily viewed in a Web browser window – something that's a constant challenge, which can be frustrating when I want to do a layout that would be easily read in the pages of a conventional book, but potentially confusing on a screen where the reader scrolls down.

I import the panel shapes into my Photoshop file, save them as a Path, and apply a stroke to all of them on their own Multiply Layer. The dialogue is typeset next, within Photoshop, in a font I created of my handwriting using Fontographer. That gives me a good idea of how much room I have for imagery and a chance to double-check my thumbnails and panel arrangement for flow and action.

In a sketchbook I use specifically for this purpose, I rule out the page, block out the art, and draw my roughs. This is when I will determine if I'll need art reference, though I don't necessarily seek it out yet. Or I might have it already, either as photos taken with my thumbnails as my guide or a pose or part of a pose picked out from one of my photo reference books. I used surprisingly little reference for page 30, mostly some sketch reference of hands and a couple of photos of people writing in books on their laps.

After my rough pencils are done, I scan them in and place them within the Photoshop file. I adjust elements within the page, either by moving or resizing them so that they work better within the panel and with the dialogue. I will also adjust the dialogue at this point, either in placement or content.

In the case of page 30, a significant change at this stage was not letting the first panel be silent, with Grae glaring. Didn't really work, not in story or mood. So I moved some of Griffen's dialogue into it as a voiceover, which made the panel work much better in a story context.

Next, I convert the roughs into bluelines using the *Hue/Saturation* menu. By bluelines I mean non-photo blue art: a light, almost cyan blue that photo-based equipment has a hard time picking up. Non-photo blue pencils are still used by many illustrators for pencils under their inks, saving them the necessity of erasing the pencils afterwards.

Upon completion, the final line art is scanned at full size, 300ppi. I rotate and clean up the scan before placing it in my final file. A quick way to do this is to select the *Ruler* tool, clicking at one end, then the other of a line or edge that should be square; for me it is the faint trace of a panel border printed in blueline. After doing this, go into the *Image* menu, select *Rotate Canvas*, then *Arbitrary*. The menu box for *Arbitrary* rotate will pop up with the angle and direction needed to square the image from the information already entered in the appropriate fields; simply hit the OK button.

Next, I do *Level* adjustments, which go a long way to clean up the line art and effectively remove all remaining traces of the bluelines. There is no set formula for this, I always gauge by eye the right amount – determined when the background is effectively white, the line art solid, clean but not too dark and without losing the character of the pencil line. I will continue to clean up the art as I work on the page using the *Paintbrush* tool.

I open the *Hue/Saturation* menu and check the *Colorize* box, then enter the following settings: *Hue*:190, *Saturation*:100, and *Lightness*:96. These are the best settings for a non-photo blue that work with my printer and scanner. I then print these bluelines on smooth Bristol for my final line art.

4 FINAL LINE ART

I execute the final line art with a 4B Creatacolor stick, which is a solid piece of graphite and clay in a .25" round, sharpened to a point, and an HB .5 mechanical pencil. My final line art is in pencil partially as a time-saver, as I am a much more accomplished penciller than inker, but also because I prefer the look of pencil lines with the colouring technique I have developed for *Dicebox*.

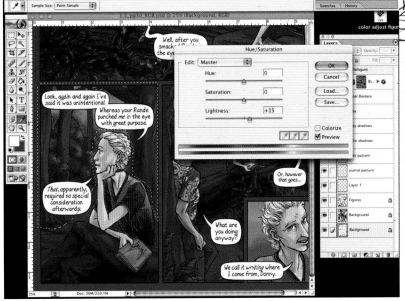

Then, I import the scan into the final layered file I have prepared for the page and make sizing readjustments, enlarging or cropping a panel or elements within a panel. In the case of page 30, I felt I needed to enlarge the figure of Griffen in panel five to have it fit in the setting better and be the proper distance from Grae visually. The line weight isn't usually an issue when I enlarge, and if it is, I can always paint it down a bit.

I will often colour the line art slightly, again with the *Hue/Saturation* menu, when I don't want a pure black line. Then I sometimes lighten just the line art for the background elements so that they fall back a bit, either using the *Dodge* tool or selecting the line art and fading it back in the *Hue/Saturation* menu. Often I wait to do this last step when I have just about completed a page so that I properly judge how much I want to fade the line art back.

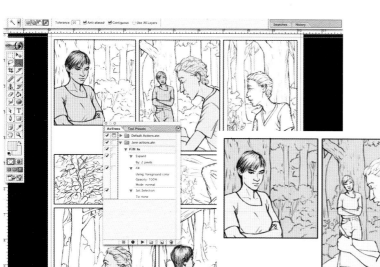

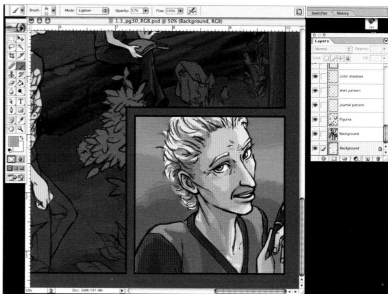

5 COLOUR

The colour palette I chose for *Dicebox* was partly inspired by the colours found in early-twentieth-century illustration, such as the works of Ivan Bilibin, Edmund Dulac, Elizabeth Shippen Green, Kay Nielsen, and Arthur Rackham. It's a tricky colour palette on the Web, given how various monitors will independently interpret the colours, which leads to some compromise in my colour selection.

Before I begin colouring, I make my panel gutters grey by creating and flooding a layer with a medium grey and then knocking out the panel shapes. This grey is the same colour as the background of the webpage that this comic page will be presented on: Web hex colour 666666. I find the glowing white of a computer too harsh for my art for *Dicebox*, and a straight black to be too moody.

I do my colouring on *Multiply* layers over the line art, the bulk of it in two layers, one for the figures and one for the background, occasionally using a third for foreground. I start by carefully tracing each major figure in their base skin tone, use the *Magic Wand* to select the inside and then apply an Action I created to expand the selection, fill it, and deselect.

After I finish the figure shapes, I select them, contract the selection slightly, and knock them out of the colour I've flooded the background with. I now have discrete, easily adjustable areas that I can select and colour quickly while leaving other areas alone. Or I can simply lock the Transparency of, say, the *Background* layer so that whatever freehand painting of foliage I do has no danger of interfering with the art on the *Figures* layer.

Now I go in and define with flat colour the main elements of the art. It is not unusual for me,

when first colouring a specific setting, to affect whatever colours I've laid down universally through *Hue/Saturation* or *Color Balance* so that they sit together better. I'll sometimes change the hue of the background completely to get the right mood or complement the figures better.

This is also the stage when I do my colour line effects, either by cutting and pasting into a *Spot Color* Channel or, as in the case of Griffen's eyebrows, going over the line art with a brush set to Lighten with a mid-tone of Griffen's hair colour.

Though this part is mostly about mapping the large colour shapes, I will apply any colour effects or pattern that I feel will influence my rendering and shading decisions for the page, especially in reference to the main figures – in this case, both Griffen and Grae's shirts.

The gradient in the main body of Griffen's shirt was actually done with a very large soft-edged brush as opposed to the *Gradient* tool. This not only allows me to better control the fade-off point, but also allows colour shapes to follow the contour of her body and the gesture of her pose. I used the *Magic Wand* to select the main body of the shirt, then made a brush diameter just about as large as the length of the shirt and stroked along the bottom edge of the shirt with a colour the same as the shirtsleeves and collar.

The pattern in Grae's shirt took some prep work. I wanted an organic, deco-influenced pattern, something I could use for an effect later on in some other textile. I used as a starting point a photo of a deco vase I found online and created a layered file with the vase on a layer over a background of an unrelated colour – in this case, yellow. I quickly

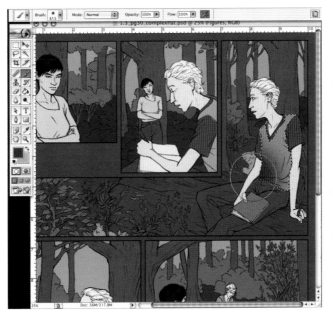

erased what I wouldn't use for pattern making and applied an extreme Level adjustment to flatten the black and white areas. Then I cut apart and distorted sections to get a more flat pattern from what had been a rounded vase. Then I painted and erased until I felt I had a nice section of pattern that I could repeat and fit together in a larger field. I duplicated this layer to give me the pieces I fit together to make my pattern, sometimes flipping or rotating sections for a more random effect. When I had judged I had enough of a pattern field, I changed the background to black, flattened the file, and did some additional touch up.

I made a copy of that pattern file that I then coloured a dark blue. Then I selected the whole image and copied it. In the file for page 30, I selected the colour shape of Donny's shirt and chose *Paste Into* from the *Edit* menu, which created a separate layer mask with the art. The art can still be moved about and scaled. After I applied the pattern to all the instances of the shirt, I flattened the various shirt pattern layers into one with a setting of *Multiply*, with an *Opacity* of 69%.

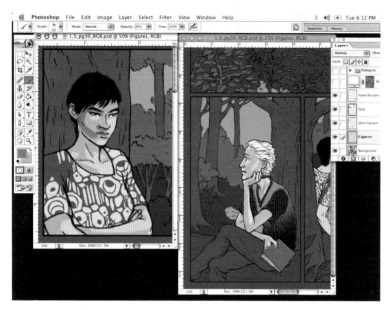

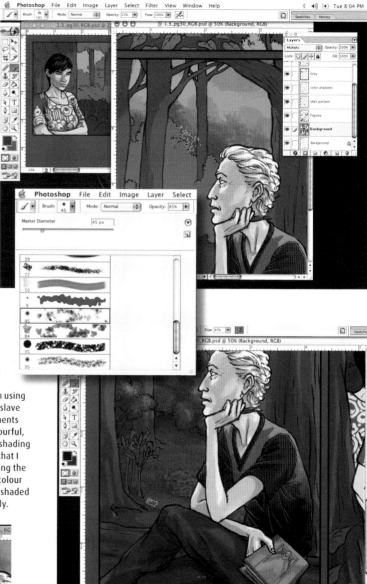

6 RENDERING TEXTURE AND EFFECTS

I begin rendering or shading by choosing a key figure on the page to make decisions about lighting effects and directions, as well as contrast.

In the case of this page, I chose one key Griffen figure and one key Grae, as I had a certain way that I wanted the shading to work on them both. The brush I use is a personal setting of Photoshop's basic *Charcoal* brush, which actually has a soft bristle effect, allowing me to get painterly effects. The brush size and edges are affected by pressure of my pen on my Wacom tablet, sometimes the opacity as well. Sometimes when rendering, I lay down a brush stroke whose shape is perfect, but is a bit too dark in value. So I'll lighten it by going into the *Fade* menu and reducing the opacity.

The main figures always get colour-specific rendering, that is, each level of tone is its own colour, as opposed to painting grey on a *Multiply* layer, which I do for cast shadows and background elements. I have two to three swatch sets for each major recurring character and setting, for various light settings; here I'm using what I think of as my basic set. I am not a slave to these palettes, and I will make adjustments accordingly. In the rendering of these colourful, decorated shirts, I had decided that grey shading would look awful, and I wanted shading that I could work back and forth without affecting the pattern. I created a *Multiply* layer called 'colour shading' specifically for this purpose and shaded the shirts in light blue and red respectively.

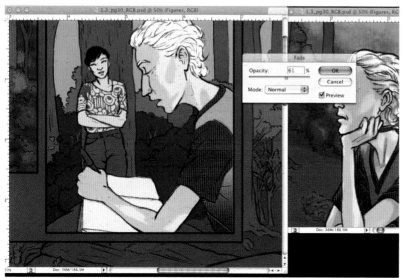

As I continued to render the page, I started to apply texture areas, beginning with those areas that had their whole colour value shift with the addition of the texture. In the case of this page, most of the background was a texture application for me.

I started with the far-off foliage haze, using the *Charcoal* brush at a very large size with a reduced opacity to build up the texture. I actually used a similar approach for the closer shrubbery, only with smaller and different brushes and more colour variations. For the forest floor I applied a dark brown over the medium brown with a *Pastel* brush at a reduced opacity and a reduced flow to have a greater textured effect.

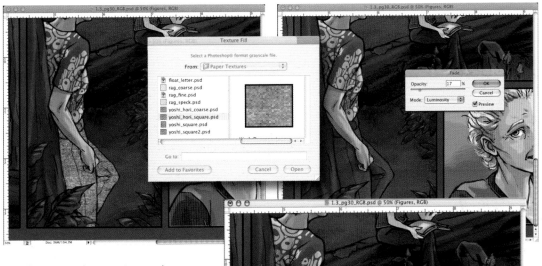

The other way I apply texture is to use the *Texture Fill* filter, as I did here with Grae's trousers. I applied *Texture Fill*, using my own texture samples, largely the paper texture from a Japanese woodblock print, which has a nice fine paper texture with interesting variations in tone. I then implemented a *Fade* on the filter with different effects: *Luminosity, Multiply*, etc. I also 'painted' with it, by decreasing the effect with the *Art History* brush or increasing it with the *Burn* tool.

After a certain level of rendering, I begin to add additional decorative elements, such as the design on Griffen's diary, which I created in Illustrator and then imported into Photoshop as pixels. I pasted it on its own layer and then proceeded to do a *Perspective Transform, Scale, Rotate*, and then a *Distort Transform*. I left the decoration on its own

The figure of Griffen in panel five was somewhat clunky-looking after I had enlarged it, so I copied and pasted the figure into a new file, converted it to bluelines, printed it out, re-pencilled, scanned it in, pasted it back into the file, and adjusted the colour areas affecting it. This was another half an hour of work, but I will feel much better about the page in the long run. I balance it against the time I would have spent redrawing that before scanning it in the first time, which would have added the same amount, if not more.

Once satisfied with the page, I prep it for the Web. I save a flattened copy of my file, take down the resolution to 72ppi, and reduce it by 86%. I then convert it to a progressive JPEG, which gives me the best quality at a smaller file size.

I mainly use Macromedia Fireworks to prep my graphic files for the Web, and Macromedia Dreamweaver to generate my HTML files – along with CSS and additional JavaScript.

The first piece of advice I'd give about preparing images for the Web is to experiment – try out different file formats to get the look you want at the smallest file size. Next, just as important, be mindful of how it'll display on different monitors, not only the different resolutions they can be set at, but how colour displays on various monitors and across different computer operating platforms.

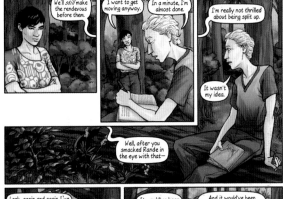

layer at a reduced opacity so I could continue to work on the rendering of the diary if I needed. Same goes for the text of the diary.

Then I created word balloons out of vector shapes and did final dialogue placement, which brought me to a stage I think of as my initial render of the page.

At this point I like to step back from the page and evaluate what it needs to complete it, ideally not looking at it for a day. When I came back to page 30, I made some corrections and applied broad shadow

areas to the background by painting with grey on a separate *Multiply* Layer. I also added details to the background and added effects like the dirt on Griffen's trousers, moss on the log, etc. This is also when I used the *Liquify* filter to have the pattern on Grae's shirt and the writing in Griffen's book conform better to their surfaces.

I also decided to universally alter the colour on this page, warming it up a little. I used the *Color Balance* menu to do this, with different settings for the *Background* and *Figure* layers.

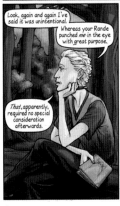

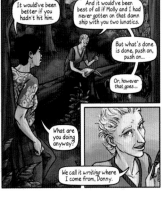

I'm a storyteller, so for me the storyline is the most important aspect of creating comics. That said, presentation is a very close second. That's one of the main reasons I work on the Web; as a medium that's not well-defined (because it's constantly changing as technology evolves) the Web gives me the opportunity to experiment.

When I first started making webcomics (in 1996), a 28k modem was considered 'state-of-the-art'. Because of slow modem speeds, I designed my *Traced* series to look the way it does. I knew that most people would only have 14k dial-ups at home and if I wanted them to be able to see my work without getting frustrated by download times, I'd need a streamlined visual style.

I chose to use black and white images instead of colour, since colour would add to the overall image size. I created white line drawings on transparent backgrounds and used HTML code to create the secondary shade (BG COLOR="#000000"). In this way my images never got larger than 5k (which was almost instantaneous on a 14k modem). Setting parameters, or having imposed parameters (like file size), is often the best path toward innovation – I usually find the more restrictions I have, the more creative I end up being.

Think about why you're doing something. As long as you have a reason, anything you do is fine. For example, you might decide you want to publish on the Web because you can work in colour, which is expensive in print. That will most likely mean that you won't care how large your files are or how long the download times are. It's up to you to think it through and make conscious decisions.

After writing a comic, I ask myself a series of questions to help guide its presentation:

1. Who is the audience? Are they people who are on the Web all the time, or do they need more hand-holding? Young, old? All these things will factor in to how you present your stories.

2. How will the majority of people view the work? By this I mean how fast is the connection (if your audience is mostly university students, it will be fast) and what browser will the majority use?

3. What will the layout look like? Are you trying to be experimental? Or are you using the Internet as a way to get work meant for print publication out to a larger audience?

Once boundaries like these are set, presentation comes into focus: I always ask myself how I can display my comic in a way that is unique to the medium and that advances the story without making it subservient to technology (otherwise known as 'the bell and whistle syndrome'). In fact I've generally felt that my webcomics, if they're successful, should not easily make the transition to another medium.

I really want for my audience to interact with the stories in a way that they can't in print. The beauty of the Web is its ability to reach people anywhere there's a computer and the ability of everywhere to converge back to one place (like your website). Since *Traced* is made up of autobiographical stories about universal moments that lots of people have, I decided to introduce message boards at the end of each episode so that people could share their own stories on the same topic.

Tracy White is a storyteller who lives in New York City and eats dark chocolate every day. She teaches a graduate course in digital comics at New York University. Her comics appear online, on-air and occasionally in print. Find out more than you may want to know about Tracy's life at www.traced.com.

Above: For the *Traced* story 'Fieldtrips', I created a column consisting of HTML links (the green text on the left-hand side of the screen) that lead to different chapters in the same story so that it can be read in any order a person wishes. On the right-hand side, smaller HTML links lead to merchandise and an Ecard section, so readers can send out notes about their own trips.

Left: As the reader progresses through 'Fieldtrips', she or he encounters several HTML links (indicated by blue text) that open pop-up windows to other *Traced* episodes. This is a way to take advantage of one of the Web's unique attributes: the ability to make immediate connections to stories or information.

Below left: After reading the chapter about what to eat on a field trip, the audience is invited to add to the story by sharing their own favourite sandwich recipes. I modified a simple CGI message board script to do this. Working scripts can be found for free on the Web and then tweaked as needed for specific requirements. Check out Matt's Script Archive (www.scriptarchive.com) for free pre-made scripts. Of course you can always write your own from scratch!

ALEXANDER DANNER & BILL DUNCAN

While most of the webcartoonists featured in this book work primarily alone, Alexander Danner and Bill Duncan represent the growing group of collaborative duos and teams who employ – often at long distances, with little or no 'face-to-face' interaction – the Web's unparalleled person-to-person networking and file-sharing capabilities. Their webcomic, *Picture Story Theatre*, is an amiable, and at times outlandish, amalgam of their individual imaginations and unique skillsets.

ALEXANDER DANNER

When and how did you and Bill begin collaborating?

I was a fan of Bill's first ongoing comic, *Japanimation Fist*. I loved that he was doing an intelligent kids' comic, and his art style was really unique. I knew pretty early on that he was someone I wanted to try working with. I actually wrote *Amy Plays a Game of Chance* specifically with Bill in mind, even though I had barely spoken to him at that point. In fact, that was the first script I ever wrote with a particular artist in mind. I sent it to him right around when *JF* was wrapping up, in the hope of catching him between projects. Happily, it worked out – he liked the script and finished the art very quickly. The whole project just went superbly and was published in *Modern Tales Longplay* in May 2003. Bill and I started working on a couple of other little things after that, including a second Amy story, so when Joey Manley asked us if we'd be interested in doing an ongoing strip for *Modern Tales*, we were all set.

Briefly describe *Picture Story Theatre* and *Asleep: The Afternoon Passes*.

Picture Story Theatre is an anthology series – rather than one ongoing story, Bill and I present a series of short stories that have run anywhere from as few as seven pages to as many as 30. There are some recurring characters, such as Amy, but most of the stories are completely self-contained. There are two main sorts of stories we tend to do – on the one side are the mostly realistic stories of kids facing the world at large. On the other side are original fables and retellings of traditional stories. The stories are all meant to be good reading for kids, but in much the same way that Grimm's Fairy Tales are good reading for kids – some of them are lighthearted and fun, but just as many are dealing with serious, troubling stuff, but presenting it in ways that we hope kids will find accessible.

 Asleep: The Afternoon Passes is a story about a young boy's brief encounter with the divine. It's both the shortest, and the most optimistic piece we've completed thus far – in fact, it was specifically written as a mood-lightener to follow the much longer and darker story, *The Little Bear Who Knew Fear*. While *Asleep* does include a very sweet depiction of God, it's meant as more of a 'what if?' than as any sort of particular religious endorsement. Like most of our stories, it presents an interesting scenario but lets the reader decide what it really means.

Your strongest skill as a creator? Your greatest challenge?

My playwriting background has been a definite asset. It has certainly helped me develop an ear for dialogue. On the other hand, playwriting helps a lot less than one might think, in terms of writing visually. The rule in playwriting is that you don't describe appearances or actions any more than is absolutely necessary for

plot reasons. It's considered insulting to the director to include those details. So, when I sit down to write a comics script, my natural instinct is to write all the text and only a minimal hint of physical description. Most of the visual stuff I leave to the artist – which some artists like, and some don't. That's actually a big part of why I decided to write the Amy stories as silent comics – it's a way of training myself to think more about the visual storytelling aspects.

BILL DUNCAN

When and how did you begin creating comics?

I began making comics nearly three years ago when a friend of mine invited me to take part in a 24-hour comics event called Solitary Confinement. Before that I had always thought of myself as a writer and hadn't drawn anything more than a doodle since I started school. I'd read Scott McCloud's *Understanding Comics* earlier that year, and I had been an avid comics fan for many years, but the idea of taking up pen and ink myself (or a Wacom tablet, for that matter) seemed unlikely at best.

After completing a fairly decent 24-hour comic, I went on to do a short fill-in on my brother's ongoing comic strip, *Man Man*, which he does with a good friend of mine. After a few weeks of filling in, I had the bug, and I've been making comics ever since.

Your strongest skill as a creator? Your greatest challenge?

One of my strongest skills as a creator is that I continue to learn and expand my visual vocabulary with each new project. Also, I would like to carve out a niche for myself somewhere between children's literature and comics. The biggest challenge is that there is still so much I have to learn. It will come with time, so long as I am open and willing.

NAME: ALEXANDER DANNER
HOME: CURRENTLY NEWTON, MA. GREW UP ON LONG ISLAND
URLS: MODERNTALES.COM, SHADESOFDECEMBER.COM/ ALEXANDERDANNER/BLOGGER.HTML
EDUCATION: BA IN PHILOSOPHY, LEHIGH UNIVERSITY. WORKING TOWARD MFA IN CREATIVE WRITING (PLAYWRITING FOCUS), EMERSON COLLEGE
CURRENT OCCUPATION: GRADUATE STUDENT

ARTISTIC INFLUENCES: JACK GANTOS, DAVID WISNIEWSKI'S *GOLEM*, FOLKLORE, SAMUEL BECKETT, EDWARD ALBEE, STEVE ERIKSON, SALMAN RUSHDIE, ALAN MOORE, WILLIAM BOUGUEREAU

NAME: BILL DUNCAN
HOME: THE EASTERN TOWNSHIPS, QUEBEC, CANADA
URLS: MODERNTALES.COM, DUNKTANK.CA
EDUCATION: STUDIED DRAMA AND ENGLISH LITERATURE BEFORE RECEIVING A GRADUATE DEGREE IN EDUCATION
CURRENT OCCUPATION: EDUCATOR

ARTISTIC INFLUENCES: LONG BEFORE I BEGAN MAKING COMICS I WORSHIPED AT THE FEET OF STORYTELLERS LIKE RAY BRADBURY, TERRY GILLIAM, TIM BURTON, AND EDWARD GOREY, ALL OF WHOM HAVE A PECULIAR WAY OF BLENDING INNOCENCE WITH SOMETHING DARKER AND MORE SINISTER. THOUGH I CAN'T SAY THAT I CONSCIOUSLY ASPIRE TO EMULATE ANY PARTICULAR ILLUSTRATOR, I WILL CONFESS A STRONG FONDNESS FOR THE WORK OF FOLKS LIKE SHAG, DR SEUSS, MAURICE SENDAK, AND SHEL SILVERSTEIN. I'LL ALSO CONFESS TO HAVING VERY FOND MEMORIES OF THE HARVEY COMICS OF THE 1970s (PARTICULARLY TITLES LIKE *HOT STUFF* AND *CASPER*, WHICH WERE AMONG THE FIRST COMICS I EVER READ).

DANNER ON LONG-DISTANCE COLLABORATION

Obviously, geography ceases to be a factor in finding a good partner. Bill and I have never met – we don't even live in the same country. If we weren't involved in webcomics specifically, we probably never would have even seen each other's work, let alone found the opportunity to collaborate. And, of course, working electronically means we can share ideas, files, and work-in-progress very quickly. That helps to keep the project moving steadily along.

On the other hand, there's really something to be said for sitting down with your partner and a pot of coffee, and just kicking ideas around for a few hours. There's a spontaneity to face-to-face collaboration that we haven't had the benefit of utilizing. Not yet, at any rate.

Thus far, we've been fortunate in that we haven't run into any real difficulties. There are always potential pitfalls, of course, but we've done a good job of avoiding them. The most important thing is to remain flexible but honest. If something isn't working for you, you need to be able to say so. But at the same time, you have to be willing to adapt to your partner's ideas and experiments.

For a writer, I think that the hardest part about collaborating is giving up the idea that it's 'my story'. That idea may be fine for some short individual projects, or for projects where you've brought in an artist on a work-for-hire basis. But that's not collaboration. For an ongoing project of this sort, both people need to have a personal investment, and both need to have a sense of shared ownership.

1 THE IDEA (DANNER)

Since *Picture Story Theatre* is an anthology of short stories, idea generation is a constant process, rather than just a starting point. Ideas come from all over – I've drawn on dreams, interesting phrases overheard in conversation, favourite traditional fables, or even just an unusual image or concept. Sometimes I have a narrative concept that I want to try, such as when I first wanted to try a silent comic, so I come up with a story to suit. I'm also very fond of looking through unpublished and incomplete pieces I wrote years ago, in search of worthwhile nuggets that can be cannibalized to make something better. 'Asleep: The Afternoon Passes', for instance, was originally a poem that I wrote in my final year of university.

For short pieces, I generally go directly to Step 2 once I have an idea. For longer pieces, I'll usually send a few premises to Bill, to find out which ones most interest him.

2 MULLING (DANNER)

The most time-consuming step in my process is the step where it looks like I'm doing nothing at all. What I'm actually doing is planning out the entire story, beginning to end, all in my head. This may only take a night or two for a short piece, or several weeks for a longer one. My rule is that I don't write anything down – no notes, no sketches, not a single word of dialogue – until I know what the entire story arc looks like. If I try to start writing too soon, I invariably wind up with useless drivel that peters out halfway through. Of course, the decisions I make are flexible, and may change at any point. But I need to know where the story's going, even if the destination might change later. I usually plan out most of the major dialogue bits at this stage as well.

For *Asleep*, this step was very brief, since it's a short piece, and the idea was pretty well encapsulated in the original poem.

Asleep: The Afternoon Passes

A boy came home
from school one day,
and found God
asleep in his bed.

Lost in a half dream,
God hugged the boy's favourite bear,
and mumbled,
'Just a few more minutes.
I'm so tired.
It's been a long day.'

The boy smiled,
drew the blanket up to God's chin,
and pulled the door shut behind him.

3 THE OUTLINE (DANNER)

Once I know the story, I write up an outline, usually consisting of just a word or two per page – just enough to capture each page's 'beat' and jog my memory later. For instance, the outline for *Asleep* looked like this:

1 Title
2 Boy comes home from school/aura
3 God asleep in bed
4 Muttering in his sleep
5 Tucking him in
6 Leaving

Believe it or not, this is actually much wordier than a typical outline, particularly page two.

This is also the step where I get a rough page count worked out and decide on the pacing of the story. A very important aspect of making those decisions is establishing the number of panels per page. For *Asleep* I decided on four panels per page, which is actually somewhat generous for a full-colour comic that updates three times each week. For Bill's sake, I usually try to stick to only two or three panels per page, unless I'm working with a narrative trick that will allow less art to go further. (Writing pages that call for a single large picture to be divided into several panels is one example of such a trick.) *Asleep* already had such small, quiet movements, though, that I felt that dividing it up over too many pages would kill its energy. And since it was such a short piece anyway, I decided it was safe to go with a higher panel/page ratio.

4 THE SCRIPT (FIRST DRAFT) (DANNER)

Since I do so much of the actual writing in my head, before I sit down to type it up, assembling the script itself is really just about filling in the details. I already know what happens on each page – it's just a matter of dividing it into panels. Of course, this is also the first chance I have to find out if an idea isn't working quite right. For instance, when I started scripting *Asleep*, I realized right away that the opening wasn't working. While starting immediately with the boy's odd discovery was an interesting technique for the poem, it was unsatisfying in the comic. So I added in a couple of pages introducing the character of Charlie and establishing the frame of mind he was in when he made his discovery. I also realized that the material I originally had planned for page 2 was really only enough for a single panel, so I rolled it into page 3. Staying flexible through this process is very important – you never want to marry yourself to a weak idea.

The scripts themselves tend to be light on the physical description. I describe the plot elements, and the mood that I want to capture in each panel, but leave the physical details up to Bill. A typical page, including panel breakdown and dialogue, might look like this:

Page 5

Panel 1
From Charlie's POV, looking into his room – asleep in Charlie's bed, radiant but exhausted, teddy bear near at hand: It's GOD!

Panel 2
Shot of Charlie looking in – completely awed.

Panel 3
Back on God, brow furrowed as he mumbles, half-asleep.

GOD: Please, just a few more minutes.

Panel 4
God rolls over and hugs the stuffed bear.

GOD: It's been such a long day.

5 THE SCRIPT (SECOND DRAFT) (DANNER)

Once the first draft of the script is complete, I do a read-through, tweaking dialogue, fixing smaller pacing issues, and making other little fixes. Then I send it off to my editor (Steven Withrow) for a thorough edit. This includes proofreading, of course, but is much more substantial than just that. He reads for problems of tone and pacing, points out plot elements that aren't clear, makes suggestions on word choice and phrasing – he's there to ensure that I always do my best writing.

When I receive his comments, I read through them, decide which comments I agree with and which I don't, and then work up solutions to the weak spots he highlighted. This may mean simply tweaking the dialogue further, or it may mean adding in whole new pages. Of course, the more ambitious a script is, the more likely it is to need substantial revisions.

6 OFF TO BILL (DANNER)

After I have a good second draft, I send it off to Bill, who pretty much takes over from there.

7 MORE MULLING (DUNCAN)

When I receive a script from Alexander, the first thing I do is print it and give it a few thorough read-throughs. Occasionally, a few of the panels will leap out at me right away and I will draw thumbnails in the margins, but generally I try to let the story sink in for a few days before I begin illustrating.

After I've been away from the script for a few days, I sit down with pencil and paper and begin sketching out ideas. I tend to start with the most prominent character in the story and work my way out from there, developing a look or style for each story as I go. This is something I used to do on the computer, but I find that using a pencil at this point in the process is much faster, and often more intuitive. I'll often fill several pages of my sketchbook this way, while I work things out.

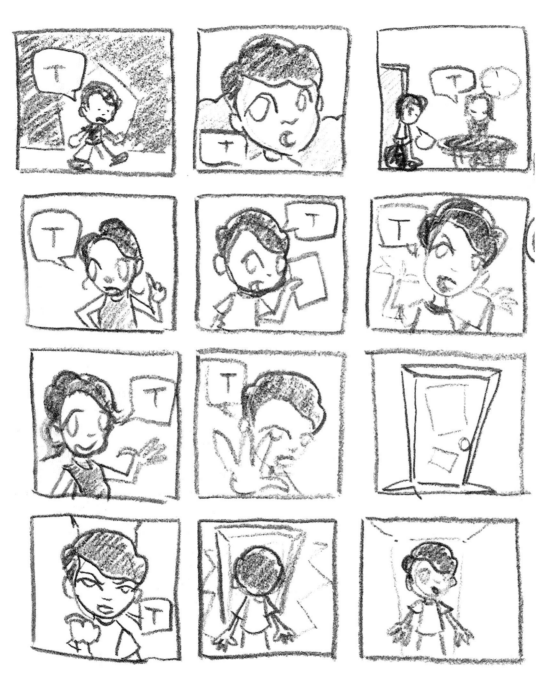

8 THUMBNAILS (DUNCAN)
Once the characters have been relatively well defined, and I'm ready to start working on the story proper, I will sit down with the script and draw thumbnail sketches of each panel in the margin. These thumbnails will serve as my map as I begin to construct panels on the computer, so I usually try to get as much information into them as possible.

9 THE DIGITAL CANVAS, PART 1 (DUNCAN)
I have been drawing comics digitally for nearly two years now, and I've developed a process through trial and error that works most of the time. That process begins on a plain white canvas in Macromedia FreeHand MX. Here I begin to construct my first panel, beginning with the focal point (usually the story's protagonist), by drawing the 'foundation' shapes.

FreeHand is a vector drawing program that produces images that resemble construction-paper collage. Each figure or object is composed of layers. Once I have my initial foundation shapes, I draw several more layers of detail to complete the character or object.

In the case of a character like Charlie, in *Asleep: The Afternoon Passes*, I begin with a simple circle. I choose my fill colour and build from the circle to create the rest of Charlie's head.

Next I draw in his eyes, beginning with the whites, and working my way towards the foreground with his pupils and eyelids. Along the way I give him the hint of a nose and mouth, and add any other distinguishing facial features.

Charlie's hair comes last, and I generally draw it over the top of the other layers, to frame his face properly, and then send it back. Most vector programs, like FreeHand, allow you to move objects from layer to layer with ease. Now, with his hair in place, I draw in his fringe and eyebrows.

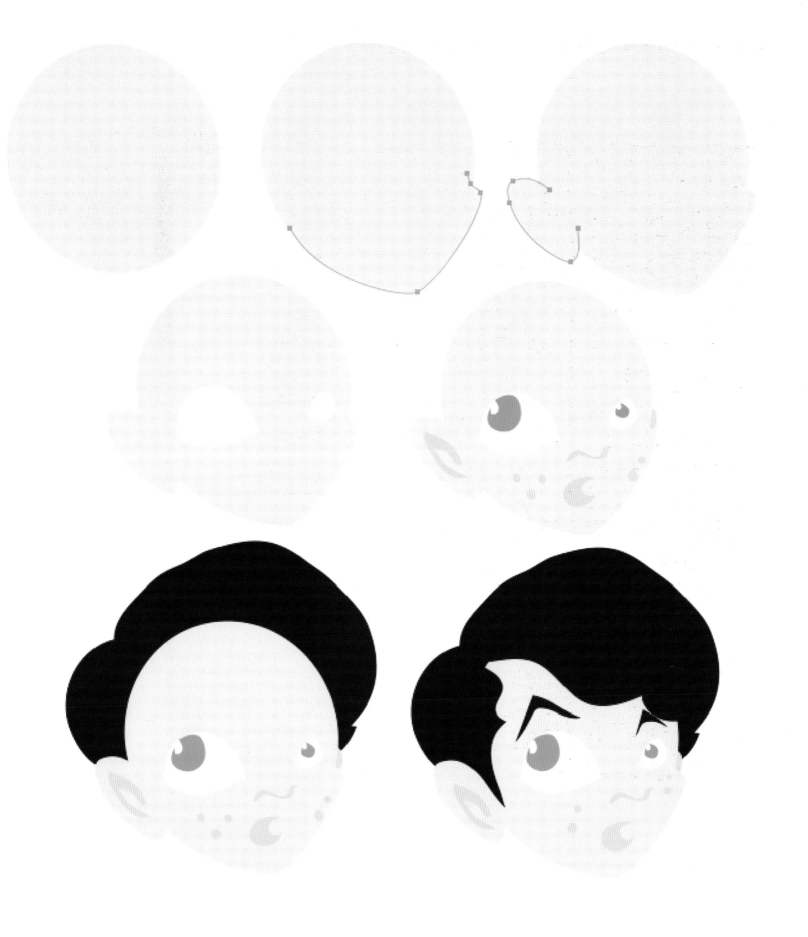

10 THE DIGITAL CANVAS, PART 2
(DUNCAN)
I repeat this process with each element, in every panel, but after nearly two years of working with my digital drawing tablet in the same drawing program, I've become much faster. Depending on the number of elements in any given panel, it can take me anywhere from 15 minutes to half an hour (and sometimes more). It can be time-consuming, but to produce something similar on paper would take longer, and probably wouldn't have the same effect.

11 FINISHING TOUCHES (DUNCAN)

Although I could finish assembling all the elements in FreeHand, I've developed the habit of finishing each panel in Macromedia Fireworks MX. Fireworks is designed to build Web graphics, and I find that it gives me more options when a panel is nearing completion. Here I can add any special effects I may plan to use in a given panel, and choose the format for the saved images. Since a good portion of readability on the Internet has to do with file size, I try to choose a file format that will make for the most efficient load-time possible. In most cases, I export all my images in either GIF or PNG-8 format.

Because I move my images from FreeHand to Fireworks, I've found it much easier to letter each panel in Fireworks, before exporting it. Although the two programs are compatible in nearly every way and were designed to work together, Fireworks tends to undo whatever font choices I've made when importing from FreeHand. Besides which, I find it a good idea to leave the lettering to the last step, since Alexander may want to make a few minor revisions once he sees the finished panels.

12 PUBLISHING (DUNCAN)

Before we actually upload a story for the general public, I build rudimentary webpages and upload them so that Alexander can have a look at them. At this point we're usually just looking for things to polish up, but on occasion we may want to add a panel to help with pacing.

Once we both have something we're happy with, we open the curtains, and another episode of *Picture Story Theatre* is born.

Tyne Metropolitan College

Embleton Avenue - Wallsend
Tyne & Wear NE28 9NJ

INFINITE CANVAS

'Infinite canvas' is a term coined by Scott McCloud in his seminal book *Reinventing Comics*. In that book, McCloud describes the computer monitor as a window that can show part of a comic that spreads across infinity. In practice, the term has come to be used to describe comics that require the reader to scroll with his or her browser. Sometimes the term is used to describe any type of webcomic that utilizes the particular 'formal' possibilities of the Web.

Webcomics can be created in which the reader must scroll in one or more directions. Often, the comic will be laid out so panels follow in a straight line, either up-and-down or side-to-side. The comic can be composed of discrete panels in sequence, multiple series of panels running in parallel, one image with no clearly defined borders but with images fading and overlapping, or any number of other styles and methods.

Infinite canvas comics can be created by any means and can be put together in several ways. Programs like Photoshop allow you to create 'slices', which let you export a single image as a series of smaller Web images, and an HTML page that puts them together. This is useful if you wanted to create a long, seemingly single-image comic.

You can also use HTML tables to house your images at specific places. This requires a lot of planning and a good mind for coding (though you can use a program like Dreamweaver to help with that).

Infinite canvas has come to represent – for some webcomics creators – the special formal possibilities offered by creating and reading comics digitally. For some creators, this is an important reason for making webcomics; for other creators, the idea of the infinite canvas moves too far away from what is appealing about comics.

Below and far right: **This infinite canvas webcomic was created in Photoshop. Using the *Slice* tool, the creator can set up 'slices' of the comic, broken into separate images (JPEGs, GIFs, or PNGs) and Photoshop will write HTML to reassemble them in a browser window.**

Right: **Scott McCloud's *Zot Online* was one of the earliest and most popular infinite canvas comics.**

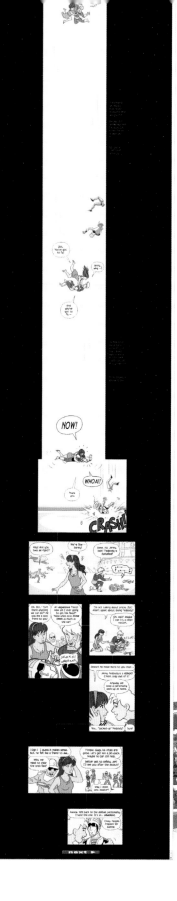

FLASH AND COMICS

Flash is an animation program created by Macromedia that has been adopted by several webcomics artists as a means of presenting – and interacting with – their comics.

Some artists use Flash to tell a linear story, as Scott McCloud did in *The Right Number*. Flash is well suited to present comics on the Web because it can load and play at the same time, so the reader can be loading panels while reading other ones. Flash was designed to work with vector images, but handles pixel-based images very well.

Flash files are built around a timeline that breaks every second of time into a number of frames. The artist adds 'keyframes' at certain points when events occur. For instance, say you were to create a comic where a panel faded in over a period of two seconds. You'd place the panel in frame one and make it transparent. Since 12 frames per second is standard for the Internet, you place another keyframe 24 frames (two seconds) later, at frame 25. Here, you can change the attributes of the panel from 0% opaque to 100%. By adding a 'tween' in the middle of the two points, Flash creates a smooth transition from transparent to opaque.

Other artists, most notably Daniel Merlin Goodbrey, use Flash's ActionScript programming language to create comics that react to what the reader does, creating a new form of comics. His 'Tarquin Engine' combines the technical qualities of Flash with the formal ideas of the infinite canvas.

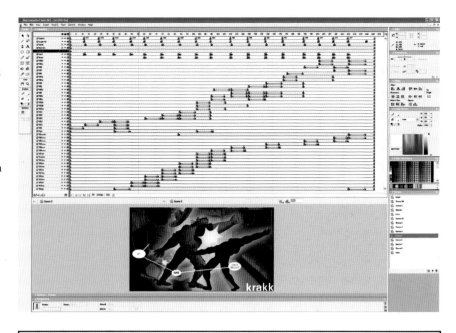

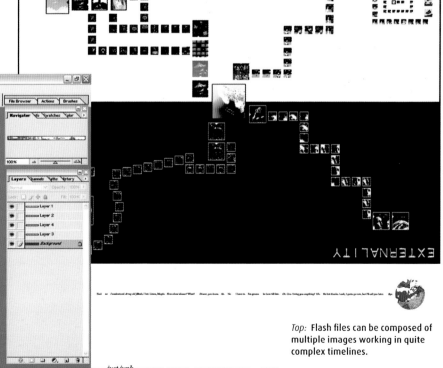

Top: Flash files can be composed of multiple images working in quite complex timelines.

Above: Daniel Merlin Goodbrey's 'Tarquin Engine' (a set of Flash ActionScript code) was a breakthrough in Flash comics, and was used in his own *Externality*.

NICK BERTOZZI

What's *The Salon* about?

The Salon is a book about Picasso and Braque discovering Cubism in 1907 Paris. It's currently running one page per week on *Serializer.net*. Knowing that the subject might be a little dry for some, *The Salon* is also about Picasso, Braque, Gertrude Stein, Erik Satie, and Guillaume Apollinaire's search to find creatures that have come to life from famous paintings via a mysterious absinthe. It's an excuse to draw old Paris, old costumes, old famous paintings, and drunken people.

How did the comic come about?

I was pitching a number of series to different publishers and came up with the idea of famous paintings coming to life. I liked this idea so much that I decided to develop it on my own. It was going to be an ongoing feature in my series *Rubber Necker*, but Tom Hart, a good friend and the editor of *Serializer*, suggested I put it online. I was more than happy to do that, since I wanted to work in colour. He also asked me for a name for, and design of, the site. So blame me!

How do you balance what's interesting to you versus what's interesting to the audience? Is it different for work-for-hire comics and your own stuff?

I imagine a reader who wants to get inside my comics vehicle and see what it's like to ride around in my head for a while. That's what I like to see in any form of art. Doing comics as work-for-hire [work that is commissioned and owned by the publisher] is no different to me. They have to achieve that connection with the reader. I fail at this more often than I succeed, but I think I learn a little bit more with each attempt.

Is *The Salon* your first webcomic?

The Salon is the first comic that I've put on the Web that has any kind of presence. I've had a bunch of comics online, but never in any kind of regulated manner.

Would you do more comics if the job paid better, or are you happy with comics' place in your life?

I'd do comics exclusively if I had the opportunity. I'm working towards that day, touch wood and all that.

Was *The Salon* always intended to be collected into print?

I planned from the beginning of working on *The Salon* that it would be a printed book. I'd like to make a comic that's just for the Web, but I have to come up with the right content first.

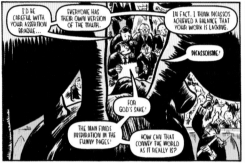
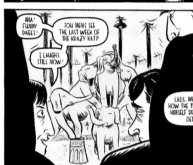

Do you think there's a split – real or perceived – between print comics creators and Web ones?

I don't see a difference right now, other than the webcomics creators are generally a little younger than the print creators.

It seems like the Web allows creators greater freedom in economically serializing long-form graphic novels.

I would agree. While paper is still a cheap and convenient format to publish stories, many potential readers will not enter a comics shop, the traditional market for a 32-page comic.

Will these potential readers find comics via the Internet? I'm actually not a very good person to ask about this, since I don't have a firm grasp on the Internet community. I like the direct author-to-reader relationship of the forums, but I don't know how to make more people read my strip! Also, I don't know enough about how the print versus online battle goes outside of comics. Newspapers and magazines, for example. And what about 'digital paper'?

People will always say that the sky is falling and have been writing the epitaph for comics for years, and certainly they could all disappear tomorrow, books included. All the more reason then to concentrate on creating the best content one can, rather than worry about what form comics will take.

So do you think there is a webcomics community? Do you see yourself as part of it?

Absolutely there's a webcomics community. But it involves spending a ton of time posting on message boards, and I have a daughter, and a book to finish. Maybe I can get a stand-in to post for me.

stellar cartography

NICK BERTOZZI ON HIS EARLY DAYS

When Dean Haspiel was my roommate, we visited his mother's antique shop where she had, hanging on the wall, a beautiful map of the United States just after the Mexican–American War. Seeing the map triggered the idea of creating a comic using the map of the USA and using the boundaries of each state as a panel border. I was working through this difficult challenge when Dean said: 'Just make it a road map in which each of the folds of the map is a new panel.' I did just that and sent it off to the Xeric Foundation to try for a grant, which I received.

I'd been making comics for several years that were in the dark humour vein that no one had been buying or would publish. When *Boswash* came out, people started buying the book and e-mailing me, telling me that they liked it, and I was startled by the positive reaction to the piece as opposed to the drone of crickets that had met my previous work.

Boswash works in the sense that it is a comic as an amusing Art Object, but I received a good deal of criticism about the lack of content in the book. *The Salon* is meant to be read for its content, and its format is intended to be as 'invisible' as possible. I plan to do more stories that experiment with form, but *The Salon* is me trying to work out how to tell a story within a classical form.

I made the online version of *The Salon* horizontal after reading Derek Kirk Kim's *Small Stories*, which had been formatted horizontally online. I was intrigued by this format and wanted to try it for my own comics to see if it feels more natural to read all the way from left to right than to scroll top-to-bottom. My focus has been to make the reading experience as simple and obvious to the reader as possible, since I want them to pick up on the content.

HOME: NEW YORK CITY

URL: SERIALIZER.NET

EDUCATION: BA IN SPANISH LITERATURE, MINOR IN FINE ART FROM UNIVERSITY OF MASSACHUSETTS AMHERST

CURRENT OCCUPATION: CARTOONIST/ ILLUSTRATOR

ARTISTIC INFLUENCES:
HERGÉ, JACK KIRBY, DR SEUSS, EDWARD GOREY, MATTHEW BARNEY, THE COEN BROTHERS, ANSELM KEIFER...TONS OF OTHERS AND WHATEVER BOOK I'M READING AT THE MOMENT

NICK BERTOZZI WORKTHROUGH

1 My scripts start as a rough plot that describes what happens on each page; then I add dialogue and flesh out the actions. I try to make each page a self-contained unit, with some action that comes to a resolution. Having the four-panel format has really helped me decide what's most important to convey to the reader. Since the space is so compressed, I have to leave out tons of dialogue. That's good because it forces me to try to give a character depth by concentrating on their actions or how they interact with an object. Also, I really try hard to cut out plot exposition in the dialogue. Obviously, there's going to be some exposition, but I try to cover it up with a joke or force it into the subtext of a conversation that the characters are having. I want the author's stamp on this book to be as invisible as possible.

I do the majority of my writing on the computer, but I will occasionally write out plot and dialogue in my sketchbook.

```
Page 98 Plot Outline:

98. Salon drives through town. They go from nice part of town to
crappy. As they pass police, P & B duck down in the carriage.

_____

Page 98 First Pass:

98a. The Salon ride in a carriage pulled by two horses and
driven by a very old man. The bg shows that they are in the nice
part of town. Gertrude sits next to the driver. She waves her
hand in front of the driver's face.

Gertrude:

If You're really blind, then how
do you know which way to go?

Driver:

I don't.

The horses do.

98b. Gertrude looks at Driver, unbelieving.

Gertrude:

The horses do.

Driver:

Yes, they tell
me everything...

Such as the approach of group
of policemen coming around the
northeast corner, to your right.

Gertrude:
```

...aque and Picasso hit

2 The next step is the rough. This is the hardest part for me because I have to squeeze so much information into these tiny panels: character poses that make sense in relation to the architecture, the characters around them, and their physical placement within the scene's 'space' across all four panels; making sure the placement of dialogue balloons is as clear as possible; varying the content from panel to panel so that I don't end up with talking heads (my most-hated comics cop-out).

I do all the roughs in the same sketchbook at roughly the same size as the finals. I'll usually sketch out a character's pose or the relation of two characters' poses to one another or the background on a sheet of paper before putting them into the rough panels.

Also, at this point I have my three readers look over the rough and give me their feedback on which I make changes. This includes fixing continuity mistakes and adding information to unclear scenes. Then I take another look to make sure that the page is interesting and could stand on its own, separate from the other pages. That's not always possible, but it's something I like to think about.

98A

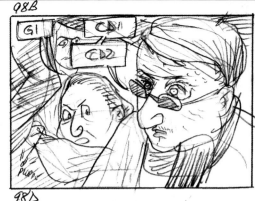

98B

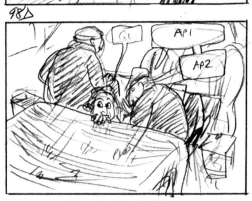

98C

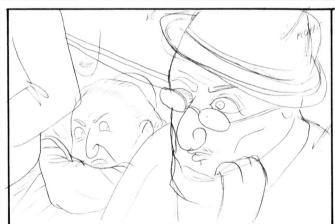

98D

3 The next step is laying out the panels on the paper. I use 100-lb semi-smooth 14" x 17" paper. The individual panels are 8¼" x 5¼" and are arranged in two tiers of two panels each. I lay out the panels on the paper in pencil and ink in the borders with a black Sharpie marker.

4 Now I move to pencils. I use a mechanical pencil with a hard 4H lead. If I use a softer lead, my pencils quickly turn to mud. The trade-off is that with the harder lead, I gouge the paper, which makes it more difficult to ink, but since the art style is pretty loose, I don't mind. At the pencilling stage I refer pretty closely to my roughs, but sometimes I still change significant aspects of the drawing.

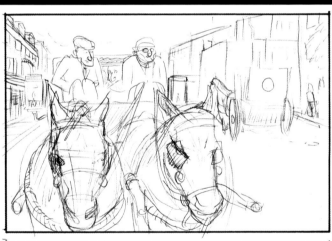

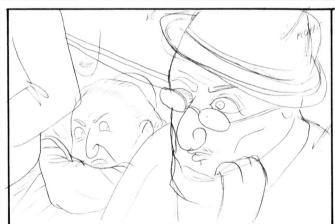

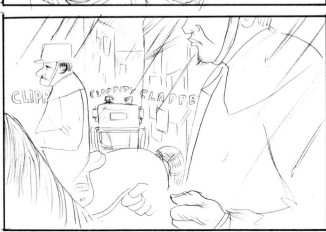

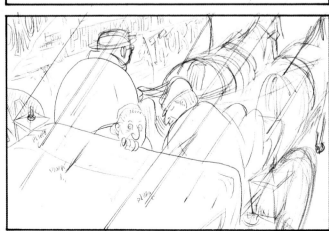

5 For the inking I use a Windsor-Newton Series 7 #1 brush and Sumi ink. Sometimes I use an Aitoh cartridge brush-pen when I'm working on big areas that can use loose inking. Lately, I've really been trying to work out the big black areas of ink at the pencilling stage. I also try to keep line widths in the foreground larger, and line-widths in the background thinner to give the illusion of depth.

After inking, I erase the pencils with a white eraser, since the gum erasers don't pick up enough of the pencil for me. The Sumi ink really sticks to the page when I erase.

6 I scan at 100%, 1,200ppi (optical, not interpolated) as a 'black-line document', sometimes with the contrast pushed up a tiny bit. Once the page is scanned in, I open it in Photoshop and clean up any little marks that I don't like, convert it to greyscale, switch the image size to 300ppi (without resampling), convert the image to CMYK, and add a 'colour' layer below the 'line' layer, which I set to *Multiply*.

7 I've only been using three colours per page: straight black for the line, and then two other colours that fit the mood and time of day of the scene. Then I break those two colours each into a dark version and a light version. I guess I use white as a colour, too.

I colour the characters (and any objects that they may be holding) in one colour, then everything else is the other colour. This helps to make the characters stand out against the background, since my drawings are often messy and hard to discern in just black and white.

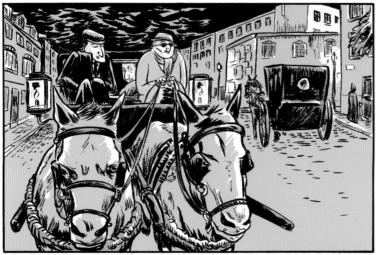

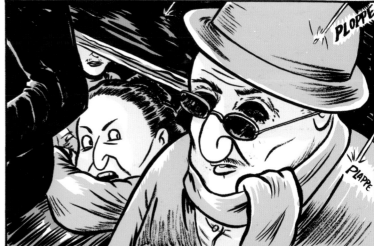

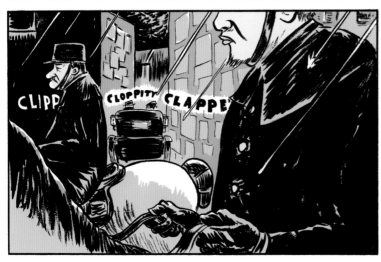

8 I've been doing the lettering in Adobe Photoshop using a typeface that I created using Macromedia's font generation program, Fontographer, from my handwriting. I create the balloons using the *Ellipse* tool, adding the balloon tails with the *Add anchor point* tool and pulling it (and the balloon itself) around with the *Direct Selection* tool. I fill the balloon shapes with white and then stroke with black. For the printed version, I'm going to redo the lettering and balloons in Adobe Illustrator. This'll be a pain, and I should have thought to do it earlier, but I was stupidly lazy!

9 The final step is flattening the image, moving the bottom two panels of the page to the right of the top two so that the on-screen page reads horizontally, and then saving it all out as a GIF image using the *Adaptive* colour setting. I upload it through an FTP program, to www.serializer.net, and it's done.

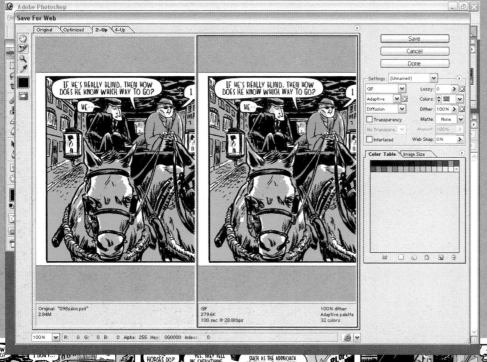

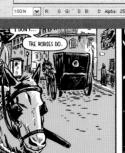

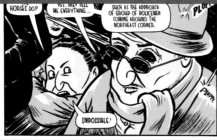

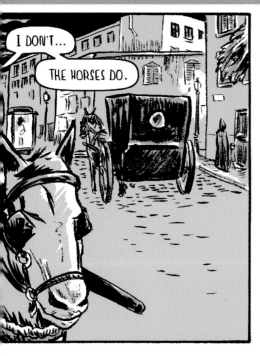

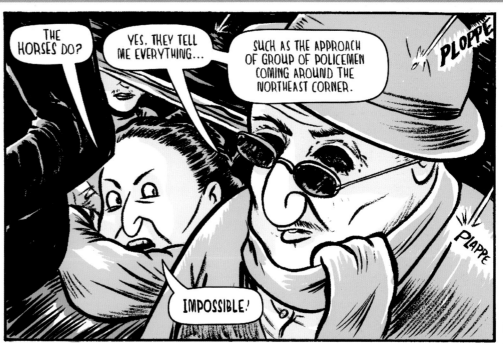

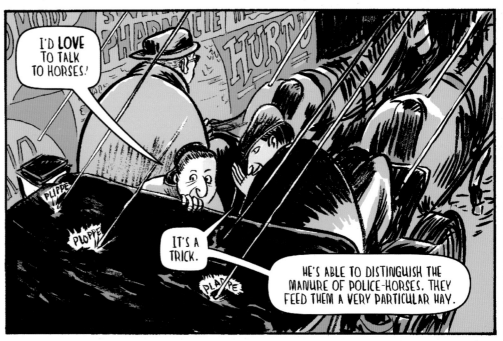

EXPERIMENTAL TECHNIQUES

When most people think 'comics', they think of bold, black lines and cartoony (or at least heroically idealized) art. Even when people think of webcomics, the basic tools of creation that tend to spring to mind are paper and ink.

But today, there are many more options open to comics creators. Comics were once defined by the technical limitations of print – bold ink lines were the norm because cheap reproduction would render anything else illegible. Flat colours were required (if colour was available at all) because nothing else was economically feasible. And certainly nothing could move or make sounds, because that simply isn't possible on a printed page.

The digital revolution has changed all that, and some comics creators (in print as well as the Web) have grabbed hold of these new possibilities. Photo-comics have existed for decades, but have tended to require expensive equipment and printing. Today, of course, anybody with a digital camera and some image editing software can create them.

Webcomics can make use of repeating ('looping') animations by using animated GIFs or Flash movies. These effects can add to some comics, but too many can easily become distracting. With Flash (or video software like After Effects) hybrids of comics and animation can be created.

Some artists have also begun experimenting with sound. Some have tried to turn comics into multimedia pieces, combining animation with spoken words and sound effects – almost becoming limited films. Others have added specific sound effects for particular scenes, or added background music to accompany the comic.

Many people argue that these experimental techniques take away from comics, and feel that comics should be left as they have traditionally been – ink on paper, even if the paper gets scanned. Ultimately, this becomes a personal choice for each comics creator. And, make no mistake, each of these elements has moved from being a technical necessity to an aesthetic choice. Certainly, as the technical requirements of today's Web give way to new technologies, future generations will have whole new vistas open to them. Whether or not to explore these new territories is best left to the individual.

Above: Photographs – even photographs of toys – can be manipulated with Photoshop (comic by John Barber).

Right: Cayetano Garza Jr. often uses repeating animations to create an odd, surrealistic feel (from *Cuentos de la Frontera* at www.moderntales.com).

Below: Daniel Merlin Goodbrey has experimented with sound as well as vision (from *The Mr. Nile Experiment* at www.e-merl.com).

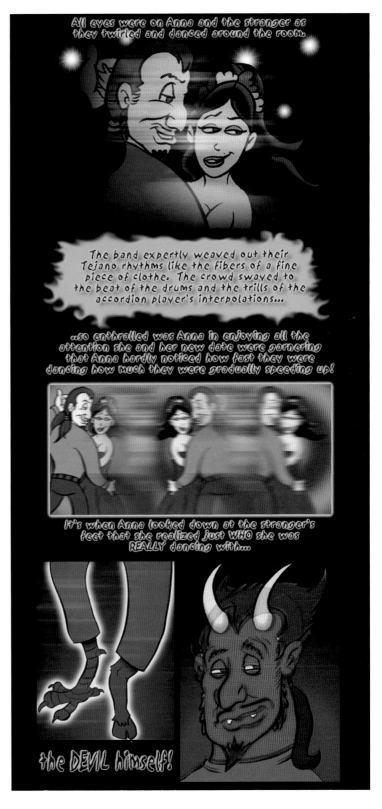

Do you come from a print comics background, a Web background, or both?

I come from a print background only in so far as I used to sit around and create comics that would 'someday' be printed.

I liked the immediacy of webcomics – finish the piece and post it. Done. I tend to be very results-oriented, meaning that if the piece isn't going to 'perform' (get out there in front of eyeballs), why bother doing it? I don't necessarily want to think this way – I'd like to do art for art's sake – but it's my natural tendency. So, psychologically, webcomics work very well for me – I know that there's a built-in distribution mechanism, which implies a built-in readership.

Do webcomics have any advantages or disadvantages compared to print?

The primary formal advantage of webcomics (as distinct from the distribution issues mentioned above) is the use of a medium that is far more elastic than paper. Webcomics open the doors to animation, sound, 'free' colour (meaning it doesn't cost more to do a piece in colour than in black and white, as it does in the print world), non-linearity, and a host of other tricks. Many of these doors should arguably stay closed, but it does give the creator the freedom to play with them.

I'd say the primary disadvantage to webcomics is the same disadvantage to everything virtual, which is that it doesn't really exist. There's no pride of ownership in a stream of 1s and 0s – you can't put a webcomic on a shelf next to other webcomics. Also, this introduces physical barriers – you can't read a webcomic on the toilet.

Is there a webcomics community and if so are you a part of it?

Yes, there is a webcomics community, and I suppose I'm part of it by default. This is, in large part, due to the Web-based marketing mechanisms we have. Marketing your work mostly involves forums, e-mail lists, blogs, etc. These things all engender 'community'

whether you want them to or not. I mean, you can go to great lengths to avoid being part of the community, but in the absence of active evasion, you have tacit conformity.

There's a mixing of Japanese and American comics styles in your work, right?

Sure. I think most contemporary artists have mined manga – some more successfully than others. I don't want to draw characters with huge eyes and tiny noses, but some of the more subtle aspects of good Japanese comics art (such as the way they do folds in clothes) seem to work well for me.

Also, the much-discussed pacing and layout conventions of manga can be really rich. Someone once pointed out to me that American comics tend to have this structure where each panel accomplishes a specific moment and point in the storytelling. That is, each panel is absolutely necessary for the story to be properly understood, and each one showcases a unique moment in which something pertinent to the plot happens.

Japanese comics tend to use panels in different ways – for instance, six sequential panels of a leaf falling to the ground. Manga generally provides much more ambience and 'feel' than American comics (I'm talking typical American comics here), and I try to use some of that in my work.

What part of the artistic process do you find most rewarding?

Being done with it. A long time ago, someone asked me whether I found the work or the product more rewarding, and I'd say it's probably the product. Having something that you can hold in your hands (or look at on your screen) that is the end product of your mind and capabilities...well, that's just cool. While I'm working on it, I don't see it from that point of view – I'm trapped in details.

But as for during the process, I'm not sure. I enjoy all the steps. Colouring is probably my least favourite, as I've always been

more interested in line and shape than in colour and tone. I used to really love pencilling, but I get tired of it quickly in any given session, and I've become lazier and lazier at it. My pencils now are for little more than layouts. Inking used to be less mentally stimulating for me, but the more I offload the artistic shape of the piece onto the inking, the more I like it. Inking is where I get into the details and I turn shapes on paper into three-dimensional objects. Shadows and light appear, and things really start to look like things. Plus, a brush is a really compelling tool to use. It's much less forgiving than a pencil, but it gives you this amazing power to turn a line into a part of something. It's this great, really organic process that I still haven't seen equalled – by a dip pen, Wacom, or anything else.

Of course, writing is a lot of fun, too. In some ways, I think I like it best. In the course of doing the art for a comic, there are always scenes or panels I'm not excited about drawing, but I'm always excited to do dialogue.

Does doing comics make you any money? And if so, in what way?
The only webcomic I do is *Outside the Box*, which makes money from the revenue-sharing model of *Modern Tales*. I haven't yet ventured into micropayments, and I haven't professionally (i.e., for pay, for a publisher) published any print work. I would love to expand into these other areas, but as yet, haven't.

PHYSICAL AND VIRTUAL MEDIA
I have a collector mentality in a lot of ways, so I'm kind of anguishing over the impending death of 'pride of ownership'. To me, buying a CD is always better than downloading the tracks because you get the artwork, sometimes you get cool packaging, and you get something to slot on your shelf. I like being able to look at a shelf full of CDs, visually tracking the completeness of certain collections, or the history of my musical tastes. Looking at the file list of my 'iTunes Music' folder isn't nearly as exciting. But I realize that a lot of this is a function of my age. I grew up with physical media – kids coming up now haven't known a world without MP3s, so to them that's how music is supposed to be distributed. Eventually, the collector mentality will probably disappear. It's awfully hard to be sentimental about your possessions when they're infinitely duplicable.

HOME: SAN DIEGO, CALIFORNIA
URL: MODERNTALES.COM
EDUCATION: BFA IN STUDIO ART, UNIVERSITY OF CALIFORNIA, SAN DIEGO
CURRENT OCCUPATION: CREATIVE DIRECTOR OF A SMALL COMMUNICATIONS MEDIA AGENCY

ARTISTIC INFLUENCES:
PRINT COMICS: MATT WAGNER, MASAMUNE SHIROW, ALAN MOORE, CHRIS BACHALO, GRANT MORRISON
WEBCOMICS: JOHN BARBER, DANIEL MERLIN GOODBREY, DIRK TIEDE
FILM: DAVID FINCHER, BRYAN SINGER, PRESTON STURGES, ORSON WELLES, HOWARD HAWKES, AND SAM RAIMI
WRITERS: AYN RAND, ROBERT ANTON WILSON, STEVEN BRUST, GEORGE R.R. MARTIN, GEORGE ALEC EFFINGER, ALEXANDRE DUMAS, RAYMOND CHANDLER, AND MAX BARRY

Would you do more comics if it paid better, or are you happy with comics' place in your life?
The *Modern Tales* revenue share is currently little more than a pittance (especially compared to what I can make hourly selling media design services), but it is fairly steadily increasing and, at some point in the future, could conceivably be some real money.

I'm definitely motivated by profit. I invest the most in areas that I think will 'perform' – get out into the market, get noticed, and make me some money. If I could do comics (or some fusion of various creative endeavours) full-time and make a good living (notice I didn't say 'decent' – I said 'good'), I'd love to, but I'm certainly not the type to give up a lucrative 9-to-5 in exchange for starving and drawing all day.

Where do you see webcomics in general going in the future, and where do you see yourself within that future?
I think that, in a certain sense, anything that can be, will be. Most new markets, products, and ideas are introduced not through tumultuous revolution, but through steady assimilation. Technology drives creativity, which drives technology, endlessly. In a way, it was inevitable that webcomics would come to exist – if not in their current form, then in some other electronically deliverable form.

Ta Fa Lt Xo VA Yu

3 I start the storyboarding process by sitting down with the script and dividing it into panels, which I mark with a letter. Then, while I'm doing the layouts on the storyboard, I jot that letter in the correct panel. This is important so I don't totally forget what I was thinking later on.

I storyboard Flash comics in a very conventional way. I break them into pages and panels with the understanding that the 'pages' won't end up meaning much. But it is a way to get an idea of what's going to be on-screen at any given time. The Flash frame is dynamic, so different panel configurations will come up at different times. Sometimes a certain panel will stay up while several others move in and out around it. Each 'page' in the storyboard represents a specific panel configuration I want to get to.

1 Before I do anything else, I write up a treatment outlining the basic plot of the story: the beginning, middle, and end; the main characters; and the themes I want to deal with. This is usually pretty vague, and quite often a lot of it changes throughout the story. But it at least gives me a sort of map to work from as I move forward.

Since each story arc has a different feel, I like to refresh the graphic design of the series each time. This includes promotional images, title cards, credits screens, etc. I choose fonts, colours, and visual elements that map to the feel and theme of the story. It's important to me that *Outside the Box* (*OTB*) has an individualized look, so I use a custom-made font for dialogue and voiceover.

2 Then I get to the fun part: writing the script. I write scripts mostly in screenplay style, but with a fair amount of me-as-scripter having a conversation with me-as-artist. Because I do everything on *OTB*, I can feel free when I'm scripting to cut corners, withhold information, and admit that I don't know how to finish a scene. No artist is going to see the script and laugh at me.

Jamie: Okay, that's the piece.

Claire: Pardon?

Ⓛ **Jamie**: Carlyle family scandal. There's no money. Hasn't been for years. Disgrace scares ~~you~~ her more than losing ~~your~~ daughter. her

Ⓜ **Claire**: Mr. Black, I wouldn't presume to judge your principles, or the way you conduct your affairs. There is much you don't know about this family, and I don't intend ~~on sharing~~ it, I just want my daughter back and this unpleasantness brought to an end. to share with you. Small receding

Elizabeth: ~~You see the picture now, don't you?~~ E: No money, No Cops...

Jamie: ~~It's not a pretty one.~~ J: ...and no recourse

Claire: Pardon?

E: Which means it's up to us to find a weak link...

J: ...And it has to be Adrian — we have to get to him.

Jamie: ~~I have to bet on Adrian. Pull that thread.~~ ~~He's the weak link.~~

Ⓝ **Elizabeth**: ~~And it all unravels.~~

Claire: Mr. Black?

Ⓞ Coming back to the here and now.

Jamie: Mrs. Carlyle, I'll recover your daughter for you. Shall we talk about my retainer?

Storyboards are crucial to a project like this, because by the very nature of a Flash-based comic, the panels act independently of one another. I don't care what panel goes where on what piece of Bristol, because it's all going to get chopped up and laid out dynamically later. So an 'original' page of *OTB* art may have three panels from unrelated scenes on it, facing the wrong way from each other.

4 The pencilling stage is pretty standard stuff – I know I'll be inking, so the pencils have got rougher. These days I'm very close to just doing layouts in pencil and then hoping for the best when I start slathering indelible ink on them.

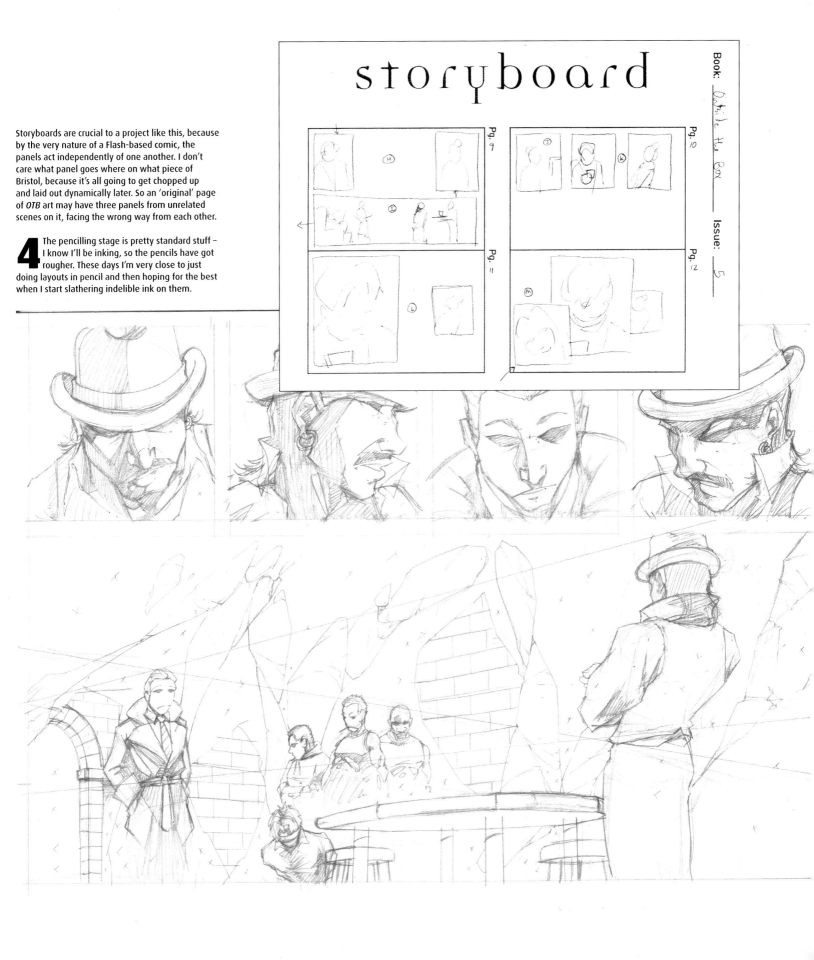

6 Using Photoshop, I go into each scanned file, pull out a single panel, and put it in its own document so that each panel of the comic is in its own PSD file. Then I clean up stray black-and-white marks that got in because of dirt on the scanner glass, or an area where the black/white threshold chose incorrectly. Also, this is where I fix a lot of mistakes from the inking process. This step takes a long time.

Then I drop out the whites – this is easy because the image isn't anti-aliased. I just put the image on its own layer, so there's only transparency beneath it. Then I use the *Magic Wand* tool with *Tolerance* set to 0 (so it only chooses the exact colour you click on), *Anti-aliasing* unchecked (so it won't try to pretend that the image is anti-aliased after all), and *Contiguous* unchecked (so it will select every single bit of white in the whole document, not just in the immediate vicinity of the mouse click). Then I hit the delete key and I'm left with a black line drawing over transparency, which is right where I want to be.

5 For the first *OTB* story arc, I used brushes for inking. The Windsor & Newton Series 7 is my absolute favourite inking implement. I love the feel, I love the look, and I think my work looks better brushed than any other way. However, brushwork is slow, so for the second arc, I switched to a crowquill pen. Speed is important in a project like *OTB* because I'm essentially doing the panel-count equivalent of about three-quarters of a 'regular' comic book all by myself every month – in my spare time.

I scan *OTB* pages at 300ppi. Even though it's a screen-res final product, I like to do all the digital work at high-res, just in case. If *OTB* ever went print, or I needed to turn a panel into a poster or a promo image in print media, it's more or less ready to go. I use the bitmap/black-and-white setting. It is very important for the colouring process that the artwork not be anti-aliased. I scan as much as possible in one go – as many panels as will fit on the glass at once. Since it will all be chopped up in the next step, I don't care if the panels end up scanned in weird configurations.

7 The way I colour *OTB* is pretty simple. I just select an area using the *Magic Wand* and *Lasso* tools, the latter generally on the setting that lets you click a series of points rather than have to draw a continuous line. Then I fill the selection with a gradient.

In the first *OTB* story arc, I used fairly naturalistic colour – I made things the colours that they are and used the gradients to imply lighting by putting the light end of the gradient toward the light source. In the second arc, I wanted more stylized colour, so I reduced each scene to two colours and used the juxtaposition of colours to imply lighting. Then the gradients became more useful for modelling and creating dramatic contrasts.

At this point, I do any special effects necessary in a scene, from smoke, to blood, to motion blurs, to lighting effects. I have a lot of little effects I like to use, and I've developed pretty good ways to do most of them consistently.

For instance, dramatic lighting effects – achieved through a combination of Photoshop's lighting filters, layer mode settings, and simple gradients – can help create dynamic images.

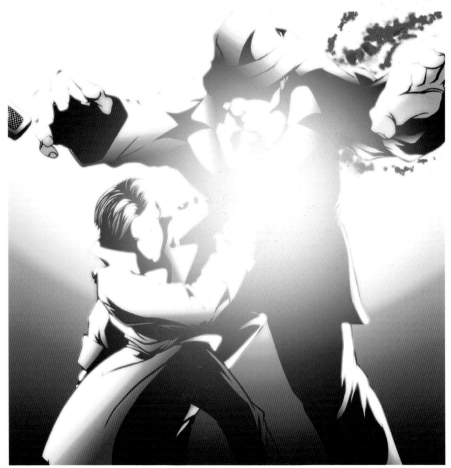

8 To output the images for Flash, I save a flattened PICT of the file (so I don't accidentally save my PSD while it's flattened), and then I scale it down to the proper size, using the *Image Size* command. My Flash canvas is 640 x 360 (which is 16 x 9 ratio, like a widescreen TV, just FYI), so I know the image has to fit properly into that space. Often, each panel will have to be a very specific size relative to other panels, so sometimes I'll make a mock-up of the Flash canvas in Photoshop and muck around with scaling and placing the images in there so I know they'll be the right size. In general, I scale the images down to about 15% (300ppi becomes 72ppi, which is about 25%, plus I draw the images at about 1.5 times their production size, which knocks the image down to around 15%), using the *Image Size* command.

Once the panel is scaled to its proper size, I save a copy for use in Flash. Depending on the image, I save it as either a JPEG or a PNG-24. Standard panels with hard borders become JPEGs. I use the *Save For Web* command because it creates JPEG files with very high quality and very low file size. If there's any sort of transparency effect used in the image (such as a drop shadow around the panel, or if the panel is a cut-out of a character), then it becomes a PNG-24. The PNG-24 format is great for this because it supports a transparency channel and Flash understands it. The downside is that when you go to publish the final product, Flash will turn all PNG-24s into JPEGs, and Flash doesn't do this as well as Photoshop.

9 Now it's time to go into Flash. First, I set all of the global document settings. This includes frame rate (15 fps), document background colour (grey, so I can see both light and dark graphics against it), and canvas size (640 x 360). Then I import all of the graphics.

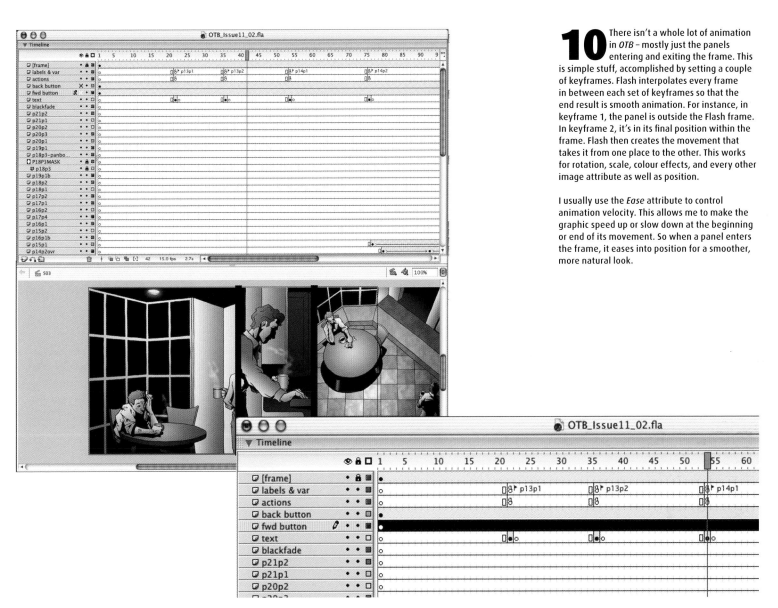

10 There isn't a whole lot of animation in *OTB* – mostly just the panels entering and exiting the frame. This is simple stuff, accomplished by setting a couple of keyframes. Flash interpolates every frame in between each set of keyframes so that the end result is smooth animation. For instance, in keyframe 1, the panel is outside the Flash frame. In keyframe 2, it's in its final position within the frame. Flash then creates the movement that takes it from one place to the other. This works for rotation, scale, colour effects, and every other image attribute as well as position.

I usually use the *Ease* attribute to control animation velocity. This allows me to make the graphic speed up or slow down at the beginning or end of its movement. So when a panel enters the frame, it eases into position for a smoother, more natural look.

11 ActionScript is Flash's language for controlling the movie and is the meat of the *OTB* programming process. Basically, a line of script tells the Flash movie to stop as each panel moves into position. Without this command, the movie would just play straight through. To get the movie playing again, there's an invisible button (a button with no image in its 'Up', 'Down', or 'Over' states) covering the entire frame, and a 'Play' action that's assigned to the button. When the user clicks it, the movie starts playing and goes until it reaches the next stop point.

12 The 'Back' button is a little tougher. It appears in the lower left of the frame, but only when the user rolls over that area with the mouse. It's a button that has no image assigned to its 'Up' state, meaning that when the user is not interacting with it, it's invisible. But when the user rolls over it, it appears, showing the image assigned to its 'Over' state.

This button is linked to a script that tells the movie to go to and play the variable 'vflag'. This line of script never changes, but the value of 'vflag' (because it's a 'variable') can change at any point in the movie. At each stop point, I include a script that tells the movie what to set 'vflag' to. When the user is viewing 'p1p2' (page 1 panel 2), the 'vflag' is set (by a single line of code) to 'p1p1'. So if the user clicks the 'Back' button, it activates the button's script, which plays the movie at the place dictated by the contents of 'vflag' – in this case 'p1p1'. Thus, the movie jumps to 'p1p1' – in the user's experience, it jumps back one panel.

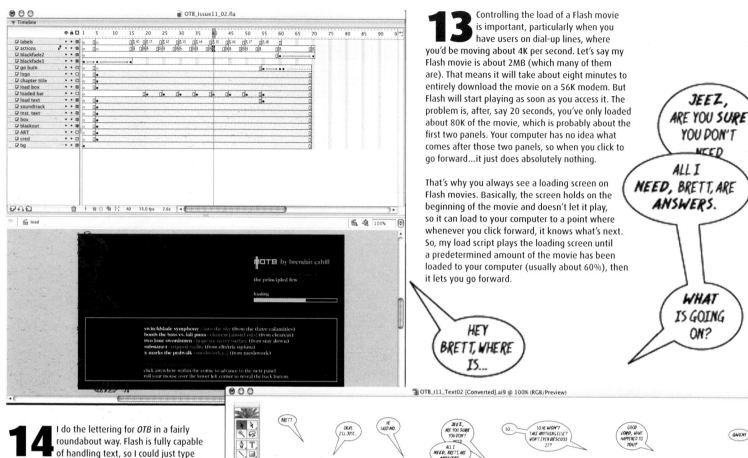

13 Controlling the load of a Flash movie is important, particularly when you have users on dial-up lines, where you'd be moving about 4K per second. Let's say my Flash movie is about 2MB (which many of them are). That means it will take about eight minutes to entirely download the movie on a 56K modem. But Flash will start playing as soon as you access it. The problem is, after, say 20 seconds, you've only loaded about 80K of the movie, which is probably about the first two panels. Your computer has no idea what comes after those two panels, so when you click to go forward...it just does absolutely nothing.

That's why you always see a loading screen on Flash movies. Basically, the screen holds on the beginning of the movie and doesn't let it play, so it can load to your computer to a point where whenever you click forward, it knows what's next. So, my load script plays the loading screen until a predetermined amount of the movie has been loaded to your computer (usually about 60%), then it lets you go forward.

14 I do the lettering for *OTB* in a fairly roundabout way. Flash is fully capable of handling text, so I could just type directly onto the Flash canvas, but there are a couple of things that keep me from doing it that way.

First, Flash doesn't kern properly, so it doesn't use the metrics I set up in my custom font. Second, part of lettering is drawing the bubbles and connectors. And here's the thing about Flash's drawing tools: I hate them. What should be a simple process of drawing an oval and then a wedge turns into a Herculean task. Their aim is to make vector drawing tools more naturalistic feeling, but the problem is that that's not what vector tools are for. I *like* Bézier curves.

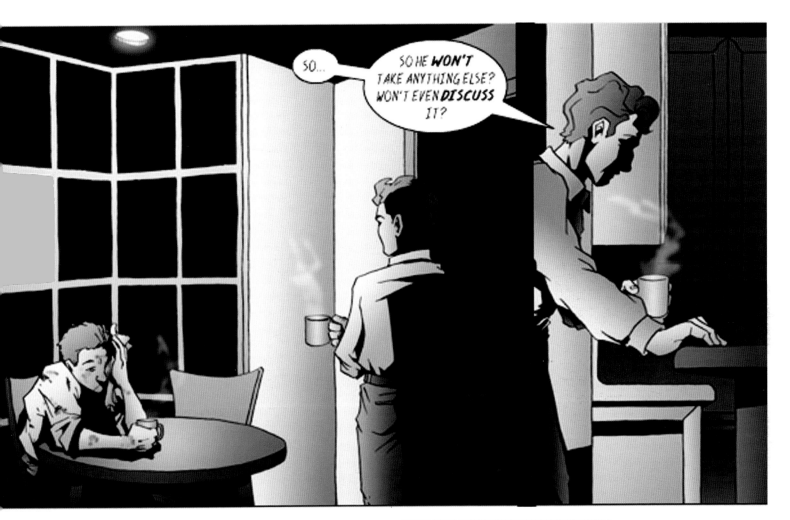

15 To get around all of this, I do it the hard way. Once all the panels are in place and in sequence, I take a screen shot of each stop point. Then, one by one, I import the screenshots in Illustrator, and use Illustrator's drawing and text tools to put all the dialogue and voiceover in. I group each set of dialogue so that all the bubbles stay in position relative to each other, and then I convert all the text to outlines (because if it remains live type, Flash will mess it up when I import it). Then I export the group to a SWF (Flash's native file format). I go back into Flash, import the SWF, and, presto, I've got my lettering ready to be placed into the story.

16 Now it's time to make the strip Web-ready. I set my publish settings, including JPEG quality (for any graphic that Flash assigns JPEG compression to), movie scalability (which I set to no), movie looping (which I set to no), audio compression (which I don't use), etc. Then I hit the *Publish* button. Flash creates the SWF, which is the movie itself. Flash is also kind enough to generate the HTML that is required to place the movie on a webpage.

JOE ZABEL

What brought you into webcomics? Did you come from a comics background, a Web background, or both?

I spent 10 years as an illustrator of Harvey Pekar's stories in *American Splendor*, and after that I self-published a series of mystery comics titled *The Trespassers*.

When did you start putting comics on the Web?

I first became interested in creating art digitally for print, but I soon realized it was easier and better to publish it directly on the Web. I did my first online graphic novel, *Rapid Eye Movement*, in 2001.

Do webcomics have any inherent advantages or disadvantages compared to print?

When I was doing print comics, I was pretty much restricted to doing black-and-white line drawings because of the economics of printing. Working with complete artistic freedom on the Web is a drastic difference for me, because I'm interested in colour and rich textures.

Can you tell me a little of what *The Trespassers* is about and how it has evolved on the Web?

The Trespassers are amateur sleuths Raymond Fish and Delphinia 'Finn' Morgan, and before I got into digital art I created a printed mystery comic about them that ran for nine issues. Some of the stories only involved them tangentially. When I moved my work to the Web, the first comic I did was a graphic novel called *Rapid Eye Movement*, which was a rather enigmatic mystery story that didn't feature Ray and Finn. My follow up to this was *Return of The Green Skull,* which was a sequel to one of Ray and Finn's earlier adventures.

My next big project after that was *The Fear Mongers,* which isn't really a mystery, although it has a detective character. It is supposedly an episode of a 1960s' TV show titled *The Trespassers.*

Mystery seems to be a genre that holds a great deal of interest for you – what is it about mystery that you find appealing?

The classic mystery genre appeals to me because it calls upon the protagonist to make use of his or her rational mind. It's an intellectually affirmative genre when it's done in the classic manner.

I'm fascinated by the atmosphere of mystery. I'm not talking about the criminal underworld – I'm not too interested in that kind of crime fiction. I'm talking about the idea that there's a place where an event occurred, and the detective can't figure out how it happened. In other words, the sense of an enigma. Take for example the film *Picnic at Hanging Rock*. It's about an enigma that doesn't have an answer. I'd love to do a comic like that some time!

Have webcomics widened the potential audience for comic books? And/or does the Web allow for a greater ability to narrowcast comic strips at specific audiences?

Webcomics are like all cultural phenomena – people tend to follow trends, and sometimes the followers outnumber the leaders by a substantial number. Right now the big thing in webcomics is to have a daily gag strip like a newspaper comic, and this genre is enjoying a much wider potential audience than ever before. For other types of comics it's more of a struggle, and non-serialized 'long-form' webcomics are rare and hard to find, and have had more difficulty finding their audience.

Does working on the Web affect the tools you use?

I've traded in pen and ink for Poser and Photoshop, two incredibly versatile new tools.

Have those tools helped you come closer to the images you have in your head?

Definitely. I've always been trying to create a realistic effect. Using actual photographs and a 3D program that creates a photo-like image is bringing me much closer to the realistic effect I've been aiming at all along.

stellar cartography

Where did the interest in photorealistic art come from?

Richard Corben's work made a big impression on me as a young artist. What he did with the comic *Rowlf* seemed to me to be more exciting and open up more possibilities for comic art than any comic I'd ever seen.

The other big influence on my art was working with Harvey Pekar on *American Splendor*. This gave me a chance to learn an entirely different approach to realism than what I'd seen in Corben's work.

Comics are a wonderful, multifaceted tool, and I have a deep appreciation of the exaggerated, reality-bending qualities that they excel at producing. But I think comics have taken unreality about as far as it can go. Realism in comics, on the other hand, is a vast, unexplored frontier.

What other creative enterprises do you spend your time on?

I've written a lot of comics criticism and comics theory. Recently I launched a website, *The Webcomics Examiner* (www.webcomicsreview.com), to publish reviews and articles about webcomics as a fine art.

Does doing comics make you any money? And if so, in what way (i.e., page rates from publishers in print, subscription services, micropayments, and merchandise)?

I'm associated with *Modern Tales*, a subscription webcomics service. It doesn't make me much money, but it feels good to get that little bit.

Would you do more comics if it paid better, or are you happy with comics' place in your life?

It's useful to develop the work habits of a professional cartoonist, because if you don't put in a lot of hours and try very hard, you can't get anything done. But the pros have to put in 60 to 80 hours every week to keep their heads above water. I think if I was under that kind of pressure, the quality of my work would deteriorate, and I wouldn't be very happy. I also don't know if I'd like working for a mainstream editor, you know, like the ones they employ at Marvel Comics....

Do you think there's a split – real or perceived – between print comics creators and Web ones?

There's still a contingent in the print comics arena that is hostile to webcomics, but their numbers are dwindling, especially since webcomics are becoming print comics, and vice versa, all the time.

Where do you see webcomics in general going in the future, and where do you see yourself within that future?

Webcomics are rapidly becoming the primary medium of alternative comic art, and eventually they will be the medium in which comic art achieves its greatest potential. As for myself, having tasted the freedom of working on the Web, I have a difficult time contemplating a return to print. I don't want to sacrifice quality to fit the format.

COMICS FORMAT

From the point of view of fine art, there should be a reason for putting something in a particular format. The Web is simply the most versatile and direct means of presenting a work, so it's well suited as the 'default' mode of comics presentation. If a comic is to be printed, the printing of it should serve an artistic purpose. *Acme Novelty Library* by Chris Ware, for instance, is presenting an experience that's intrinsic to print, and cannot be duplicated in a digital format.

Along these lines, it's interesting that more alternative comics are being presented as 'collectible' printed books, done on quality paper in odd sizes and unusual formats, capitalizing on the tactile sensation of handling a physical object. Their publishers are reinforcing the reason why something should be printed rather than presented on a screen.

HOME: CLEVELAND HEIGHTS, OHIO

URLS: MODERNTALES.COM, WEBCOMICSREVIEW.COM

EDUCATION: ART MAJOR FOR A WHILE AT YOUNGSTOWN STATE UNIVERSITY

CURRENT OCCUPATION: PROGRAMMER/ANALYST AT A MAJOR HOSPITAL

ARTISTIC INFLUENCES: STEVE DITKO (PRE-*SPIDER-MAN*), JIM STERANKO, AND RICHARD CORBEN. LATER WHEN I SAW WILL EISNER'S AND BERNIE KRIGSTEIN'S WORK, I COULD SEE WHERE MY FAVOURITE ARTISTS WERE PICKING UP A LOT OF THEIR IDEAS. CORBEN IN PARTICULAR WAS A VERY BIG INFLUENCE, AND HE'S ONE OF THE REASONS I GRAVITATED SO READILY TO 3D COMICS

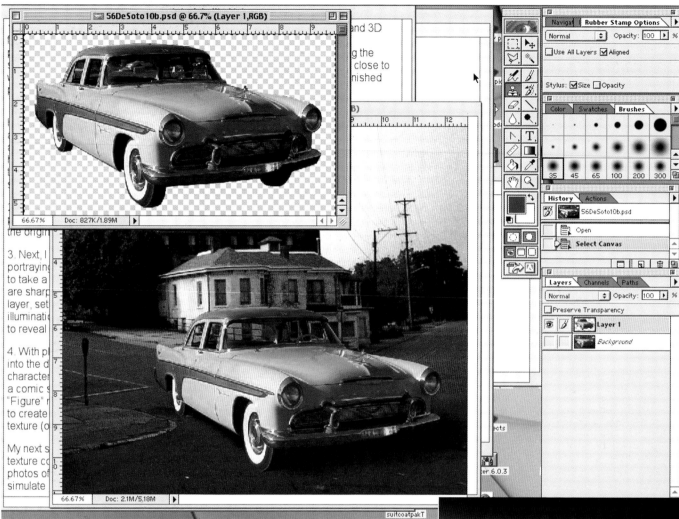

1 For my comics, I create realistic scenes with photographic backgrounds and 3D figures rendered in Poser. In a typical work session, I begin by creating the photographic background. These backgrounds play an important role in telling the story, so they have to be very specific. I begin with a stock photo that is fairly close to what I want. In Photoshop, I copy this photo into an image the size I want the finished panel to be, then I paste in various elements from other photos.

Here, I need a 1950s car in the picture, so I use the *Selection* tool to take the car from another photo and copy-and-paste it (on a new layer) into my Photoshop image. Then I adjust the car to match the background, changing the lightness/darkness, contrast, hue, and saturation. If the lighting on the car doesn't quite match the background, I fix that by lightening and darkening with the *Burn* and *Dodge* tools. Then I airbrush a shadow under the car.

2 Next, I transform the illumination of the scene. This is especially important when I'm portraying a night-time scene, because I never use night-time photos – it's always better to take a daytime photograph and tint it to look like night, because the daytime photos are sharper and have more detail. For a day-for-night transformation, I create a new layer, set it to *Multiply*, and fill it with a blue-grey tone. Where there's direct illumination, I either airbrush the light onto another layer, or erase part of the colour tone to reveal the image below.

3 With photographic background in hand, I open Poser and import the background into the document window (using: *File > Import > Background Picture*). Then I build the character I want to show in the picture. Usually, I'll use the same characters throughout a comic series, but if I'm starting from scratch, I bring in the model by going to the *Figure* menu and selecting one that matches (at least somewhat) the character I want to create. The model appears completely nude and bald, usually with a simple skin texture (or sometimes none at all).

4 My next step is to wrap the figure with a skin texture suitable to the character. A skin texture consists of a high-res coloured texture (an image that is composited from photos of actual human skin) and a bump map (a greyscale image that Poser uses to simulate minute surface variations of height and depth). These are laid out so that all skin areas are represented in a sinusoidal manner – as if they were flat surfaces (like a 2D map of the world that represents a 3D Earth). Most commercial skin textures wrap automatically onto the figure.

I then use parameter dials to modify the face and figure; I can give the figure a pug nose, thin lips, a prominent chin, a muscular build, or any of hundreds of features that in combination individualize the character. Predesigned character settings can be purchased and can transform the figure into anything from James Bond to an elf, but I prefer to build my characters from scratch.

5 To complete the character, I add a wig-like hair object, and select various articles of clothing from the *Figures* library. This is not necessarily all of the clothing they will wear in the final picture – sometimes I paint clothes on later in Photoshop. The hair objects and clothes objects either come with the software or are purchased separately. Textures for clothing can also be purchased, but I frequently create my own clothing textures. The downside is that my textures lack the sinusoidal aspect and so look stretched out around the shoulders.

Hair objects are more complex, and I prefer to use objects and textures created by others. You can change the hair colour fairly easily in the *Materials* window; for example, a blonde can be changed into a redhead by adding a crimson tint to the blond texture. One of the gimmicks used with hair is a transparency map. This is a map that makes part of the object invisible. For hair, a simple hood-like object is created in 3D, and then the transparency map is used to define the fringe of the hair.

6 Once you have the character fitted with hair and clothes, you can save the figure in a folder on the *Figures* menu. That way, if you want to use the character again with those same clothes, hair, and textures, all of these will load automatically with the figure.

7 Now that I have the character standing in the document window in front of the photo background, I pose the character via parameter dials. Here I can tilt the hips, lift an arm, turn the head – in short, adjust every body part. You don't have to use the parameter dials – you can click directly on a body part and drag it into a new position – but I find this method more difficult to control, and the dials let me change a figure's position by as little as .001 degrees!

If I happen to have a pose saved that's close to what I want, I can put the figure in that pose with one click, and then adjust it accordingly. You can purchase sets of poses in a wide variety of positions or save your own poses for future use. I constantly use saved poses for walking, running, standing contrapposto, and sitting. The facial expression is posed in the same way. You can save facial poses as well, though I usually pose expressions from scratch.

I take care to make the pose fit with the background so that the character seems to be standing on the ground, leaning against a wall, whatever the picture requires. It's important to make the figure at home in the background and responsive to it. After all, the figure and the background are like dancing partners, together bringing the picture to life.

8 Next, I adjust the virtual illumination of the scene so that the Poser character is lit from the same angle as the background. Poser can be used to create 'dramatic' lighting effects as well as more neutral, realistic lighting. Remember, if you're using a photo background, the Poser lighting will have no effect on it, and the Poser figure will cast no shadow; this must be added later in Photoshop.

By default, Poser starts out with three lights, but you can add or subtract lights as needed. Two types of lights are supported: infinite lights, which produce parallel rays of light like sunlight; and spots, which produce angular light from a single-point light source. For my purposes, I manage pretty well with three infinite lights. Poser cameras and illumination are not as sophisticated as those in other 3D packages, and Poser artists often import their work into other apps to do the final render. One way to leverage Poser lights to do sophisticated tricks is to make two renders of a scene with different lighting and then combine the two images in Photoshop.

I find that if I try to manipulate more than one high-res figure on my computer, it becomes very slow and tends to crash. So as a general rule, I render one figure at a time (even if there are more characters appearing in the panel) then save the image and the Poser settings. Then I open a new document and import the render from the previous session as the background, so the first figure appears there. I load the other character into the Poser window, and voilà, I have the two characters in the same scene.

9 When all my settings are ready, I 'render' to get a detailed image of the scene, which I export as a PDF format image file. I always use PDF because JPEG format involves compression, and Poser is not the best application for compressing images (I use Photoshop for that). Poser will allow you to render an image at a larger size than the document window; however, if you ask it to blow up the size of the photo background, the quality of the image will noticeably degrade.

If you wish only to save the rendered image, you can export it using *File > Export > Image*. If you want to save the image, and also save all the settings of your current Poser session, you use *File > Save As*, and it will prompt you for where you want to save both the image and the Poser settings (as a Poser file).

10 With all the renders finished, the hard work begins. I open the image file in Photoshop and go over every square inch of it, refining the image and adding details. I look over the figure for cracks and other defects in the 3D render, and use the *Airbrush*, *Smudge*, and *Paint* tools to make repairs.

I sometimes enhance the detail of the figures and correct anatomical problems (elbows, for example, are often too sharp). I integrate the figure into the background, airbrushing in shadows on a separate layer and pasting in anything that's supposed to stand in front of the figures. In some cases, I paint

in additional clothing – 3D skirts, for instance, tend not to hang very well, and Photoshop can easily create the effect I want.

Finally, I adjust the overall colour and tone of the picture with the *hue/saturation* and *darkness/contrast* adjustments. The finished image is ready to add to the comic strip – panel borders, word balloons, and sound effects are created in Photoshop to go with the images.

11 For a comic strip, I generally have each panel on a separate layer, and each word balloon and sound effect occupies its own layer as well. The PSD file for a comic strip can end up with 40 or more layers with different elements on them! I save it that way as a permanent back-up file, which makes it easy to make corrections and revisions later, then I use the *Save for Web* function to create a JPEG version of the strip, and that's what I post on the Web.

12 These steps are essentially the same regardless of the version of Poser you use. This tutorial was done using Poser 4; Poser 5 offers substantially more features; the new software is only beginning to make an impact in graphic art, but promises a vast array of new possibilities.

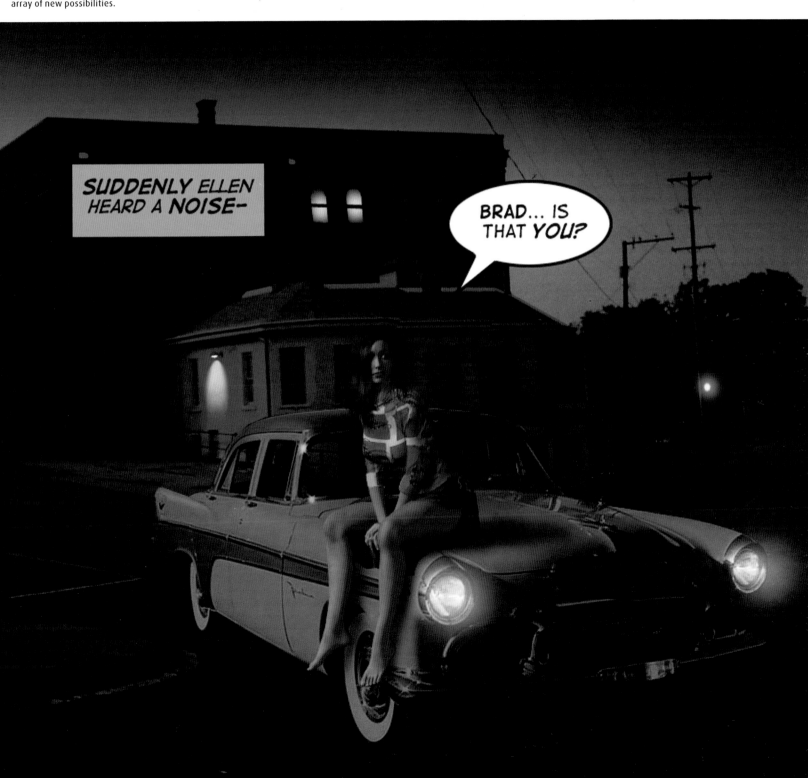

DANIEL MERLIN GOODBREY

What brought you into webcomics? Did you come from a comics background, a Web background, or both?

A bit of both, I suppose. I got into comics the same way a lot of people do – started reading them as a kid, the interest became a hobby, and then the hobby grew up into something more serious while I was at university.

At university I did a degree in multimedia design and then a master's degree in the digital practices of hyperfiction [stories that make use of the technical possibilities of the computer in a way that can't be (easily) replicated in print]. So, at least in terms of my skill base, you could definitely say I come more from a Web background than a comic one. It was during the course of my MA that webcomics – and more specifically hypercomics – became the chief focus of my studies. The final project for my MA was the hypercomic anthology, *Sixgun*. It was while working on this that I realized comics was pretty much what I wanted to be doing with my life for the foreseeable future.

Do webcomics have any advantages or disadvantages in relation to print?

When I first started making webcomics, the main advantage of the Web was speed. When you're using a computer, every single stage of webcomic creation is faster than for print. Well, okay, not the writing itself, but everything else.

Artwork is faster because you only have to work to 72ppi rather than 300. Formatting and layout are faster because you can easily try out a bunch of different ideas until something sticks and then quickly implement that across the whole comic. I'm talking in the past tense because, while I still appreciate the speed of webcomic production, it's no longer such a massive driving force in my work. I've slowed down a bit, and I'm more comfortable with letting myself get distracted, if that's what my brain wants to do.

Portability is probably the key disadvantage to working on the Web. While I'm sick to death of people telling me you can't read webcomics in the bath, these people have sort of got a point. Print is still the best and easiest-to-read portable medium we've got. I've started making comic stories for print during the last couple of years, and in terms of telling traditional linear narratives, it's a hard act to beat.

Have webcomics widened the potential audience for comics?

I get a reasonably steady stream of hits from people who find specific stories on my site through search terms they've typed into Google. 'Amputee Fiction' is one phrase that used to get me a bunch of hits (although whether tales of a mentally disturbed ninja is exactly what those people were looking for is not something I like to speculate on). Some of my comics are made specifically so that all the dialogue in the comic is searchable (and translatable) via Google.

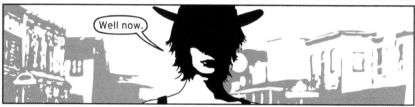

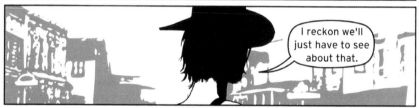

Does creating comics make you any money? And if so, in what way?

Making comics does make me a little money, but so far only very little. My current revenue streams are as follows:

Subscription services: I do a regular weekly strip at www.serializer.net – *The Nile Journals* – that runs every Monday. I do okay from that (better than I expected to, actually), but it still doesn't bring in very much.

Tip jar: I have one on my site and get occasional donations via it. Very occasional, truth be told, but still.

Merchandise: In the last year or so, I've started making small-press print comics for sale at conventions and from my website. I enjoy making them and plan to continue, but whether I'll ever actually make a real profit from this is questionable.

Do you think there's a split – real or perceived – between print comics creators and Web ones?

Well, not as much as there used to be, but there's still something there. In terms of up-and-coming creators, I think maybe it's a split between those who understand what the Web is (and how to use it) and those who don't. And the latter group is getting fewer in number every year.

From the reverse point of view, there are still webcomics creators who work solely with the Web in mind, but increasingly everyone seems to have an eye on putting out a print comic collection somewhere down the line. I still get a kick out of designing hypercomics that just plain defy conversion to print, but I do wonder if I'm shooting myself in the foot a bit when I do it.

Where do you see webcomics in general going in the future?

The future of webcomics probably hinges on figuring out the financial side of things. We need a system whereby people are happy to pay for electronic content on the Web. Fortunately, webcomics creators are far from the only people in need of such a system, so I'm sure something will get figured out eventually. BitPass seems pretty cool, and I'm hoping *Modern Tales* will continue to move from strength to strength. But overall, time will just have to tell.

Something I've been wondering about lately is how the established webcomics community can go about attracting eyeballs from the ever-growing manga readership that currently dominates printed comics. There are plenty of talented people working in webcomics who already have a manga-friendly tone to their work, and so – presumably – there should be some crossover potential there. But what I'm really wondering is whether or not your average manga reader can be persuaded to take interest in something like my stuff, which really has very little manga vibe to it all (the occasional *Ninja with No Arms* story excepted). Again, I guess time will tell.

MY FIRST WEBCOMIC

My first webcomic project was *Rust* with Alasdair Watson for the website www.popimage.com in 1999. Alasdair approached me having seen some of my artwork on the Warren Ellis Forum [at the time a popular Internet forum for discerning comic book readers] and wanted to know if I'd be interested in collaborating on something.

Rust was a great learning experience for me in several ways. To begin with, it was the first time I'd ever worked from a proper script to tell a story – and Alasdair Watson wrote great, detailed scripts that were really fun and challenging to illustrate. Importantly, *Rust* was designed from the beginning with the Web in mind. Alasdair gave a lot of thought to how to use the layout of the screen and how to incorporate animation and interactivity in such a way as to really serve the narrative.

The last couple of lessons I learned from working on *Rust* were particularly important, as they set the tone for my work over the next few years. First, as good as Alasdair's script had been, I realized while working on it that being an art-monkey wasn't enough for me. I had my own stories to tell, and the hours I was spending on someone else's ideas were hours taken away from my own. Second, I discovered from a practical point of view that I was much better suited to telling short, self-contained narratives rather than complex epics. I was very wary coming off *Rust* of starting another new project without being sure I would be able to finish it. My solution was to stick to short stories and to be sure that I had the whole thing finished and ready to go before posting any part of it to the Web.

HOME: ST ALBANS, ENGLAND
URL: E-MERL.COM, SERIALZER.NET
EDUCATION: MA IN HYPERFICTION FROM UNIVERSITY OF HERTFORDSHIRE, UK
CURRENT OCCUPATION: ART AND DESIGN LECTURER

ARTISTIC INFLUENCES: ARTISTS: FRANK MILLER (ESPECIALLY *SIN CITY*), SCOTT MCCLOUD
WRITERS: GRANT MORRISON, ALAN MOORE, AND WARREN ELLIS

1 *The Nile Journals* are a journal comic created by Mr Nile, a homicidally metafictional comic book character who resides with his friend Spooky Lizard in a world a good deal stranger than our own.

Well, actually, no. *The Nile Journals* are, quite obviously, a fake. And I'm the one who fakes them. The comic is Flash-based, but the process of creating each new episode of Nile's life is a journey through several different programs. But it always starts in pretty much the same way, with me working out the dialogue for the strip in Microsoft Word. I don't bother with writing full script for the comic, but I find it very useful to establish who says what, so I've got some idea of how each scene breaks down.

2 With the basic pacing of the strip established by the dialogue, I then move into Poser and begin to arrange the characters in the scene. I keep each of my main cast members as a separate Poser file that I then bring together in one new file for each separate sequence of panels. There's no real secret to working with Poser – much of the time it's an awkward program to use and getting the most out of it requires patience and lots of practice.

The characters in *The Nile Journals* are mostly assembled from figure and clothing elements found within Poser itself. One of my chief aims when putting a character together is to try and create something that doesn't immediately look like it was created in Poser. Often this means coming up with non-standard ways to use the elements built into Poser or finding ways to customize the basic models with elements taken from outside the program. Some elements such as the handguns featured in this strip are based on 3D models I've found on the web. Other items like Spooky's glasses are made specifically for the character with the program 3D Studio Max.

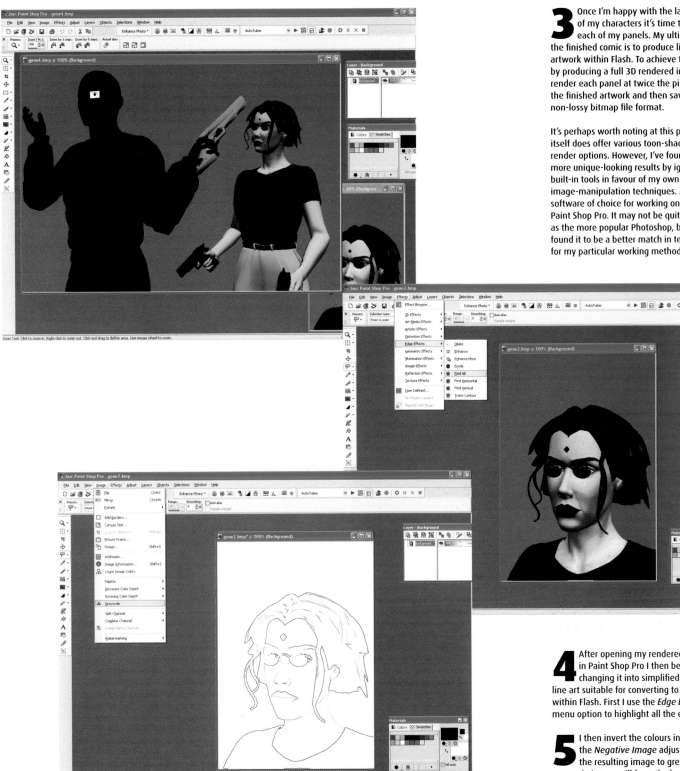

3 Once I'm happy with the layout and pose of my characters it's time to render out each of my panels. My ultimate aim for the finished comic is to produce line drawn vector artwork within Flash. To achieve this aim I begin by producing a full 3D rendered image in Poser. I render each panel at twice the pixel size needed for the finished artwork and then save the image in a non-lossy bitmap file format.

It's perhaps worth noting at this point that Poser itself does offer various toon-shading and sketch render options. However, I've found that I can get more unique-looking results by ignoring Poser's built-in tools in favour of my own sequence of image-manipulation techniques. My image editing software of choice for working on the *Nile Journals* is Paint Shop Pro. It may not be quite as fully featured as the more popular Photoshop, but over time I've found it to be a better match in terms of ease-of-use for my particular working method.

4 After opening my rendered bitmap image in Paint Shop Pro I then begin the process of changing it into simplified black and white line art suitable for converting to vector artwork within Flash. First I use the *Edge Effects > Find All* menu option to highlight all the edges in the image.

5 I then invert the colours in the image using the *Negative Image* adjustment and convert the resulting image to greyscale. This greyscale image will form the basic outline for my finished line art but at this stage is still in need of a good deal of cleaning up.

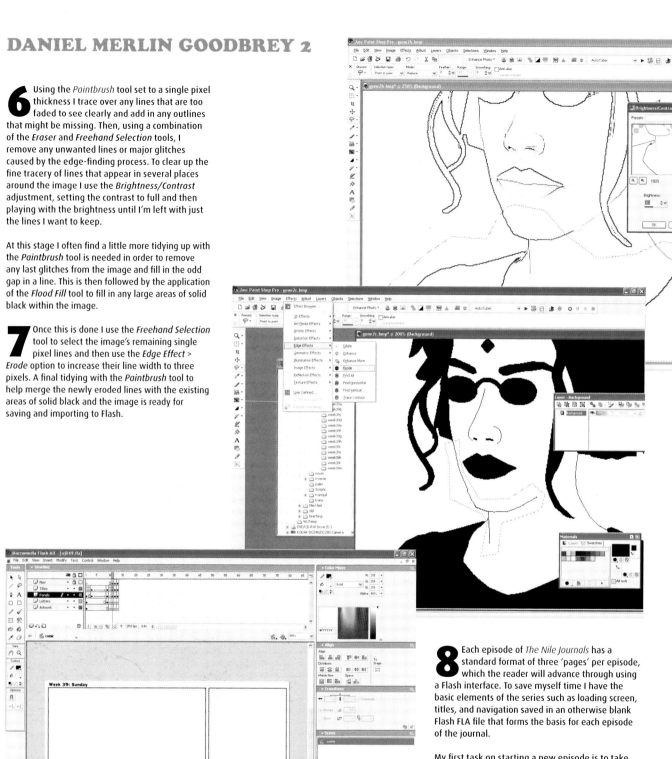

6 Using the *Paintbrush* tool set to a single pixel thickness I trace over any lines that are too faded to see clearly and add in any outlines that might be missing. Then, using a combination of the *Eraser* and *Freehand Selection* tools, I remove any unwanted lines or major glitches caused by the edge-finding process. To clear up the fine tracery of lines that appear in several places around the image I use the *Brightness/Contrast* adjustment, setting the contrast to full and then playing with the brightness until I'm left with just the lines I want to keep.

At this stage I often find a little more tidying up with the *Paintbrush* tool is needed in order to remove any last glitches from the image and fill in the odd gap in a line. This is then followed by the application of the *Flood Fill* tool to fill in any large areas of solid black within the image.

7 Once this is done I use the *Freehand Selection* tool to select the image's remaining single pixel lines and then use the *Edge Effect > Erode* option to increase their line width to three pixels. A final tidying with the *Paintbrush* tool to help merge the newly eroded lines with the existing areas of solid black and the image is ready for saving and importing to Flash.

8 Each episode of *The Nile Journals* has a standard format of three 'pages' per episode, which the reader will advance through using a Flash interface. To save myself time I have the basic elements of the series such as loading screen, titles, and navigation saved in an otherwise blank Flash FLA file that forms the basis for each episode of the journal.

My first task on starting a new episode is to take this basic template and add to it the particular layout of panels needed for each of the three strips. On the surface, *The Nile Journals* is supposed to look like a normal comic strip, so I tend to be pretty conservative in my layouts. I keep a reserve of the more common panel arrangements in another Flash file from which I can simply copy and paste the one I need. Once this is done and any necessary minor layout adjustments are made, it's then time to bring in my artwork.

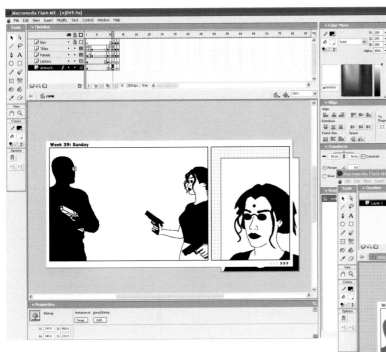

9 Using the *File > Import* menu option I bring in the black and white bitmap art for my first panel and place it on the stage in the bottom layer of the movie. As noted earlier the bitmap is twice the size of the actual comic panel so straight away I use the *Transform* panel to reduce it in size by 50%. I carefully align the panel artwork with the panel borders in the layer above and, once I'm happy with the positioning, use the *Insert > Convert to Symbol* option to convert the artwork into a graphic symbol.

10 The next step is to convert my bitmap artwork into editable vector artwork using Flash's in-built bitmap tracing routines. Vectors differ from bitmaps in that vector files exist as a set of instructions on how to draw a shape, while bitmaps define an image by storing the colour value of every single pixel that goes to make up the image. My decision to use vector artwork for the characters in the comic was largely a stylistic one. I like the smooth line style of vector images and this also serves to further disguise the original Poser origins of the artwork. But vector images also offer some important practical advantages such as smaller file sizes and no loss of quality during image scaling.

To convert my artwork I first double-click on the newly created graphic symbol to allow me to edit its content. I then select the bitmap image inside the symbol and use the *Modify > Trace Bitmap* menu option to bring up the *Trace Bitmap* dialog box. There are a number of settings to consider when carrying out a bitmap trace and the best way I've found to determine the right ones to use is to simply experiment with different values and then view the results. In the case of the black and white *Nile Journals* artwork I always use the same settings – a two-pixel *Minimum Area* with a Tight *Curve Fit* and a Normal *Corner Threshold*.

11 Once the image has been traced the artwork becomes fully editable using the various vector creation and manipulation tools provided in the Flash toolbox. I start by selecting and deleting the unwanted areas of white background around the characters. Next I look over the artwork for any lines that haven't converted in the exact manner I intended and then use a combination of the *Arrow* tool and the *Smooth* and *Straighten* options to fix them.

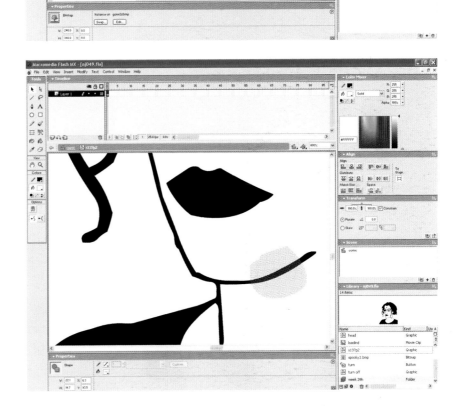

12 When it comes to colouring my characters, the style I'm aiming for requires that I mostly rely on flat unshaded areas of block colour. I apply this colour by using the *Paint Bucket* tool.

One exception to this rule is Spooky's trousers, which are filled using a tiled bitmap image imported to the Flash file's Library specifically for this purpose. This isn't the only place in the finished comic I make use of bitmaps – the backgrounds that sit behind the vector-based character artwork also consist chiefly of bitmap images. This mix of flat, line art foregrounds and photographic backgrounds is intended to give the comic an odd, hybrid look suggestive of the altered state of reality in which my characters reside.

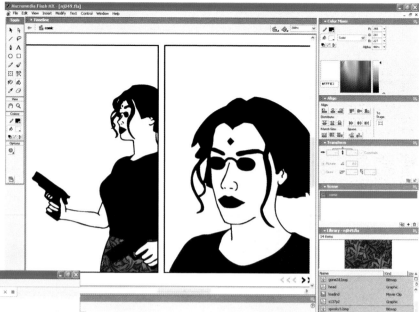

13 I prepare each episode's backgrounds in Paint Shop Pro by layering together different combinations of photographs I've taken with a digital camera, often playing extensively with the *Contrast* settings and *Blend Mode* of each layer. I'm not really aiming at realism with these backgrounds but rather a sampled and remixed version of reality, favouring bright, almost glowing colour palettes and a photonegative worldview. The one thing I'm cautious of is to avoid colour combinations that will compress badly when I come to publish my comic for viewing on the Web. Flash uses JPEG image compression to reduce the file size of bitmap images and this can result in unwanted fuzzy pixellation on bright areas of red and some shades of green.

14 Once all the vector and bitmap artwork for the strip is in place I start to think about implementing any animated elements called for in the episode's plot. I try to use animation sparingly – usually to indicate an action or event that goes against the usual flow of reality in the comic strip. In the case of the episode covered in this tutorial, the only animated element is a rogue panel border that sweeps across the screen between scenes and erases Spooky Lizard from existence.

The panel border is animated to move across the screen using a standard Flash motion tween. Spooky's disappearance is achieved by placing the graphic symbol containing Spooky's image into a separate layer and then adding a mask to control the visibility of that layer. At the start of the strip, the mask covers the whole of Spooky so that the character is fully visible.

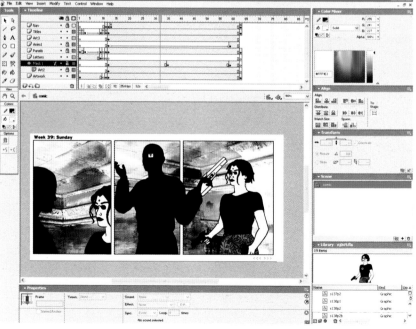

stellar cartography

15 The mask itself is then animated using a simple shape tween to reduce its width in time with the progress of the animated panel border. This gives the effect of the panel border seemingly erasing Spooky from the panel as it moves over the top of her.

16 The final stage needed to complete the comic is the addition of each strip's dialogue and speech balloons. Starting with the dialogue, I take a new layer and copy and paste each line direct from Word in an effort to cut down on any opportunity that spelling errors might have to creep in. I prefer easy-to-read sans-serif fonts for my webcomics and in the case of *The Nile Journals* everyone speaks in 15-point Interstate Regular. Once I'm happy with the arrangement and placement of each block of words I draw in the speech balloons around them. The *Oval* and *Line* tools provide me with a basic shape that I then adjust to exactly match the flow of the text using the *Arrow* tool.

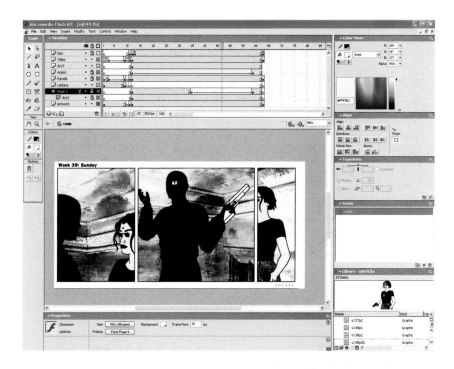

17 After the last finishing touches are complete I select *File > Publish* to compile the comic into a SWF file that can be viewed within a Web browser. I always find it a good idea to give the SWF a thorough looking over at this stage, as sometimes errors or unwanted compression effects can creep in during the compilation process. Once I've checked for these and made any changes that are necessary, I create a simple piece of HTML to call the Flash file into a webpage using Dreamweaver. With that done it just remains for me to upload the SWF and HTML to www.serializer.net and the finished webcomic is ready to be viewed by the public.

Week 39: Sunday

<<< >>>

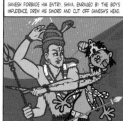
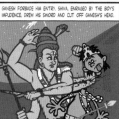

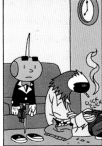
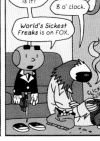
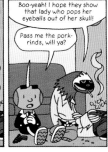

Top: From Steve Hogan's *Acid Keg* at www.acidkeg.com.

Right: From Derek Kirk Kim's *The 10 Commandments of Simon* at www.lowbright.com.

Opposite page: From Derek Kirk Kim's *Half Empty* at www.serializer.net.

Left: From Derek Kirk Kim's *Oliver Pikk* at www.lowbright.com.

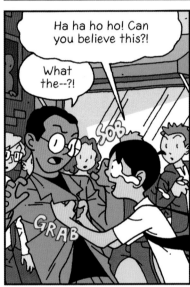

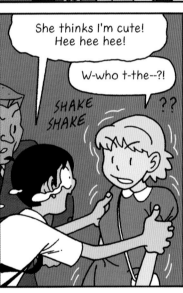

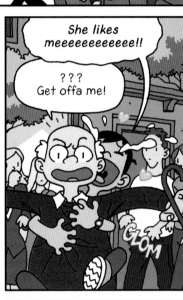

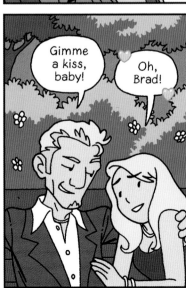

Hey, Backhouse, check out my new puppy. He's called Eric.

AAAGH!

THAT—

—is NOT—

?

—a PUPPY!

episode 18:
GRATUITOUS DINOSAUR STORY

Hi, Kathy!

?

THUNK!

VVVRRRMMM!

SQUEEEAA!

episode 21:
CHICKEN HIMMLER

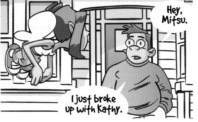

Hey, Mitsu.

I just broke up with Kathy.

Above: From Roberto Corona's *Welcome to Heck* at www.pvcomics.com.

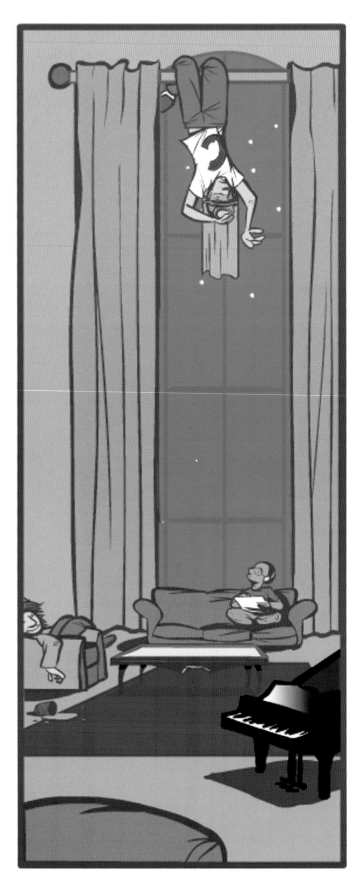

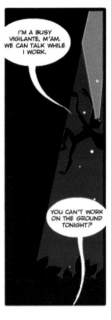
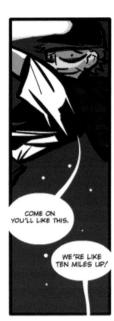
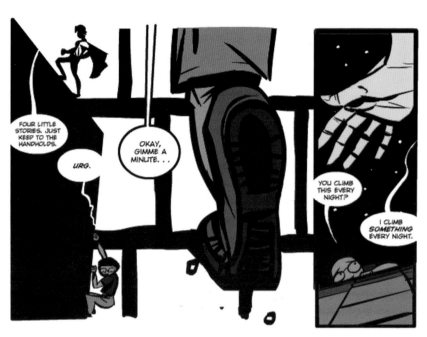

Left and above: Bob Stevenson's art from *More Fun*, written by Shaenon K. Garrity, at www.graphicsmash.com.

Right: From Roberto Corona's *Welcome to Heck* at www.pvcomics.com.

episode twenty-three: "the line."

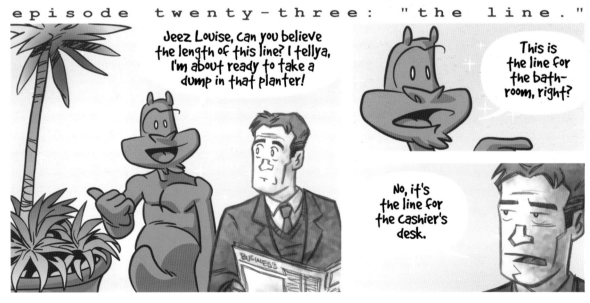

GALLERY 3

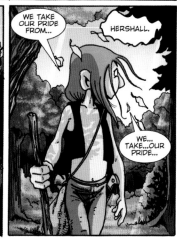

Above: From A.P. Furtado's *Tween* at
www.tweencomix.com.

Below: From Matt Johnson's *Dewclaw*
at www.pvcomics.com.

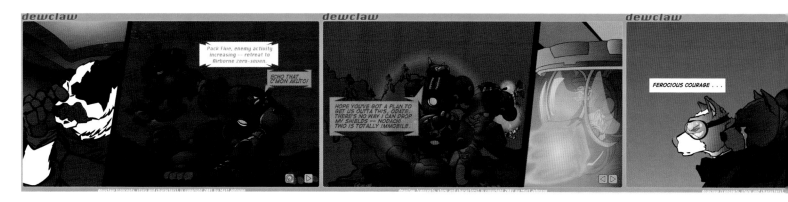

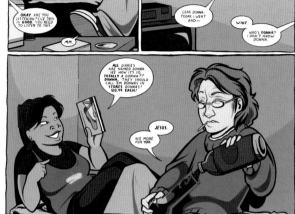

Right: From Spike's *Lucas & Odessa* at www.girlamatic.com.

Below: From Steven James Taylor's *The Nephilum* at www.pvcomics.com.

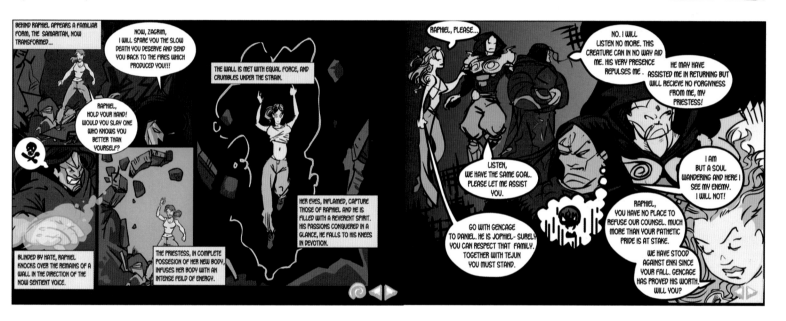

GALLERY 4

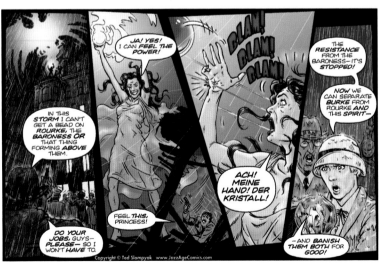

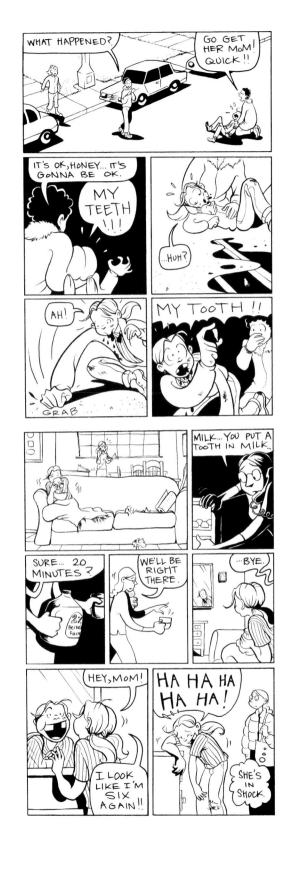

stellar cartography

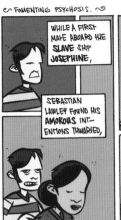
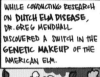
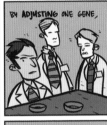
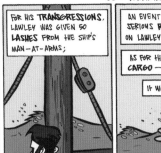

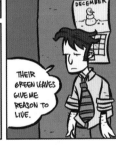
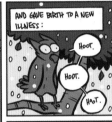
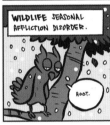

Far left: From Ted Slampyak's *Jazz Age* at www.jazzagecomics.com.

Left: From Raina Telgemeier's *Smile* at www.girlamatic.com.

Right: From Bryant Paul Johnson's *Teaching Baby Paranoia* at www.moderntales.com.

Below: From Marcel Guldemond's *dot dot dot* at www.serializer.net.

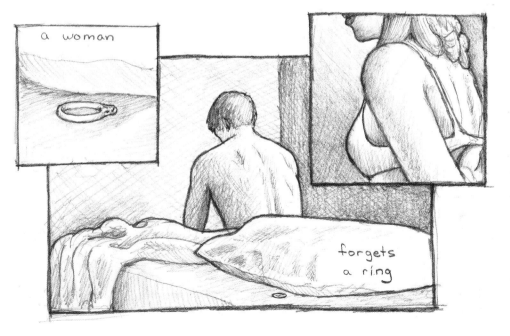

Opposite page: From Neal Von Flue's *The Halcyon Years #17* at www.ape-law.com/hypercomics/comics.htm.

Above: Neal Von Flue's *New* at www.ape-law.com.

Below: From Neal Von Flue's *The Jerk* at www.ape-law.com.

Right: From Barry Deutsch's *Hereville* at www.girlamatic.com.

GALLERY 6

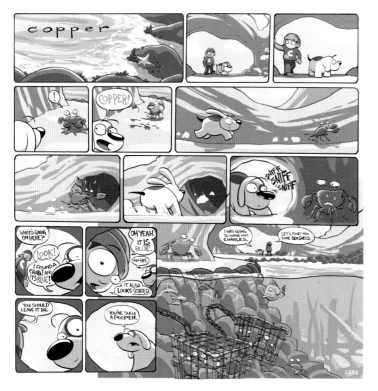

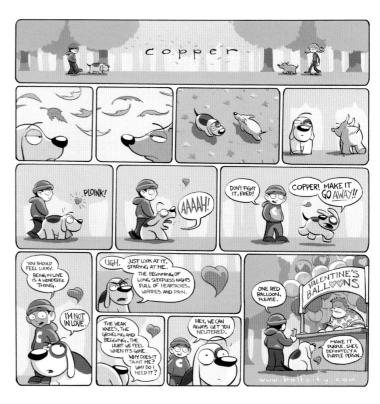

stellar cartography

SOMETIMES I WISH I NEVER HAD TO GET OUT OF BED. I COULD LIE AROUND AND READ ALL DAY.

MAYBE THE BED WOULD BE MOBILE.

EVENTUALLY MY LEGS WOULD WITHER UP AND BECOME USELESS.

HE THINKS SO DEEPLY.

Left: From Kazu Kibuishi's *Copper* at www.boltcity.com.

This page: From Drew Weing's *Pup* (www.serializer.net), *Little Trees* and *The Journal Comic* (www.drewweing.com).

GALLERY 7

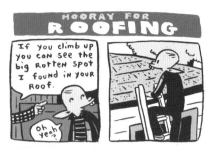

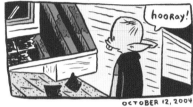

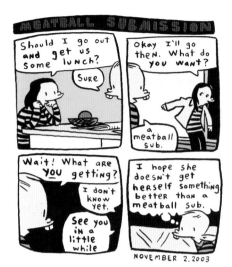

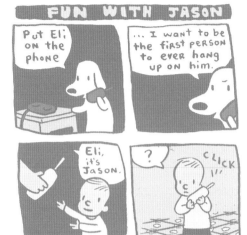

Above: From James Kochalka's *American Elf* at www.americanelf.com.

Below: From Cayetano 'Cat' Garza's www.whimville.com.

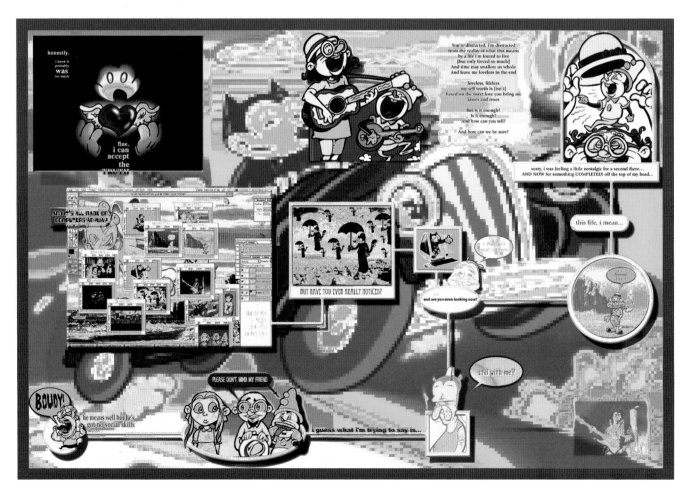

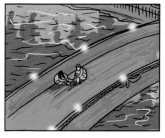

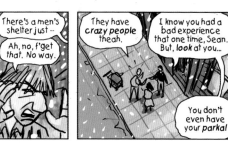

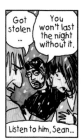
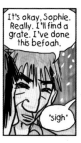
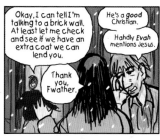

Above: From Roger Langridge's *Fred the Clown* at www.hotelfred.com and www.moderntales.com.

Right and below: From Scott McCloud's *Morning Improv* at www.scottmccloud.com.

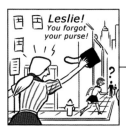
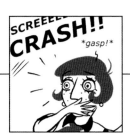
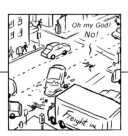
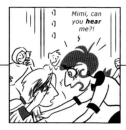

All images: From Amber 'Glych' Greenlee at www.picturedworld.com and www.moderntales.com.

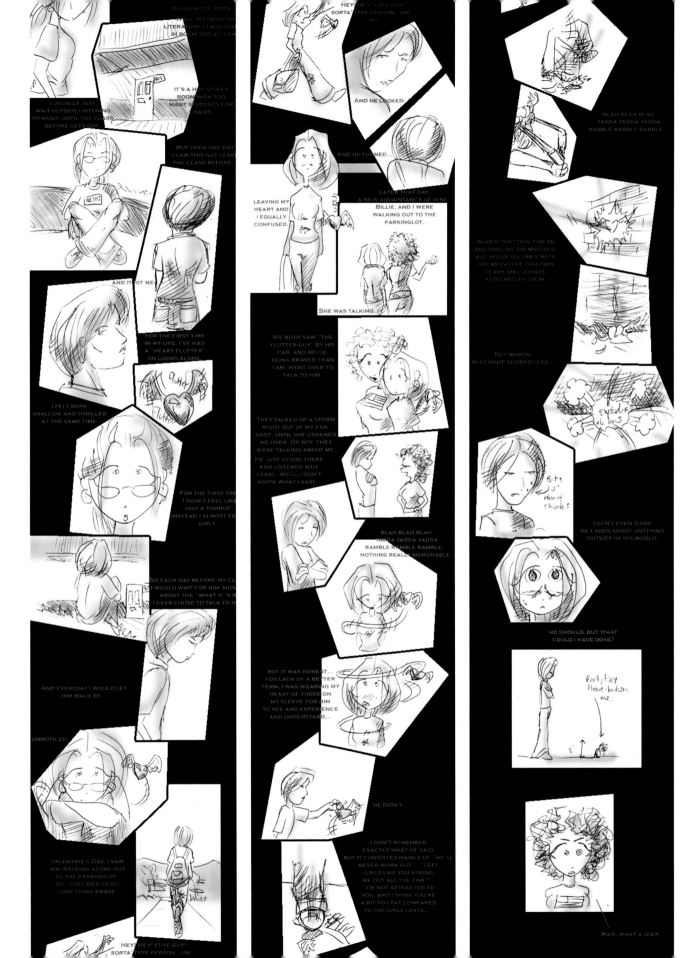

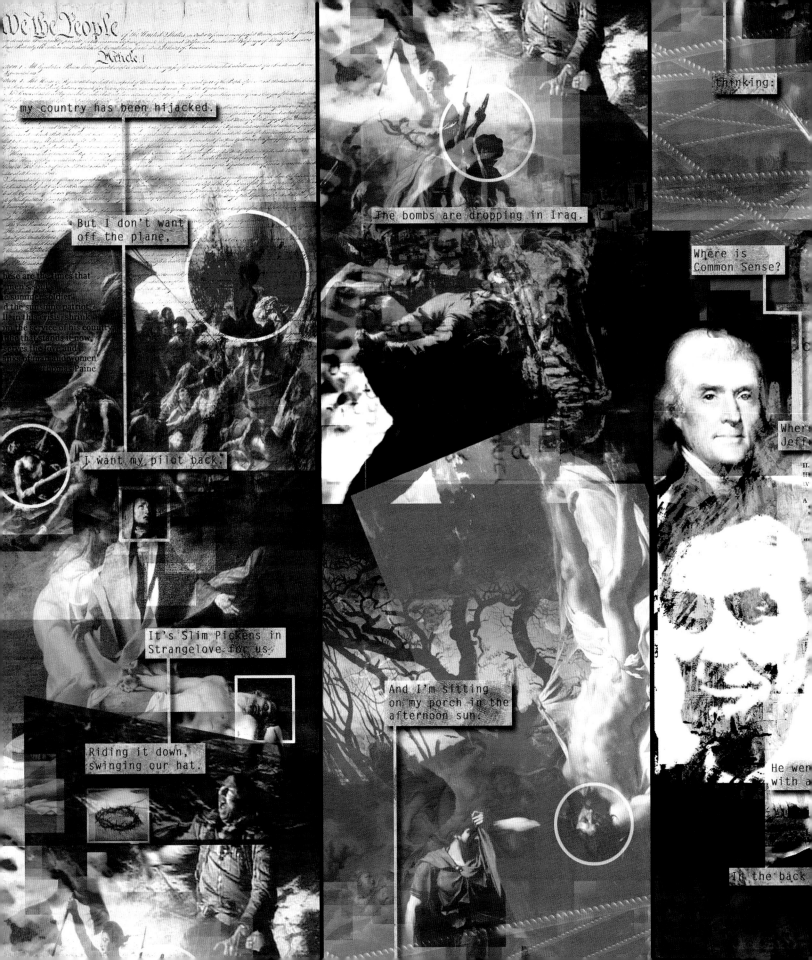

We the People

my country has been hijacked.

But I don't want off the plane.

I want my pilot back.

It's Slim Pickens in Strangelove for us

Riding it down, swinging our hat.

The bombs are dropping in Iraq.

And I'm sitting on my porch in the afternoon sun.

thinking:

Where is Common Sense?

Where Jeff

He wen with a

In the back

#FOUR

STORMS ON THE PERIPHERY

This section will briefly explore the margins of webcartooning –
where artistry and craft meet law and business. Often the
collision of commerce and art is pleasant and productive; at
other times it's more tempestuous and troubling; but it's always
exciting to watch or join in. Also, you're invited to join our
Anthology Site Editors' Roundtable, which highlights a more
congenial collision of opinions and approaches. Finally, the book
concludes with lists of additional resources as well as a glossary of
terms. Hope you enjoy the storm!

There are as many reasons to create webcomics as there are creators. For many – probably most – webcomics creators, the medium offers a chance for unfettered expression, a personal escape from everyday life. For others, though, the Internet offers a distinctly different Holy Grail: the possibility of making a living by creating comics.

Becoming a professional comics creator is a difficult ambition to realize, whether in print or on the Web. The Web certainly allows for easier distribution of your comics, but introducing money into the equation is quite a challenge. At the worst, though, you're likely to lose less money on the Web than in self-publishing print comics.

There is a strong resistance by many people against paying for Web content. This is due to several factors, but an overwhelming part of it is that, traditionally, Web content has been free. The vast number of comics available for free makes it difficult to find customers who are willing to pay for specific comics on the Web.

Most people who make a living from webcomics in fact don't charge to read the comics – they use the comic to attract an audience and then sell that audience merchandise, or sell space to advertisers who are targeting that audience. A daily comic strip can become habitual entertainment, and this can spawn a loyal fan base that will provide eyeballs for advertisers, and that may buy t-shirts, print collections, posters, etc.

However, some people do buck public perception and sell their actual comics online. There are primarily two methods for selling webcomics: subscriptions and micropayments.

Subscriptions allow a reader to view and read comics for a certain duration of time – a month, a year, whatever – for a fixed price. While a single comics creator can sell subscriptions to his or her own individual site, most subscription sites are collectives featuring several creators.

The most successful webcomics subscription site is www.moderntales.com. *Modern Tales* is owned by Joey Manley, who brings comics creators in to the site by offering profit-sharing – the relative popularity of each comic is calculated and, based on that number, the site's profits are divided between the creators and Manley (who maintains and programs the site and handles relations with the creators and subscribers). www.pvcomics.com is another subscription site – this one is an artist collective. All the money (and, of course, site maintenance/marketing work) is divided between the creators of the sites' comics.

Micropayments were championed by webcomics pioneer Scott McCloud long before they were a reality. Micropayments are small payments taken from an account the reader has put money in, and transferred electronically to the creator's account on a per-view (or per-some-number-of-views) basis. The idea is that the price of an individual micropayment is so small – a few pence – that the person paying it will barely be affected, but for the creator, the payments will accumulate.

Both systems have proponents and detractors – some readers refuse to pay subscription fees, but are willing to pay micropayments; and vice versa. Again, like so much else, this is a path the comics creator must navigate with his/her own instincts and personal preferences.

Several strips – like Chris Onstad's *Achewood* – use merchandising as a source of revenue.

In *I Can't Stop Thinking*, Scott McCloud put forth an argument in favour of micropayments, a few years before such a thing was possible.

Once comics are paid for – either by subscription or micropayment – they're usually viewed on the screen, just like a regular webcomic. Of course, it is possible to set up a system where the comic is downloaded onto the reader's computer (as a PDF, for instance) and can be read or printed out by the reader. For some, this overcomes the lack of feeling of ownership of not gaining any physical item from their payments. But if the success of music sites like iTunes is any indication, the future is opening up for pay content on the Web.

If delivery still works the same way for paid-for Web content, that still leaves the question of how to accept money electronically. Most of us don't have the facilities to accept credit card transactions, and sending a cheque or postal order to read something on the Web is self-evidently absurd. As of this writing, there are two main ways of paying for content online: PayPal and BitPass.

PayPal became popular as eBay grew. Users transfer money from their bank account to a PayPal account, and the funds can then be transferred to anyone else who has a PayPal account. PayPal takes a percentage of all the money it moves. PayPal is best suited for relatively high value transactions – over a pound or two, anyway – because of the amount it takes off the top. It's ideally suited for subscription sites, and can be set up to accept periodic payments. It is also hands down the Internet standard for selling physical merchandise like books and t-shirts.

BitPass was the first viable micropayment system – like PayPal, users transfer money into a BitPass account, but unlike PayPal, the amount BitPass takes from small transactions is only a few pence. BitPass was specifically designed to be used for making small payments for Web content (whereas PayPal was designed to transfer money in a general sense) and has an extremely easy-to-use interface for paying for content.

But it's important to realize that the face of paying for content online is changing very, very rapidly. It's best to look very carefully into anything that involves money, and as a creator, try to avoid paying for access to payment systems. A big part of what makes BitPass and PayPal so valuable for selling webcomics (and merchandise) is that you don't pay any money out front to sell things with them – they only take money out of money you make. Be extremely wary of any payment system that doesn't offer those terms.

*Below: **Modern Tales** is a successful subscription service that uses PayPal.*

Right: BitPass and PayPal are both useful for Web-based financial transactions (www.bitpass.com and www.paypal.com).

Jim Zubkavich's *The Makeshift Miracle* (www.makeshiftmiracle.com) ran on *Modern Tales*, but is now available from Jim's own site, via BitPass.

JOEY MANLEY DO WEBCOMICS HAVE A MAINSTREAM ALREADY?

With the launch of *WebcomicsNation* (WCN), as well as a few other tweaks and twists here and there on my other sites, I'm trying to shift my business to take advantage of the three 'mainstream' business models for webcomics, and to make it easier for the cartoonists I work with to do so, as well.

I'll happily admit that applying the term 'mainstream' to any webcomic business model is a bit generous, maybe even hyperbolic, given the newness of the artform itself, and the even newer newness of its commercial incarnation. How many people make a living, or even their monthly mortgage payment, from webcomics? Maybe a few. There's no independent confirmation – how could there be? Believable claims have been made, let's leave it at that. But a small clutch of cartoonists scraping out a middle-class income from webcomics does not an industry make.

Beyond webcomics, Web publishing in general has not proven to be all that profitable. Yes, there is profit to be made. It's just not the kind of profit we were once promised. Everybody – from the least-known blogger to the slickest corporate media baron – is still obliged to experiment with different business models. Nobody (nobody who is both intelligent and honest) would tell you that his/her business model is exactly, perfectly, untouchably right. Making money from Web content is not, and never will be, easy.

This is good news.

If making money from Web content were easy, if it were simply a matter of applying one perfect strategy to the problem, you and I wouldn't stand a chance. Disney, Time Warner, Rupert Murdoch, whoever – you know, the suits – would have slapped down their x's and their o's in every corner of the board, and won the game, years ago. That's exactly what they were trying to do during the dotcom bubble: establish utter domination, as quickly and coldly as possible. That's what they do. This does not mean, by the way, that they are evil. It just means that they are large corporations.

But back to the point: if this game were easy, you and I wouldn't even be allowed to play.

It is precisely because the business of Web content is contradictory, counterintuitive, ever-changing, and, well, practically impossible, that small entrepreneurs like you and I (and, yes, if you're making a webcomic in the hopes of deriving a profit from it, you are an entrepreneur) have any hope at all of success.

Joey Manley's first novel, *The Death of Donna-May Dean*, was published by St Martin's Press in 1992. He was the original Director of www.freespeech.org, and worked at www.streamingmedia.com, where he was eventually promoted to Vice President, Interactive. He launched www.moderntales.com in March 2002, www.serializer.net in October 2002, www.girlamatic.com in April 2003, www.webcomicsnation.com in 2004, and numerous other websites along the way, most of them focused on webcomics, or on other forms of Web-native entertainment.

So when I say 'mainstream', I suppose what I mean is: 'business models that a number of fairly well-known cartoonists have tried, with sometimes promising results'. These are the three:

1. Advertising and sponsorships, such as *Keenspot, PvP, Penny Arcade*. This was probably the first, and is still the most prevalent, business model for webcomics. It is also the one with a relatively large number of believable success stories (if you can accept the phrase 'relatively large number' to describe, say, five or six people – ten or eleven, tops).

2. Merchandise and book sales, such as *Diesel Sweeties, Homestar Runner* (which is not technically a webcomic, but close enough in spirit to be included here), and *Sluggy Freelance*. In this model, the webcomic itself is 'bait', and the real business is the sale of physical items, like books, t-shirts, or plush toys. These businesses are only distinguishable from old-world businesses using the Web as a promotional brochure by the frequency and quality of the content they publish. If you ignore those two elements (high frequency and high quality), something like *Diesel Sweeties* is not a lot different from Marvel dotComics, or even the clickable page excerpts from graphic novels at Amazon, business-model-wise. Not that there's anything wrong with that.

3. Pay content, such as *The Right Number* by Scott McCloud, *Modern Tales* and its sister sites, and *OnlineComics.net Exclusives*. It's no secret that this is my 'favourite' of the three – or, at least, it's the one I'm known for using, and promoting. Even I don't pretend that it's perfect: when you're competing with a thousand thousand freebies, some of which are excellent, even the smallest price can look outrageous, and drive away readers.

Most of the sites I've listed above, with the possible exception of *Modern Tales*, do not limit themselves to one business model. *Sluggy Freelance* has banner ads. *Keenspot* has a subscription service. *PvP* has a print comics deal with Image Comics. The categorized listings above are intended to serve as examples of sites where one business model or another seems to have done particularly well, not as examples of sites completely dependent on one model or another. You will also notice that I did not include tip jars and donations. Begging is not a business.

So there they are, the currently-established business models, looking scruffy and disreputable, as Tycho from *Penny Arcade* has described them, 'lined up...at the police station. All of them cast in an unflattering light, none of them possessed of magical powers'.

In other words: business of any sort has never been a particularly magical activity, if, by 'magical', you mean, for example, 'fun and sparkly like Tinkerbell', or even if you mean 'infallible, like a silver bullet hurtling towards the heart of a werewolf'.

No one business model, nor any specially blended, carefully balanced, nicely packed collection of business models, can guarantee success, in webcomics, or any other field.

CSI has the same business model as any TV series that gets cancelled after three episodes. Michael Jackson and Jermaine? Same business model. Oreo and Hydrox. Apple and Commodore. Pepsi and RC. Pilates and Tae Bo. Two similar products operating along the same lines of business. One thrives; the other fades to the back. It's not about the business model. It's also not about quality, depth, worthiness or skill: Justin Timberlake outsells Tom Waits. On the other hand, it's not about selling out, being slick, or dumbing down: Pink Floyd, U2, REM and the Rolling Stones have each sold more albums than Justin Timberlake will ever sell, in aggregate – and the Grateful Dead have at least as many fans as, say, Jessica Simpson. I have no idea why these things are true. Business success doesn't make a lick of sense at all. Obsessing over business models is fruitless.

And yet it's necessary. While having the right business model will not give you any particular advantage, not having the right one will guarantee utter and abject failure. Yes, the game is rigged that way: you can't do anything to improve your chances, but you can do everything to ruin them. That's business.

WEB TO PRINT

While the Web offers many possibilities for new ways of creating and structuring comics, it also works well as a system for serializing more traditionally formatted comics; comics that can later be collected into printed editions. The Web tends to allow for greater success for more disparate points of view than either comic books or newspaper comic strips.

Unlike the often homogeneous comics industry, three of the most successful comics to move from the Web into print could hardly be more different: Scott Kurtz's *PvP* – a joke-a-day webcomic – has entered comic book shops (published by Image Comics) to become one of the few successful non-superhero monthly comics, while Kurtz simultaneously pioneers new modes of newspaper syndication; Derek Kirk Kim's introspective drama *Same Difference* (www.lowbright.com) sold through a self-published graphic novel print run to be picked up by one of the major literary comics publishers, Top Shelf; and Fred Gallagher's manga-inspired *MegaTokyo* (www.megatokyo.com) is in bookshops worldwide at the vanguard of Dark Horse Comic's manga line.

Many webcomics begin life with print foremost in their creator's mind. Dirk Tiede says his supernatural crime webcomic *Paradigm Shift* 'was originally conceived as a graphic novel in the strictest sense, but early on I realized that it would take a long time for it actually to see print'. So Tiede brought it to the Web. 'While all my exposure to comics up until that point had been from the print world, professionally I was a Web guy.'

The collision of these two worlds led Dirk to confront a formal challenge that many other webcomics creators had been dealing with: presenting tall pages on wide screens. 'Due to their tall aspect ratio, traditionally sized comic pages don't fit on screen, so you're forced to scroll to read the entire page. It wasn't until after I started talking with other webcomics artists, and got a brief critique from Scott McCloud, that I started to rethink how I presented my story on the Web. Eventually I latched on to his "infinite canvas" idea and experimented with stacking my pages on top of one another into a long, scrolling page that encompassed each scene.'

Right: Dirk Tiede's supernatural crime comic *Paradigm Shift* first appeared on the Web (at www.dynamanga.net and www.moderntales.com), and has since been collected in print.

PRINT TO WEB

This changed the way Dirk thought about his comics' layout. 'Before,' says Tiede, 'I was thinking in terms of two-page spreads. Now, in addition to that, I need to do layouts with stacking in mind, so it adds a little complexity to designing panel layouts. I now have to keep in mind how things will flow in two directions, but it's a fun puzzle.'

The Web has also attracted creators who had already made a name for themselves – sometimes even creators who have been creating comics in print for decades, like former *Batman* and *Camelot 3000* (among many other series) writer, Mike W. Barr. Barr, along with artist Dario Carrasco (also a mainstream print-comics creator), created *Sorcerer of Fortune* at www.graphicsmash.com.

For Barr, the Web is a welcome release from the negative aspects of the superhero-fuelled American print-comics mainstream. 'I won't claim the strip has been a great moneymaker, but it's given me a chance to keep my hand in an industry from which I've been otherwise virtually blackballed, and to tell stories

storms on the periphery

I want to tell without the increasingly top-heavy bureaucracy of editors and vice presidents at many of the print companies, few of whom have the power to say "yes", but all of whom have the power to say "no", as well as the authority to change my work without my knowledge or consent.'

Becoming part of the webcomics community is also clearly something Barr enjoys. 'When I read the e-mails from my fellow webcomic writers, many of whom are doing several strips at a time, I resolve to think more about the fun and the creativity and less about the money. These guys and gals shame me with their energy, optimism, and creativity.'

Todd Nauck, a mainstream comics artist who publishes his series, *WildGuard*, through Image Comics, sees the Web and print as working in tandem. 'I had talked with Scott Kurtz about his *PvP* site where he posts his strips. It seemed like a pretty fun and easy way to get your creations out there. Since I had just wrapped up the *WildGuard: Casting Call* mini-series, the traffic for www.wildguard.com had slowed down. I reckoned doing Web strips would be a quick and easy way to keep the story going, keep *WildGuard* fans interested in the characters, and hopefully gain some new readers. They can read the strips for free and if they like what they see, they'll buy the [print] comics.'

But there is a significant difference between doing it yourself on the Web and self-publishing in print. 'Print is so much more expensive than the Web,' says Tiede, as *Paradigm Shift* moves into a new printing. 'To do a small single print run will cost around $2,000. Combine this with a lack of steady employment and a weak economy, and it made for quite a struggle.'

One thing that's made self-publishing books easier is the development of print-on-demand (POD) services. These are companies that make use of digital printing technologies to print very small runs – even individual copies – of books on an as-needed basis. In traditional offset printing (the way most books and magazines are printed), the publisher orders a specific number of copies – usually a minimum of 1,000 – and pays for the print run upfront. With POD, there's usually a set-up fee followed by a per-book cost, as copies are needed.

The upside of print-on-demand is that there's no huge outlay of cash, and no unsold copies – meaning no warehousing costs or wasted print runs. The downside is that the per-unit cost of POD is much higher than traditional printing, and most distribution networks (to comic book stores or "regular" bookstores) won't stock POD books.

Tiede used POD for his first print run of *Paradigm Shift* and doesn't regret the experience, but says that while POD is 'fine for a test run, I don't recommend it for the long term. It doesn't cost that much more to do an offset run and get four times as many books. Once you know you can sell them, you might as well go with volume'.

Of course, self-publishing isn't the only way to go into print. Building an audience – and a catalogue of completed material – is a good way to get the attention of a publisher, and more and more comics publishers will be looking to the Web in the future. Barr says that 'Dario and I control print rights for *SoF* and would love to see it collected in a nice trade paperback,' and they're always on the lookout for interested publishers.

Left: Todd Nauck's *WildGuard* series started as print comics (from Image Comics), but the characters also appear online in all-new strips (www.wildguard.com).

ALEXANDER DANNER LEGAL ASPECTS

Like creators of any form of original artwork, it is vital for webcomics creators to be familiar with their rights and responsibilities under copyright law and, to a lesser extent, trademark law. These laws govern ownership and use of intellectual property, as well as the method of recourse against those who infringe upon your rights as a creator.

What follows is only a brief introduction to copyright and trademark law, and should not be taken as a substitute for seeking professional legal advice.

Copyright

Copyright protection applies to 'original works of authorship fixed in a tangible medium of expression, now known or later developed, from which they can be perceived, reproduced, or otherwise communicated, either directly or with the aid of a machine or device'. This includes written works, films, music, and, of course, comics and webcomics. What's more, you own the copyright to your work the moment you create it. While there are benefits to registering a copyright, registration is not required – you automatically own anything you create. However, copyright cannot be applied until the work is actually created. You can't copyright an idea – only the expression of the idea.

As a copyright holder, you own certain exclusive rights pertaining to your work. These include the right to produce and distribute copies of the work, as well as the right to produce derivative works, such as sequels and spin-offs. Violation of these exclusive rights is called 'copyright infringement'.

However, there are certain circumstances where it is legal to reproduce copyrighted work, in whole or in part. These circumstances are collectively known as fair use. The commonly accepted uses include reproduction for purposes of criticism, news reporting, and (usually) parody, as well as reproduction for educational or research purposes. However, there are no hard and fast rules for what constitutes fair use, leaving specific instances open to judicial interpretation, based on factors such as whether the use was commercial or non-profit in nature, as well as whether the use inhibited the ability of the copyright owner to profit from his or her own work.

Dealing with Copyright Infringement

As a webcomics creator, the most likely method of copyright infringement you'll face is simply the case of a fan collecting some favourite comics on his or her website. In this case, legal action is almost always overkill. It's important to understand, though, that this is still an infringement of your copyright, and you are no less justified in demanding that your work be removed from their site. Fortunately, getting someone to take your work down doesn't have to be a complicated matter. A polite 'cease and desist' letter will usually do the trick, with no need for legal action.

Trademark

While copyright protects an artistic work as a whole, trademark applies to the various symbols and devices associated with the work, such as logos, characters, or costume designs. The purpose of a trademark is to mark a particular product as coming from the same producer or belonging to the same set of products. For instance, the 'DC' in a circle is a trademark that identifies any book published by DC Comics. Superman's 'S' symbol is also a trademark (as is Superman himself) – one that identifies a narrower subset of products within the larger DC line.

As with copyright, registration is not imperative for establishing ownership of a trademark. Unlike copyright, a single use of a trademark does not entitle you to ownership. Instead, trademarks are established through commercial use – in other words, you establish your claim to a trademark by selling products bearing that trademark.

Once established, the strength of a trademark varies according to numerous factors – the most important being uniqueness. 'Webcomic', for instance, would be a very weak trademark for your online comic, since any number of online comics creators can also make a reasonable claim to it. However, if you wanted to trademark the phrase 'Ugly Cheese', you will have a much better claim, since it's unlikely to apply to other webcomics. The more unique a mark is to your work, the stronger your claim to the trademark will be.

Furthermore, since the strength of a trademark is governed by commercial use, a trademark that has been established in one geographic region may not be protected in another region. Likewise, a trademark that has been associated with one sort of product may not be protected against use with another sort of product. For instance, let's say you sell 'Ugly Cheese Comics' only in London. Your trademark 'Ugly Cheese' would be protected against other comics publishers in London. However, you would not necessarily be protected against a restauranteur opening an 'Ugly Cheese Pizza House' in London. Nor would you necessarily be protected against a comics publisher offering 'Ugly Cheese Comics' in Birmingham (so long as they're not the same comics – that would be a copyright infringement).

Clearly, the rules governing trademark law are complicated and open to interpretation. In fact, one of the major benefits of registering your trademark – in addition to adding considerable strength to your claim – is simply that it will give you a more concrete idea of where and how your trademark is protected. If you do believe you have suffered a trademark violation, you should consult a lawyer.

Contracts

Since most webcomics are self-published, the issue of contracts won't arise very often. The exception to this is if you've been invited to join one of the larger webcomics anthologies, such as *Modern Tales* or *Keenspot*. To date, said publishers have been noted for use of contracts that favour creators' rights to a much greater degree than the larger print publishers. However, it is still true that you should always read any contract in its entirety before signing – and asking a lawyer to read it as well is never a bad idea.

TWO COPYRIGHT ISSUES FOR WEBCOMIC CREATORS

SPRITE COMICS

Sprite comics are a popular form of webcomic that uses artwork composed primarily of low-resolution pixel-based artwork. While some sprite comics use only original artwork, many borrow existing sprites from other media – most notably video games of the 8-bit Nintendo era, such as *Mega Man* or *Final Fantasy*.

Most such strips are presented as parody of the original work. Parody is usually – but not always – taken to fall within fair use. The trouble is that there is a fine line between parody and derivative work. As some sprite comics have developed substantial plot-driven stories using this copyrighted material, it is not unthinkable that, if brought to court, the webcomic could be found to have crossed that line. The fact that some of the creators are profiting from these parodies further complicates the issue. Ultimately, though, only the courts can decide if a work is legal parody or an illegal piracy. Such determinations are made on a case-by-case basis.

Thus far, most of these creators have gone unharassed by the copyright holders. But this unspoken tolerance should not be taken for consent. By neither approving nor condemning these works, the copyright holders are allowing the work to continue, but still retaining the right to change their minds at a later date.

COMIC SCRAPERS

An issue affecting a larger range of webcartoonists is the technology known as 'Comic scrapers'. Comic scrapers are essentially specialized Web browsers that aggregate a collection of user-chosen webcomics into a single display. They accomplish this by checking the comics' websites daily and then linking directly to the image files for the new comics. The benefit to users is that they are saved the time of visiting each site individually, as well as the time of waiting for each comic's full webpage to load.

The problem, however, is that by presenting the creator's comic without the surrounding webpage, these programs are interfering with the comics creator's ability to make money from his or her comics – and any advertising that the site hosts is lost, as is any information about merchandise or print editions that the creator is offering. Furthermore, some creators hold that the artistic integrity of the work is compromised as well, since their Web design is intended to support and enhance the comic itself.

While most creators would agree that these comic scrapers are at best disrespectful and at worst a threat to the profitability of their webcomics, the larger question that still remains unanswered is whether or not comic scrapers actually constitute a copyright infringement.

On the one hand, proponents of comic scrapers hold that since scrapers are displaying a publicly accessible image file directly from the server that it's meant to reside on, there's no cause for claiming a redistribution infringement. According to this argument, scrapers are nothing more than specialized Web browsers that allow users greater control over how they view the websites browsed. On the other hand, opponents of scrapers argue that since scrapers deliberately remove the comic from its ability to earn the creator money, the creator's rights have been infringed. The larger intent of the scrapers may be illegal, even if the technical details aren't.

Strong arguments have been made on both sides of the issue, but again, the issue can only be decisively settled by the courts. In the meantime, creators have found various ways of dealing with the problem – some by building in mechanisms to baffle the scrapers, some by integrating their advertising into their image files, and others by making deals with the scraper designers themselves.

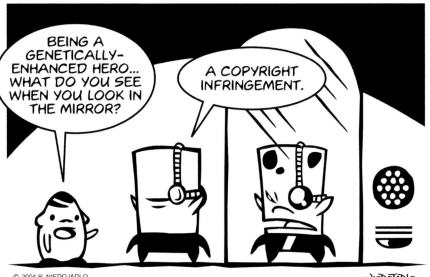

BEING A GENETICALLY-ENHANCED HERO... WHAT DO YOU SEE WHEN YOU LOOK IN THE MIRROR?

A COPYRIGHT INFRINGEMENT.

© 2004 R. NIEDOJADLO

NIEDOJADLO

ANTHOLOGY SITE EDITORS' ROUNDTABLE

We invited five webcomics editors to discuss a range of issues from editing, to delivering, to marketing online comics. This section gives a more informal overview of some of the key concerns in today's webcomics scene.

What do you see as your editorial role or mission for your site?

Logan DeAngelis (www.pvcomics.com)

My personal role is to make sure that the trains run on time. While Stuart Robertson takes care of all the Web wizardry, I set schedules, deadlines, handle our print division, and offer an editorial sounding board to anyone who asks for it. My relationship in an editorial sense varies a lot from creator to creator. Very rarely do I catch something that needs correcting, and only once have I ever asked one of the creators not to do a project because I felt it was inappropriate for the site.

Barry Gregory (www.01Comics.com)

01 publishes only creator-owned comics, and we have a strict 'no editorial meddling' policy. When it comes to the stories and their telling, the full extent of my editorial input is to point out misspellings and/or typos. What I do is set the standards. I will never tell a creator, 'Change this, change that, and we'll publish you'. That was what I did as a print comics editor, and I don't want to do that again. So at *01* what I do is choose comics for publication that establish a standard, a certain level of quality that says to creators and potential submitters, 'You must be at least this good to be a part of this'. I inject myself only into the technical aspects of the comics I edit. Story and art are off limits. I either accept or reject a submission as is. I will, however, speak up when I think technical aspects (lettering or colouring) are sub par.

T Campbell (www.graphicsmash.com)

Beyond the 'quality' goal, which I think we all follow, my original goal was to provide a wide variety of comics that could all still be classified as 'action' comics. It's that brand that sets *Graphic Smash* apart from any other site. In that goal, we've been an almost unarguable success. That, and to get enough subscribers so the whole thing would be worth everyone's time! I do a quick polish of the strips that need it, though. It drives me crazy when I see misspellings and grammar violations in webcomics (not just *Graphic Smash* webcomics) – if we want our work to be treated professionally, it has to look professional!

Joey Manley (www.moderntales.com)

I do not work very closely with my creators at all. I find good people, and set them loose to do their own thing. We specialize in creator-owned material. When the work is creator-owned, the creator is answering to a higher standard than any editor can set: he/she is building a franchise for the future. Meddling in that endeavour is fruitless. They wouldn't be doing creator-owned work in the first place, if they wanted or needed editorial assistance. I'm less an editor, frankly, and more of a curator. I find people doing quality work, invite them to join us, and then, mostly, leave them alone. Most of the time, it works out.

I've learned to be very careful about whom I bring onto my sites – and, sad to say, it's not just about the work itself. It's also about the personality and stability of the creators. If you've got the greatest work in the world, but you've been known to go off in flamewars on public message boards, I probably won't invite you on board. Of course, our business model requires constant updates and serialization, so I have to know that these creators are in it for the long haul, and that they're not going to end up pissing off our readers or the other creators with public ranting. If we were doing mostly one-shots, that 'personality and stability' part would be less important.

Patrick Coyle (www.komikwerks.com)

Being an Internet professional, I ended up taking the reins on submissions, posting, working with the creators, etc. However, my partner, Shannon Denton, and I both have a say in what comics make it onto our site. As for my role, I, too, am less of an 'editor' in the traditional sense of the word, and more of a comics wrangler. I move the cattle from the fields into the barn, so to speak. Though there are a few contributors on the site with whom I have active conversations about where the comic is heading, how we might improve readership, how best to format things for the Web. I really enjoy that aspect of things, when it feels more like being part of the creative process.

What are the primary advantages and disadvantages of an anthology site as compared to single-creator sites?

Joey Manley

For creators who aren't already fabulously popular, being on an anthology site can provide cross-pollination, especially if it's the right anthology site for your particular comic. Let's keep it simple: say there's an anthology site with two comics on it, each one with around 500 readers. Now, the Web is vast, its pathways intricate, and it's entirely likely that any two comics with 500 readers will not have the same 500 readers, no matter how similar those comics. If the two comics are similar enough, chances are that the 500 people reading Comic A will discover Comic B, and vice versa, leading to a doubling of popularity for each comic. Things are never this simple, of course. There's always a little bit of crossover, anthology sites are larger than two (by and large), and the number of readers who are available for cross-pollination is usually much, much larger, too.

The primary disadvantage is that, as a creator, you lose a little bit of control over how your comics pages display, and the general architecture of your website. This can be a big issue for many creators whose first reputation was made on the Web – but it's almost always a non-issue for creators who came from the print world.

Logan DeAngelis

Frequency plays a big part in an anthology site as well for some creators. A lot of the cartoonists I know make their comics at the best pace they can, but still have day jobs they rely upon to feed the family. They put as much time as possible into their true calling, but can't manage to update new comics as often as they would like. Working with other artists creates a larger pool of work, and of course more frequent updates.

The flipside of this is that depending upon whom you work with, the other comics within your group may not seem to complement your own work. Two comics with nothing in common might stand side by side at times, turning some readers off. But as with anything, one reader's negative may be another's selling point. For every reader who appreciates the one-stop-shopping of a group dedicated to one type of comics, another might find that too similar and prefer a variety of titles under one roof. The diversity included in one group may be what attracted him or her to that site in the first place.

T Campbell

With anthology sites, readers get the security of some kind of critical standard. If you like three random webcomics, you have no idea whether you'll like a fourth, but if you like three on any given site, there's a pretty good chance you will like a fourth. One editor chose all four, after all. This is why TV stations and comicbook publishing companies have brands that people trust or distrust. Also, we give notice of which strips have updated on a given day, which is convenient for speed-surfers.

Barry Gregory

I agree with T Campbell. It's the branding aspect that's the biggest advantage for creators and consumers alike. And this is where the importance of the editor as arbiter of content is important. Whether they consciously realize it or not, our potential customers base their opinions of our sites largely on the judgements made by the site's editor. Sure, Web design, user-friendliness, and reliability are big factors as well, but the first and most visceral judgments are made based on the content available at the site.

Disadvantages? Sometimes it's easy for a good comic to get lost in the shuffle. On sites with a lot of content, a great comic can just get overlooked unless the site's editor makes a conscious (and sometimes considerable) effort to keep it front and centre. Which can lead to charges of favouritism from the site's other creators.

Patrick Coyle

There's strength in numbers. But it often comes down to time and money. Most people who have time to create comics don't have the time to create, update, and maintain a decent website. Also, though it can be cheap, webhosting – as well as many other tools one might need to create a decent Web presence – costs more money than many creators can afford. In addition, many creators don't know how to go about marketing their work. Having a large group of creators work together to get the word out through e-mails, handing out flyers at local shops, or doing ad swaps with other sites – all of which can be coordinated by a central organizer – helps everyone and saves money and time.

The biggest downside, to me, is that things can get out of hand from a logistical standpoint. It's tough to keep all the creators happy sometimes. We try to treat everyone equally, but sometimes things slip through the cracks and someone will feel slighted. I hate that, because I truly do want everyone to get time in the sun, but it's a fact of life.

Describe your efforts in the areas of marketing, advertising, and public relations and discuss why you've chosen to take these routes specifically.

Joey Manley

In terms of marketing, the real trick is to turn your audience into your marketers. Every audience member is also a publisher, with dozens, hundreds, or thousands of people in his/her audience (his/her e-mail address book, for example). This is the reality behind what usually gets called, unpleasantly, 'viral' marketing. If the audience loves you, they will work as hard for you as an army of employees would work.

In terms of press, our goal is to place stories in the 'Internet culture' news media – outlets like *Wired*, *Salon*, *Tech TV*, etc. We love it when we get written up in comics-related publications (online or off), but have found that those kinds of write-ups don't translate into new readers in the same way that, for example, a write-up in *Wired* magazine will.

We are able to attract regular readers who might not subscribe at first, but whose experience of the site over time convinces them that ours is a project that they want to support. Our site traffic is high – higher than most of the comics-related sites that want us to spend advertising money for banners on their sites. We're able to reach a large, well-targeted audience (people who clearly like our comics) every day, without having to spend a penny on advertising. In effect, the latest episodes of the comics (especially when they are tooncast) are giant 'banner ads' for the rest of the site.

One important way to convert the long-term, non-paying reader is to have some limited set of material that cannot be read for free by anybody. For example, on *Modern Tales*, we have a large library of online graphic novels and short story collections called *Longplay*, which is only available to subscribers. I don't expect the existence of *Longplay* to convert the first-time visitor. I expect *Longplay* to convert the long-term, non-paying reader who is very aware of what's on the site and can't stand not being able to read that one, last, little thing.

Logan DeAngelis

Viral marketing is a core aspect of our focus as well. Entertain your readers, and if they really enjoy what they're getting from your site, they will want to tell a friend about it. That kind of grass-roots marketing makes a lot of sense in an industry where it's very easy to e-mail a link to a friend you think will appreciate a comic.

T Campbell

The phrase 'guerrilla marketing' may be even more appropriate because as marketers we're in a highly dramatic situation. We have to compete not only with the mainstream comics market but also with TV, films, online games, and DVDs, which have much larger budgets. When I worked in print comics, I quickly learned that there were all kinds of ways to spend money on marketing, with zero return on investment. It doesn't seem coincidental to me that most of the survivors in webcomics are very conservative about their marketing budgets. As the business grows and competition becomes more intense, we may have to ramp up spending a bit. But if competition grows, then our efforts will combine to some degree and raise awareness of the whole webcomics field.

Patrick Coyle

In addition to viral marketing, we've gone the more traditional route. We send out press releases on a pretty regular basis, and they get posted on the various comic-related news sites. That's been pretty successful, and we get a lot of hits after our releases come out. Things settle back down again after a week or so, depending on how big the news is that we release. But we usually manage to keep 10% of the new traffic that comes our way.

Our print anthologies were actually started more as a marketing tool than anything else. It gets our name in front of people at comic shops and in the media, and it makes some people take us more seriously than if we were 'just a Web publisher'. People look twice when we mail them books, as opposed to a nice letter or press kit. We also attend the San Diego Comic-Con every year, and that has helped out with name recognition, if not with readership.

What delivery and payment mechanisms do you use?

Joey Manley

We use the site itself, RSS, and tooncasting currently. We've tried print-on-demand without much success. Our payment model is: latest installment is free; readers pay to get to the archives. I expect to launch a modest offset trade paperback business in the not-terribly-distant future.

Logan DeAngelis

Our goal was always a two-pronged direction aimed at both Web and print. The immediacy of the Web has certainly allowed that side of our direction to move forward faster than our print division, but we are now working to change that. We offer stories in larger installments than many other sites, with less frequent updates.

Barry Gregory

The Web is our delivery mechanism at *01*. We have no real interest (for the present at least) in traditional print. Print-on-demand offers intriguing possibilities, but the unit costs are still prohibitively high. As for our payment model, we use a service called BitPass. The best thing about BitPass is that (for no extra charge) they also gatekeep our content and, as a consequence of that, do our basic accounting for us as well. The gatekeeping alone makes it worthwhile. Otherwise, I would have to do the coding and maintenance myself or hire someone to do it for me.

Patrick Coyle

Komikwerks was always intended to straddle digital distribution and traditional print methods. What we're pushing now are electronic books and some other methods of digital distribution. There's a market for PDF comics using Adobe Acrobat Reader, and we're pursuing it. Our publishing partner, ibooks, already has a successful line of children's e-books, and our relationship with ibooks is helping us to distribute our comics. As for our payment method, for the first three years of the site, we had always kept our online comics free, and that was a conscious choice. However, in 2004, we started an online subscription service featuring some well-known creators, including Stan Lee. For this service, we're using PayPal, as it is a widely used, reputable standard, with a decent user interface.

CONCLUSION

We have sought in this book to impart practical knowledge of a range of techniques and tools. However, as useful as technical skills are, they are no substitute for artistic vision, a sense of purpose, and a unique sensibility that no book can teach. Vision is the sum of an artist's past experiences, present attitudes, and future goals. Though it cannot be taught, vision can be nurtured by interacting with one's peers and studying the works of other cultures and earlier generations.

With so much material already vying for attention on the Internet, it's easy to forget that digital comics is just beginning to take shape as a medium and marketplace. The youngest webcartoonists, along with those who have yet even to begin, will inherit a dynamic and diverse opening act in the on-going play of comics online. It will be up to the new generation, more than the pioneering one of today, to determine and direct how and to what extent the story progresses in the twenty-first century. But the pioneers, who are hardly ready to retire from their own work, can help to further the form by encouraging their own children to read and create webcomics and by teaching their hard-won techniques to all who want to learn, or simply in leading by example.

Webcomics has broken through barriers of geography, gender, age, language, culture, aesthetics, politics, economics, and technology. It has generated an atmosphere of participation and connection unequalled in comics history – dream it, draw it, and you can make it happen. No doubt there are challenges ahead for all webcartoonists, and change is always the only constant, but we hope this book has gone even a little way towards helping you meet those trials head on.

See you all online!

Images on this spread are from the *Louis* webcomics series created by the Franco-Scottish duo called Metaphrog (www.serializer.net and www.metaphrog.com).

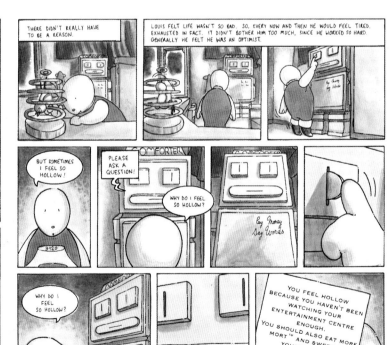

storms on the periphery

LOUIS BRIEFLY WONDERED HOW THE COMFORTER KNEW ABOUT HIS MESSY GARDEN.

I'M PROBABLY ALL CONFUSED.

...night Hamlet. And remember tonight is a lonesome town!

HIS BODY FELT HEAVY. FUNNY TO BE HEAVY AND HOLLOW. BUT HE COULDN'T LAUGH.

THAT NIGHT LOUIS SLEPT FEVERISHLY. HE DREAMT OF THE MARVELLOUS INSECT.

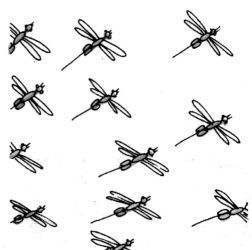

WEBCOMICS

Webcomics Anthology Sites

Artbomb – www.artbomb.net
Comics Sherpa – www.comicssherpa.com
DrunkDuck – www.drunkduck.com
Dumbrella – www.dumbrella.com
Flight – www.flightcomics.com
Girlamatic – www.girlamatic.com
Graphic Smash – www.graphicsmash.com
Keenspot – www.keenspot.com
Komikwerks – www.komikwerks.com
Modern Tales – www.moderntales.com
Online Comics – www.onlinecomics.net
OPi8.com – www.opi8.com
Pants Press – www.pantspress.net
PV Comics – www.pvcomics.com
Serializer – www.serializer.net
Top Shelf Productions – www.topshelfcomix.com
uComics – www.ucomics.com
WirePop – www.wirepop.com
Zero One Comics – www.01comics.com

Webcomics

10K Commotion – www.10kcommotion.com
A Softer World – www.asofterworld.com
Achewood – www.achewood.com
American Elf – www.americanelf.com
Bolt City – www.boltcity.com
Cascadia – www.cascadia.verunne.net
Chynco's Stuff – www.chynco.felaxx.com
The Circle Weave – www.circleweave.com
Comic Cafe – http://studiocyen.net/comics
Deliniated Life – www.thepersonunderthe
 stairs.com/~billomite
Demian5 – www.demian5.com
Demonology 101 – http://faith.rydia.net
Bruno – www.brunostrip.com
College Roomies from Hell!!! – www.crfh.net
Diesel Sweeties – www.dieselsweeties.com
Electric sheep – www.e-sheep.com
File 49 – www.randomlyhumming.com/file49
Fuzzy Feather – www.fuzzyfeather.com
Goats – www.goats.com
Haiku 5-7-5 – www.haiku5-7-5.com
Hellacomics – www.hellacomics.com
HFT Comics – www.hftcomics.com
Homestar Runner – www.homestarrunner.com
Keenspace – www.keenspace.com
Life with Leslie – www.evilspace
 robot.com/comics/lifewithleslie
Lowbright – www.lowbright.com

MegaTokyo – www.megatokyo.com
Mental Tentacle – www.mentaltentacle.com
Narbonic – www.narbonic.com
Neil Babra – www.neilcomics.com
The Nile Journals – www.e-merl.com
Nowhere Girl – www.nowheregirl.com
Penny Arcade – www.penny-arcade.com
PvP – www.pvponline.com
Scary Go Round – www.scarygoround.com
Scott McCloud – www.scottmccloud.com
Sinfest – www.sinfest.net
Sluggy Freelance – www.sluggy.com
Sourho – www.sourho.com
Strings of Fate – www.stringsoffate.com
Strongman Press – www.strongmanpress.com
Three Kingdoms Comic – www.shiji.cc/san
Urban Shogun – www.urbanshogun.com
Vacant – www.visforvacant.com
WebcomicsNation – www.webcomicsnation.com

Webcomics Journalism and Criticism

Comixpedia – www.comixpedia.com
Talk About Comics – www.talkaboutcomics.com
Webcartoonists' choice Awards – www.ccawards.com
Webcomics Examiner – www.webcomicsreview.com
Websnark – www.websnark.com

General News and Criticism Sites

Border Walker – www.borderwalker.com
Comic Book Resources – www.comicbook
 resources.com
COMICON – www.comicon.com
Digital Webbing – www.digitalwebbing.com
Graphic Novel Review – www.graphicnovelreview.com
iComics – www.icomics.com
Newsarama – www.newsarama.com
Ninth Art – www.ninthart.com
PopImage – www.popimage.com
Sequential Tart – www.sequentialtart.com
The Comics Journal – www.tcj.com
Wired Magazine – www.wired.com
Wizard Entertainment – www.wizarduniverse.com

Comics Organizations

Cartoon Art Museum – www.cartoonart.org
The Comic Book Legal Defense Fund –
 www.cbldf.org
Friends of Lulu – www.friends-lulu.org
International Museum of Cartoon Art –
 www.cartoon.org

National Association of Comics Art Educators –
 www.teachingcomics.org
Words and Pictures Museum –
 www.wordsandpictures.org

Money Transfer

BitPass – www.bitpass.com
PayPal – www.paypal.com

Fonts

Blambot – www.blambot.com
Comicraft – www.comicraft.com
Fontifier – www.fontifier.com

RECOMMENDED READING

The Art of the Comic Book, Robert C. Harvey (University Press of Mississippi, 1996)

Comics & Sequential Art, Will Eisner (North Light Books, 1994)

Comics, Comix & Graphic Novels: A History of Comic Art, Roger Sabin (Phaidon Press, 1991)

The DC Comics Guide to Coloring and Lettering Comics, Mark Chiarello and Todd Klein (Watson-Guptill Publications, 2004)

The DC Comics Guide to Inking Comics, Klaus Janson (Watson-Guptill Publications, 2003)

The DC Comics Guide to Penciling Comics, Klaus Janson (Watson-Guptill Publications, 2002)

The DC Comics Guide to Writing Comics, Dennis O'Neil (Watson-Guptill Publications, 2001)

Digital Prepress for Comic Books, Kevin Tinsley (Stickman Graphics, 1999)

Graphic Storytelling, Will Eisner (North Light Books, 2001)

How to Draw and Sell Digital Cartoons, Leo Hartas (Ilex, 2004)

Inventing Comics, essay by Dylan Horrocks (www.hicksville.co.nz/Inventing%20Comics.htm)

Manga! Manga! The World of Japanese Comics, Frederik L. Schodt (Kodansha International, 1983)

On Directing Film, David Mamet (Penguin Books, 1991)

Panel Discussions: Design in Sequential Art Storytelling, Durwin S. Talon (TwoMorrows Publishing, 2003)

Reinventing Comics, Scott McCloud (HarperCollins, 2000)

Story: Substance, Structure, Style, and The Principles of Screenwriting, Robert McKee (HarperCollins, 1997)

Toon Art: The Graphic Art of Digital Cartooning, Steven Withrow (Ilex, 2003)

True and False, David Mamet (Vintage Books, 1997)

Understanding Comics, Scott McCloud (HarperCollins, 1994)

Visual Storytelling: The Art and Technique, Tony Caputo (Watson-Guptill Publications, 2002)

Alternative comics: A term employed in the 'mainstream' of American superhero comics to describe: 1) comics that fall outside the most popular and financially successful genres and styles; 2) comics released by smaller publishers; 3) art comics: comics demonstrating ambitious artistic and/or narrative goals.

Animated GIF: A method of simple, limited animation for the Web. A sequence of images is stored in a single image file in the GIF format.

Bitmap: A digital image file that is made up of a grid of pixels displaying a fixed-resolution image. Also called 'raster'. 'Bitmap' also sometimes refers to such an image that is made up of only black or white pixels, with no other colours or shades of grey.

Closure: 1) The human tendency to perceive a 'whole' from incomplete parts. 2) The human tendency to unconsciously fill in gaps in sequences and patterns. In comics, closure is often used to create the illusion of time and motion. According to Scott McCloud, closure forms the 'grammar' of comics.

Comics: A form of graphic art that attempts to extend its meaning and impact by using various traditions. Examples include montages intended to represent events in time; the placement of images and words together to convey the idea that the images are speaking or thinking; the use of a simplified and exaggerated 'cartoonish' art style; and narratives in traditionally comics-oriented genres, particularly the 'gag' strip and the superhero genre. Scott

McCloud's famous and much-disputed definition of comics from *Understanding Comics*: 'Juxtaposed pictorial and other images in deliberate sequence, intended to convey information and/or to produce an aesthetic response in the viewer.' McCloud himself has suggested that this definition may cease to be relevant in the world of digital comics.

FLA: A native Flash file.

Flash: A software package from Macromedia that supports relatively low-bandwidth animation and other effects; it enjoys wide usage on the Web. Refers to both the software on Web browsers for viewing Flash files and the digital art tool used to create them.

Gag comic: A comic strip with the goal of delivering a punch line in each episode. If the strip is daily, it may also be called a 'joke-a-day' comic. Most syndicated newspaper strips are joke-a-day comics.

GIF: A digital image format that uses indexed colour for compression. *See also Animated GIF.*

Hyperlink: The ability of a webpage to link to other webpages and files.

Illustrator: A digital art program by Adobe, widely used by professional commercial artists to create vector-based art.

Indexed colour: A way of compressing image files. An 8-bit indexed colour file allows for up to 256 colours in a single image, compressing solid areas of colour for smaller file sizes.

Infinite canvas: A large or unconventional viewing area for a comic that is generally only practical in digital media. A common form of infinite canvas is a comic that is displayed on a long virtual webpage that requires scrolling to view it in its entirety. Other kinds of infinite canvases are supported by programs like Flash and allow for a wide variety of dimensional attributes. The term was coined by Scott McCloud in *Reinventing Comics*.

JPEG: A type of image compression for bitmap images that sheds image information to create smaller files.

Juxtaposition: The deliberate use of proximity for the creation of an implied relationship between discrete objects. In comics, juxtaposition is used primarily to create closure.

Long form: A term used in webcomics to separate long stories from gag comics, meaning: 1) A serialized comic telling an on-going story of significant length. 2) A non-serialized webcomic with a complete story of significant length.

Manga: Comics from Japan; the term also refers to various styles and influences in comics from other parts of the world, but which originated in Japanese comics.

McCloud, Scott: A comics artist best known for his groundbreaking theoretical book *Understanding Comics*. McCloud went on to author *Reinventing Comics*, which spearheaded widespread interest in webcomics and defined many of the concepts that have shaped the new medium.

Micropayment: A very small electronic payment. Micropayments have been a much-anticipated (and much debated) technology. One popular proponent is BitPass.

Native file format: The type of file a program creates, usually by default, that is designed to work specifically with that program. For instance, Photoshop can save images in many formats, like GIFs and JPEGs, but a PSD is its native format.

Panel-to-panel transitions: Scott McCloud's *Understanding Comics* defines six transitions from one panel to the next: 1) moment-to-moment, where relatively little change takes place between the two panels; 2) action-to-action, where the actions of a single subject are shown; 3) subject-to-subject, which transitions between different subjects in the same scene; 4) scene-to-scene, which 'transports us across significant distances of time and space'; 5) aspect-to-aspect, which 'bypasses time for the most part and sets a wandering eye on different aspects of a place, idea, or mood'; 6) non sequitur, 'which offers no logical relationship between panels whatsoever'.

Paysite: A website that requires payment to view part or sometimes all of its contents.

Photoshop: A digital art program from Adobe widely used among cartoonists to create and manipulate art, especially common in creating photo-collages and digital colouring.

Pixel: Short for 'picture element', a pixel is the smallest piece of a bitmap image.

PNG: Either of two digital image formats: PNG-8 uses 8-bit indexed colour, and PNG-24 allows for a full range of colours and an alpha channel, but creates larger files.

Poser: A digital art program from Curious Labs, which is commonly used to create 3D figures.

PSD: A native Photoshop file format.

Shoujo: A style of Japanese comic that is primarily aimed at teen and pre-teen girls.

Sprite comic: Any comic that uses sprites (low-resolution, pixel-based artwork) as its primary artwork. This includes ripped sprites (sprites harvested from video games or other pre-existing sources) as well as original sprites.

Subscription: A periodic fee (usually a monthly or yearly fee) charged by a paysite for access to all or part of the content of the site.

SWF: A movie exported from Flash.

Underground comics: Controversial, taboo-busting, and politically radical comic books from the 1960s and 1970s. They originated in the underground newspapers of the era and were mostly distributed to 'head shops' that sold drug paraphernalia. Enormously influential, the undergrounds spearheaded the establishment of an intelligent, adult-oriented branch of the comics medium.

Vector art: Digital image files that consist of geometric algorithms for creating the finished image. This is an efficient method of storing images, and produces scalable art that retains its sharpness when expanded in size. It is the storage method used for Flash and Illustrator files.

Webcomic: A comic that appears on the World Wide Web or is distributed via e-mail. (*See Introduction on page 10 for a detailed definition.*)

WEBCOMICS ACKNOWLEDGMENTS

Steven sends heartfelt thanks to all the webcomics creators and site editors who contributed to the creation of this book. Special thanks go to everyone at Ilex Press and Barron's; John Barber, for taking on this challenge with me; Tom Hart, T Campbell, Stuart Robertson, and Alexander Danner, for their expertise; and my family, especially my wife, Lesley.

John thanks all the creators who contributed so much time and effort to making this book possible. Extra thanks to Steven for bringing me onboard and being a great collaborator; Joey and Scott for encouragement and inspiration; Alex, Chris, Shane, Sean, Colin, Lori, and Brendan for everything; and Alison for everything else.

Picture Acknowledgments